ACID FOR
THE CHILDREN

ACID FOR THE CHILDREN

A Memoir

FLEA

GRAND CENTRAL
PUBLISHING

NEW YORK BOSTON

Grand Central Publishing
Hachette Book Group
1290 Avenue of the Americas, New York, NY 10104
grandcentralpublishing.com
twitter.com/grandcentralpub

First Edition: November 2019

Grand Central Publishing is a division of Hachette Book Group, Inc. The Grand Central Publishing name and logo is a trademark of Hachette Book Group, Inc.

The publisher is not responsible for websites (or their content) that are not owned by the publisher.

Manimal
Words and Music by Darby Crash and George Ruthenberg
Copyright © 1979 Crash Course Music
All Rights Administered by BMG Rights Management (US) LLC
All Rights Reserved Used by Permission
Reprinted by Permission of Hal Leonard LLC

"Beverly Hills"
Written by Roger Dowding and Keith Morris
Published by Irving Music, Inc./Plagued Music

Lyrics from the song "Yes, Yes, No" by Thelonious Monster used with permission from Bob Forrest

The Hachette Speakers Bureau provides a wide range of authors for speaking events. To find out more, go to www.hachettespeakersbureau.com or call (866) 376-6591.

Library of Congress Cataloging-in-Publication Data
Names: Flea (Musician) author. | Smith, Patti, writer of foreword.
Title: Acid for the children : a memoir / Flea ; foreword by Patti Smith. Description: First edition. | New York : Grand Central Publishing, 2019. Identifiers: LCCN 2019009319| ISBN 9781455530533 (hardcover) | ISBN 9781478912903 (audio book) | ISBN 9781478983514 (audio download) | ISBN 9781455530526 (ebook)
Subjects: LCSH: Flea (Musician) | Bass guitarists--United States--Biography. | Rock musicians--United States--Biography. | LCGFT: Autobiographies. Classification: LCC ML419.F59 A3 2019 | DDC 787.87/166092 [B] --dc23 LC record available at https://lccn.loc.gov/2019009319

ISBNs: 978-1-4555-3053-3 (hardcover), 978-1-4555-3052-6 (ebook), 978-1-5387-5128-2 (signed edition) 978-1-5387-5129-9 (special signed edition), 978-1-5387-5130-5 (special signed edition)

Printed in the United States of America

LSC-C

10 9 8 7 6 5 4 3 2 1

Always and in all ways, infinite thanks to my infinite girls, Clara and Sunny, who taught me what love is.

*

Dedicated to my sister Karyn, a better writer than I will ever be.

**

To Kurt Vonnegut Jr. I apologize for the semicolons.

I love you all
You little gray horizon
You little cold wet feet
You little whooshing car
You little creeping bobcat
You little cold and hollow wind
You big breaking wave
I breathe you in

Innocence

in a pitiless hand, may fall as a dying leaf
yet fate laid a finger upon a swaddled babe
born on the Australian mainland

from the tree of life he sprang, a wild thing
light-footed, kinetic, a twist of sweet breath
that for good or bad, magnified limb on limb
he cooed, baited and fished with his father
then plucked, flew above the River Yarra
to America, to Rye, dream catcher rumbling
signing the sky, dusting himself off, towering

providence assigned him an instrument
that in his hands formed a spectral voice
a color wheel spinning out of control
then returning, as a boomerang returns
to its burning center, its creative heart

the leaves of his life did not die but sang
page by page ciphers tracing the young
caravan, the raging backdrop, the litany
of faces blessed in the name of music

once in a vision there were bonfires blazing
he danced around them, dressed in his ages
innocence to experience, hungry for it all
flea the child, the devouring adolescent
with open arms, in a frenzy of gratitude

<div align="right">-patti smith</div>

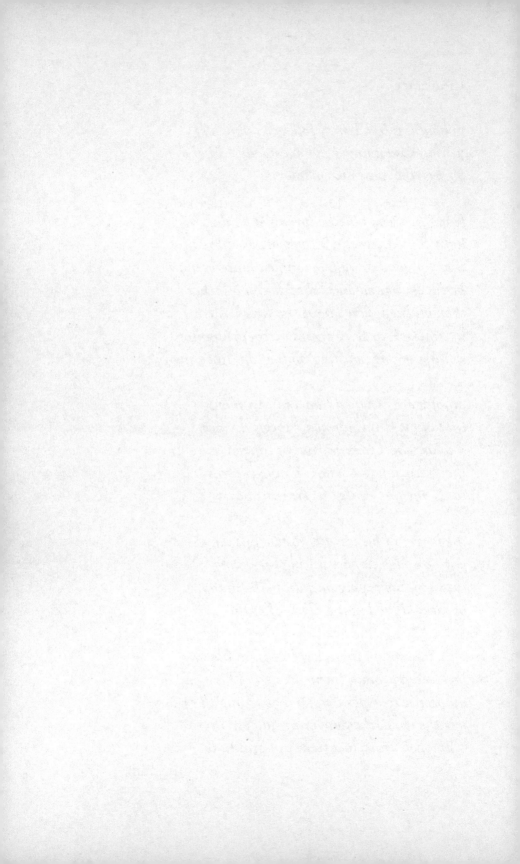

Part One

E thiopia, I yearn for you, I aspire to you, to feel you again reminding me who I am and what I am for. Your common sense reducing me to a sobbing wreck, tears of relief, a river of caring flowing down my tired cheeks. The smell of Ethiopia, of khat leaves, dust, and coffee, filled me up as soon as I arrived, satiating and reviving me, making me full of emotion and clear of vision to see the most beautiful people I've ever seen. Their houses breathe fire, their food heals you from the inside out, and their music (the thing that brought me there) makes one little Flea lurch out of his chair and vibrate like a hummingbird. Descending into ancient churches carved out of subterranean stone, then boarding a bus with a group of fellow musicians, riding through the open hilly countryside, laid out on the roof of that bus, eyes full of sky rushing by, hills growing to and fro, and women with buckets on their heads sashaying to the rhythm of their lives. Ethiopia embraced me, kept me safe, danced with me, and gave me coffee and cake.

During an adventure there in 2010, my friends and I found ourselves in a small church, down a dusty road in the town of Harar. Three elderly women sat upon a modest stage, color-

ful fabrics draped over the landscapes of their dark wrinkles of age, one holding a tambourine, the other two with their clapping hands, they percussed and sang for us, the songs they have sung for a trillion years, from the birthplace of humanity. They sang without thought, like breathing, they calmly accessed the deepest connection to spirit, their music echoing around the room, funky and hard as I could ever imagine. I was so moved by them, absolutely blown away by how good it felt, and the organic beauty of the situation. After they finished, a young woman amongst our group, Rachel Unthank from the north of England, stepped up to sing an old traditional English folk song. She sang it crystal clear and true, it was so fucking deep, and my river widened and strengthened even more as I felt the truth of my purpose reaffirmed once again, the strength of these two different cultures expressed so profoundly through the highest of human endeavors.

Like the moon looking down upon us without judgment, with that maternal and melancholy Mona Lisa smile, the elderly women looked on with bemused countenances. For them, the heart-wrenching beauty of Rachel Unthank, which awoke my spirit......that was normal. People sing. But those resounding voices reminded me of who I was, for what purpose I existed, and the beauty of it leveled me. Tears are not a sad or happy thing, they mean you care. I'm a wimp who cries too, so be it.

*

All my life has been a search for my highest self and a journey to the depths of spirit. Too often distracted by the competitive world, and tripping over my own foolish ego feet,

but driven by the beauty, I keep trying, and I stay the course, trying to let go and feel the truth of the moment. This burning thing inside has kept me always curious, always seeking, yearning for something more, always on the endless search to merge with infinite spirit, using whatever tools are available, and it has taken me into wild situations in my life, including bizarre and self-destructive places, cuz I have not been able to understand it or control it. However, it burns and burns, and I learn, I learn. My greatest hope is that, as I am compelled forward, this book will be an integral part of my journey. I have no choice but to let the wild inhaling and exhaling of the godzzz push me relentlessly ahead, and to always surrender, come what may, to the divine and cosmic rhythm, on and on, to the break of dawn......

boom bap boom ba boom bap.

A descent into an unlit place from which there is no escape, an underwater labyrinth of impossible mazes. No ghosts floating around down there with writing utensils hidden under their white eyehole sheets. I prefer to either drown like a cockroach in the toilet, or swim the English Channel like a hero. I may well be an eleven-fingered oaf slobbering over a typewriter, pounding out a thorny jumble of trash, an uneducated animal who runs on instinct and feeling. But this is my voice. The facts and figures aren't important to me, the colors and shapes that make up my world are; they are who I am, right or wrong. The limits of my memory are their own reward. Like Rashomon, the same thing looks different to everyone from their angle. The greatest fault of humankind belongs to those who think their view of what's real is the only truth.

I can only write and hope. Hope to arise from the muddy depths of this process, clear and cleansed, laser beams shooting from my eyeballs, holding the sunken treasure aloft, resplendent in silver and gold, an ebullient grin plastered on my face, and sea monsters docile at my feet.

A pang of concern furrows my brow when I wonder if I will hurt anybody's feelings in the telling of my story. I know I've gotta express the movements that shaped me.
I speak only for myself.
I hope my book can be a song.
Hope.

Bein famous don't mean shit.

The Magical
Bringer of Coziness

The greatest article of clothing I have ever owned was a black wool sweater that my nana knitted. It hung on my body perfectly, like a leaf on a tree, was so cozy, and rugged too. Made me feel just right, like I could go anywhere and do anything. I lost it in 1986, left it in a nightclub called Toad's Place in the northeast of the USA one cold and wintry eve in the aftermath of an all-night punk rock bacchanal, before I left the tour for a few days to go act in the *Back to the Future* movies. I felt so sad, but then Nana knitted me another one. No material thing ever made me feel as good as that second sweater, and never was I as handsome again (unfortunately I lost that one too). I could disappear into it and be shielded from all evil.

The magical sweater knitter, my nana (my mother's mother) Muriel Cheesewright, was a beautiful, hilarious, and bold woman. Growing up dirt poor and Cockney in the East End of London at the turn of the century, her mother died when she was eight, leaving Muriel with her Methodist minister father. My minister great-grandfather remarried a wicked witch who thought my nana was sinful because of her curly red

hair. My nana's beautiful shock of rocking red hair! Being forced to brush it with lye, to rid the sinful curls from their doubly sinful redness was painful, humiliating, and abusive. That stepmom might have temporarily straightened Nana's curly locks, but only fed her mighty resolve! MURIEL CHEESEWRIGHT FOREVER!

In the early twenties, as Muriel grew into her own early twenties, she fell in love with Jack Cheesewright. For some unknown reason, perhaps some societal issue of the time, it was impossible for them to be together. Then she fell for a married man who promised to leave his wife, but didn't. Devastated, disillusioned, and heartbroken, she boarded a ship to Australia looking for a new start in life. I can only imagine the vulnerability of her situation, a woman, all alone in the aftermath of World War I, getting on a ship bound for the other side of the world, traveling in steerage, to a place that for all she knew, might as well have been the moon. My sweet nana, with her sturdy frame, sparkling blue eyes, quirky dresses, and fierce determination.

After she arrived in Melbourne, she worked as housekeeper for a doctor. Pedaling past her workplace each day on his trusty bicycle was an errand boy delivering the groceries — Jack Dracup. She married him, and had three kids: my mother Patricia; my uncles Dennis, a sweet and hopeless romantic who maxed out his credit cards then mysteriously disappeared into the Philippines in the late nineties; and Roger, who I have never met, probably because he is very religious and disapproves of me due to my satanic rock-and-roll ways.

By all accounts, Jack Dracup was an abusive husband and a thoughtless father. When Muriel once served him salad — a new concept in Australia back then — he threw the bowl of

food at the wall yelling, "Don't bring me any bloody rabbit food!" He was a complete ass to her, and at a certain point she left him. This was a super courageous move at the time, since being an alcoholic drunken asshole was a man's right, and no long-suffering woman had society's support in challenging it.

She put her independent spirit to work and got her own place. Many years passed, and as Nana turned fifty, who showed up in Australia with a yearning heart??? My nana's soulmate, her original love, the milkman Jack Cheesewright! It was the happiest time of her life. They bought a motor home and set out to drive all around Australia. She was finally content, exploring the allure and mystery of the great continent, the first vacation of her life.

They were far out in the middle of the desert, hundreds of miles from anything when Jack Cheesewright was incapacitated by a stroke, leaving my sweet nana to get her soulmate back to the city. Nana didn't know how to drive and spent a few days with him out there, until her son-in-law, my stouthearted father, was able to go rescue her. Jack died shortly after. Thankfully, she made it back to Melbourne to live her active Nana life, and to be my grandmother.

Tender memories of her float back easily. She made the most delicious golden syrup dumplings, we played a card game called Bali, and the trips to the backyard to use her outhouse were better than any boring indoor toilet, including those in the billionaire gilded palaces that I later discovered as an adult. As a small child, my little life was made expansive by the beauty of her, the comfort of her, always the light of who she was. Those are the love visions of my Australian childhood that sustain me.

Before Nana broke through to the other side at the age of

ninety-eight, she came to an RHCP gig in Melbourne. Just before we hit, she walked across the stage to her seat in the wings, and as she passed center stage she paused, looked out to the crazed audience, sized them up, then extended both arms to the sky, beaming like the North Star. The crowd erupted in applause and the next day there was a photo of her glowing in her turquoise pantsuit on the front page of the newspaper. The headline read, ROCKING GRANNY.

A few years after Nana passed away I was in Adelaide, Australia, and happened into an art museum. I came upon an exhibition of student work, all themed around female empowerment. One piece was a collage of powerful women: Amelia Earhart, Patti Smith, and Evonne Goolagong stood out. And then I saw her popping out of the collage…the photo of my beautiful nana, Muriel Florence Cheesewright, the rocking granny, enjoying her rightful legacy.

Grandparents? What Grandparents?

I never got to know my maternal grandfather Jack Dracup. I met him only once when I was twelve. He was living in the back room of a funeral parlor in the suburban outskirts of Melbourne where he had the strange sideline job of building coffins. Our dad took me and my sister Karyn to visit. I don't remember any revealing conversation, just the kind of discomfort kids experience when they are around an adult who is unaccustomed to relating to children. He played a funny song on the piano while my sister and I did a nutty synchronous dance and felt happy for a few minutes. That was the closest I ever felt to any grandfather of mine. After that dance, my sister and I were told to wait for a while in the funeral parlor, while he and my father went around the corner to the pub.

Dad only talked about his own parents once. I was an adult and we were walking around an Australian saltwater lake looking for fishing bait when I asked him about his father. All I got was this short reply, "He was a very smart man, mate, but the drink killed him." I know nothing about his mother; I have no memory of ever meeting either of them, though there is photographic evidence of such, me the unwitting baby.

Dad did speak about his grandmother, who had come from Ireland to Australia on an orphan ship. She lived way out in the bush, the rural and wild middle of nowhere. She was a heavy drinker. As a boy, when Dad visited her he was sent to pick her up from the pub in a wheelbarrow because she was too wasted to walk. My twelve-year-old father, on a dirt path in the dark of night, laboring sturdily to push along a wheelbarrow full of drunken grandmother, while she bumped along, slurring garbled inanities at him till she passed out under the stars in a heap. On he pushed.

In a Circle

I've often felt separate from other human beings. I
have my moments of togetherness with others; I love
all sentient beings with my heart and am wildly fortunate to
have friends I can talk to, share joy and despair with; we loy-
ally have each other's back. I wordlessly communicate with
other musicians, sometimes plumbing great depths. But I'm
awkward with other people, sometimes even my closest friends.
My mind wanders, seeing others hold hands in a circle, from
my separate place. My earliest memories are rooted in an un-
derlying sense that something's wrong with me, that everyone
else is clued into a group consciousness from which I'm ex-
cluded. Like something in me is broken. As time passes I
become more comfortable with this strange sense of being
apart, but it never leaves, and on occasion, I go through phases
of intense and debilitating anxiety. Gnarly fucking panic at-
tacks. Perhaps it is a form of self-loathing, that I'm often
unable to find comfort in community. Am I the only one who's
fucked up like this? Can I get a witness?

Little Michael from Oz

I was born Michael Peter Balzary in Melbourne, Australia, on October 16, 1962. My father told me that on the day of my birth, "It was so bloody hot you could fry a bloody egg on the sidewalk, mate!"

My older sister Karyn had come into this sad and beautiful world two years earlier than me. We kind of look alike but she is smarter and prettier.

Most everyone who reads this book knows me as Flea. That name is in a far and distant future. As a kid, I am Michael Peter Balzary, a small blond child from Australia.

Australia is a strange place. I'm struck by the massive open space, the endless sky, the life-giving yet oppressively scorching light. Everything is more alive there, the food, the wildlife, the ocean. But it feels foreboding, like every beautiful thing has a meanness to it that will kill you, take you down, leave you as dusty bones. When I walk its bush trails, I'm uplifted and intoxicated by the smells, the silent and watchful animals, yet always alert that I could be killed by some kind of spider-snakemonster, or have my throat slit by a lunatic zapped by too much of that bright light, too much space and time to let

his maniac mind wheels spin. Even in its cities, I feel that way. Film directors Roeg, Weir, and Kotcheff got it right, so much peace and vibrant energy, but always the brutality, the terror, I feel it. A gorgeous, rejuvenating, friendly, terrifying, poisonous place. Is it cursed? The disenfranchised and ethnically cleansed aboriginal people put a whammy on whitey, retaliation for genocide and years of systematic abuse? It is without doubt haunted. In places there the racism can still be right out in the open, it turns my stomach. I don't know, I guess it's just an open honest place that shows all its colors (racism is better in the open, preferable to hiding poison in the sugar, my Funkadelic friend Michael CLIP Payne once told me, his wisdom penetrating my bubble of white privilege), you feel it all there, all born of the stunningly hypnotic land itself, which pulls no punches.

I always feel an umbilical connection to my birthland. It's a pillar of my life, no matter how long I'm away. My first four years shaped me profoundly, yet early childhood is a funny dream and murky memories hard to decipher. Australia's openness and dirt roads, the smell of eucalyptus forests, kangaroos dozing lazily in secret shady spots snapped to alert wakefulness by the sound of me and my dog crunching through the trail. Ahh, the taste of a meat pie from the local baker, tomato sauce dripping from its warm flaky crust. My homeland's colors and feelings are etched deeply into who I am.

Doggod

I could think all day long and still only come up with
these hard facts from my first four years in Australia,
obscure as they may be. It's truly weird what makes a perma-
nent impression on your psyche when you're a wee
toddler......

1. Wandering down the street and being mind-blown by the
 sight of an empty swimming pool. What the fuck is that???
2. Fighting with my sister Karyn over possession of a cat, and
 getting scratched.
3. My sweet nana.
4. Humping things. Pillows, bar stools, anything I could hold
 between my legs at the proper angle for humping. My
 mother called it my "bad habit" and I was scolded.
5. Peeing on the floor, and when confronted about it, blam-
 ing it on our dog Bambi.
6. A vague memory of my father going off to be in the navy.
 I was told he slept on top of a bomb. I imagined it like in a
 Looney Toons cartoon, Dad snoring atop a big black bomb
 in his sailor's outfit.

When I was four, my father Mick Balzary, who had gone straight into government service from high school, got a four-year assignment at the Australian consulate in New York City.

I confess I've never truly understood what he did at work. Something to do with the customs department; imports and exports. I'm certain he was an excellent customs official, without doubt he was a hardworking and sensible man, and he's never taken half steps in getting things done. He lived modestly and supported his family. The trip to New York was a highly coveted position, my dad nailed it, our family was excited, and in 1967, my mother, father, sister, and I up and moved to New York, ostensibly for four years, after which we were slated to return to Australia.

*

My life is marked significantly by my dogs. In Australia, a black Labrador named Bambi was a member of our family. Only Bambi understood all my thoughts. I was ecstatic when we chased each other around the house relentlessly, the peals of laughter flowing. Both of us breathing hard, we fell asleep on the floor together, my arms and legs wrapped around her furry blackness.

One evening shortly before we moved to New York, my sister and I emerged from the bathtub all clean, rosy cheeked, and pajama'd, when my parents told us the shocking truth that Bambi was no more. She'd gone to live with someone else. A misguided double-cross, they had stuck us in the tub, and then given Bambi the old heave-ho! They insensitively underesti-

mated us, thinking we couldn't handle it. I was devastated they didn't let us say goodbye. I totally understood and accepted that she had to get a new home and couldn't come to New York, but I felt betrayed that they'd denied us the dignity of a proper parting.

The King of the Sea

In March 1967, we traveled to America by sea, a two-month journey on a fancy cruise ship, the S.S. *Oriana Express*. Ship memories........

I was confronted with a bizarre challenge when told that as tradition has it, when the ship passes over the equator, King Neptune magically appears and selects one child to be painted green and dunked in the ship's swimming pool. It was an uncontrollable, unavoidable, and mystical event. I was selected to be the sacrificial child for this ceremony a week before it happened. I lived in fear for days, constantly asking the adults questions about it. How long would I be held under? Was King Neptune a benevolent or malevolent god of the sea? Who was going to paint me? What would I be like after? Did children always survive this? After days of trepidation and never getting a straight answer, the big day finally arrived. Some potbellied balding guy I'd seen wandering around the ship nurturing a beer had put on a super cheesy fake beard and brandished a lame plastic triton. He gave me a green ice cream and I waded around in the pool's shallow end while he bullshitted with the grown-ups. My first feelings of existential despair.

My sister and I were left to our own devices in our cabin most evenings, she six, and I four. The ship supplied a babysitter, but bizarrely we never met her, she was only a voice coming through a wall speaker, telling us to "go to bed, and be quiet," her ghostlike admonishments causing us no end of laughter.

Hijinks continued when I broke my arm in the cabin. I fell while crossing from one upper bunk bed to the other by means of a *Little Rascals*–style bridge we'd constructed. I ran crying to the infinite vastness of the adults' dining area to sound the alarm. I ran into that room and felt like I had entered another dimension. Deliriously past my bedtime, this monstrous never-ending arena full of besuited voyagers clinking their cocktail glasses to the sound of Stan Getz blowing "The Girl from Ipanema" stunned me, stopping me in my tracks. Standing there with my broken arm like I was floating away into space.

The four Australian immigrants took their first steps onto American soil. As we got in a cab at the ship's port, the cabbie promptly slammed the door on my head; blood gushed everywhere, I was ushered into an ambulance and stitched up. Welcome to the USA!

We All Leapfrog Our Parents Up a Hill

I've always admired my father. He is a hardworking, intelligent, kind, and humorous man, with a profound connection to the nature he feels at peace in, and also a hard-drinking, occasionally mean-spirited man, if you catch him at the wrong time. My father doesn't tolerate bullshit, and no one ever crosses him more than once. He grew up in a tough no-nonsense world of lots of beer drinking and fists meeting faces. A world where a man minds his own business and holds true to his word, or he better take a fucking hike. For him, success is measured by how strong and diligent you are. He's suspicious of people whose ambitions ring false. No patience for people feeling sorry for themselves......go out and get a fucking job. My dad is hard. His encyclopedic knowledge and oneness with the Australian bush has inspired me profoundly. My relationship to nature has given me the most contentment and joy, and I thank my father for this, the fishing, the hiking, the camping at an early age, the wonders of a psychedelic crab cavorting about in a kinetic tide pool. Those times we shared stoked the fire and desire in me to commune with nature at every chance. "That man is richest whose pleasures are the

cheapest," said Thoreau, and my father taught me early on to realize this most important truth.

On the flipside, as a child I was terrified of him. He would speak very softly when he was angry, and then suddenly explode in a fit of violent yelling that traumatized the fuck outta me. I often ended up over his knee to receive a robust spanking. I had a knot of fear in my stomach around him, worried that I was in trouble, that I was doing something wrong, that something was inherently wrong with me. Always a feeling of impending doom.

Dad and I have the same body. We are short, fast, slim, and strong. But that's where comparisons end. We have completely different heads. My father's head is hard and handsome, his ruddy complexion often reddened with alcohol and anger. His blue eyes pierce in a stabbing glinting kind of way, his nose classic and straight, he also stands straight and keeps everything in order. His nose is very unlike the soft round noses my sister and I share, and I don't know why because my mother has a normal straight nose too. My head is simian, monkey-like, and akin to the ocean, which pokes through my eyes; a head that comes from a time when we lived in the ocean, before we crawled and slimed our way to land. I live to float in the ocean, to surrender and be tossed around like any other fish or mammal, but my father likes to stand outside it, catch the fishes, his belly full of beer and his sharp hooks pulling up a delicious fresh breakfast for us. He never goes in the ocean.

Rye Milquetoast

Though Dad's job was in Manhattan, we lived in the tony suburb of Rye, a part of the world where everything and everyone is in order. No family is without an acceptable car, parents responsibly work jobs of substance, children are funny little rascals, and teenagers revolt within reason, with appropriate haircuts and music.

When we first arrived, our new home seemed massive to me. I'd never seen a house like it, a mansion, a sprawling estate, a king's castle. The road we were on had recently been paved, and kids were roller-skating up and down the block. This new world outside seemed infinite, bustling, and challenging, way bigger than the confines of my family, or anything I'd seen or felt in Australia. It was wide open and ripe with possibility.

If I could ever imagine something being normal, this was it. In this normal middle-class neighborhood we lived in a normal three-bedroom house (despite my awestricken take on it, ours was a regular *Brady Bunch* house) on a friendly normal street from which my normal father disappeared to his normal job each day wearing a normal suit and tie, briefcase in hand.

He reappeared in the early evening like clockwork, my mother had dinner ready, and the four of us sat down to dine. Everything was set up for the perfect idyllic childhood. My father worked hard, golfed on the weekends, ran a tight ship, and we had wholesome recreations.

Dad took me fishing. I was excited as we walked out onto the pier, happily talking about catching a big one, but then I got in trouble for putting on my fishhook incorrectly, and Dad angrily snapped at me that I was doing it all wrong. I felt like shit, all fun evaporated, I just wanted to get away. When he busted me for writing profanity in a Mad Libs book, I got spanked and can still hear him yelling, "When I was your age my father would beat my backside with a razor strap until it was red as a lobster!" Those words......Razors! Lobsters!

A father should be a sanctuary for a child. When Dad was nurturing and supportive, I felt whole, but when his eyes turned icy cold, and his face beet red, when the rage came out......I lost touch with my own beauty. I walked through my days slowed by a tension in my heart that only he could soothe.

The Mystery of Rocking the Fuck Out

I was five the first time I got fascinated by music. Walking down the street in my suburban white-bread neighborhood, a half dozen older kids yelled to me from an alleyway, beckoning me to join 'em. As I approached, a little bit scared, I heard tinny distorted rock music blaring and saw the kids all hyped up and playing makeshift instruments........... trashcan lids, guitar brooms, pinecone trumpets, kicking out these jamz while swaying their bodies to the rhythm.

I stood there freaked out, puzzled, and amazed. This was some otherworldly shit. They finished the song and thinking they had me fooled, sported unabashed grins and asked me, "How d'ya like our band!?" Sensing I was being hoodwinked, I turned and ran home.

I figured out about the hidden radio soon enough, but in that moment of struggling to understand how they were making this music happen, I was consumed with excitement. If they didn't do it, if they weren't the answer to this mystery, then what was? Could kids do it? Did it come from Mars? There was only one thing of which I was certain, it was magic.

I started coming up with funny little songs. One was gritty

and bluesy, a kind of a rap, "A mama and a papa and a baby Lu, all got something for me and you, so wrap it up quick and put it in the oven, it's comin' out quick so don't forget the stuffin'." Who knows what it meant. I was singing it one day alone in my bedroom, all earnest and feeling the funk, when my sister walked in, mimicking me and laughing. I was so embarrassed I wanted to crawl into a hole and be alone forever. I'd been found out. A few years later, I was singing along to the Beatles version of "Till There Was You," when my mother heard me and said, "Michael, that sounds horrible, you are so out of tune!" I've always been insecure about my singing voice.

Thirty-five years after that, I was doing a recording session with my friend Jewel when she asked about some songs I'd written and recorded a couple of years previously. It was stuff where I played acoustic guitar and sang, and she'd generously warbled backgrounds on it. I replied that I'd stopped that project, because I just didn't have a strong singing voice. She said, "Flea, I think your voice is charming." Then the producer of the session, Daniel Lanois, chimed in, "It could be charmingly bad!" Ha, I think Daniel was onto something.

First

I nurtured a crush on my classmate Molly in first grade. Ah, she was so beautiful, the cool and confident way she pulled her bicycle up from its kickstand, something magic in her skin, her hair falling into her eyes, the sound of her carefree laughter ricocheting around the hallways. At naptime, when the fluorescent lights were dimmed and we crashed out on mats on the classroom floor, I saw up her skirt, the colorful patterns on her underwear. I thought it was the most beautiful thing I'd ever seen. I cuddled cozily into my blanket, comforted by the sweet and gentle femininity.

Blip Blop Klop

It was a different time for immigrants in the USA, and Karyn and I were made to attend speech class to learn proper American English. None of those soft Australian Rs would do, we repeated over and over, CARRRR BARRRR FARRR RUN RABBIT RUN. We pretended to the other kids on the playground that we spoke Australian, inventing some kind of gobbledygook talk. "Pree zo bim him lo winkin fop?" "Ahh hahaha Bachongama hoof plate!" We thought we were pretty clever, and those fools all fell for it.

Night Night

I loved bedtime, and waited eagerly for my parents to finally close the door and turn out the lights. It was on! Free from all restraints, my imagination at an all-time transcendent apex, my friends came to me as soon as I pulled the blankets over my head and opened my eyes. Quiet time in the pitch-black darkness was full of wildly colorful characters who appeared and conversed, engaging me in all kinds of games, songs, and contests. Time spent traversing the horizons of mystical lands. This was when I vibrated whole, real, and completely content. An ecstatic trance. It's the feeling I have reached for all my life. The connection to spirit. These hours spent with imaginary friends was god speaking to me, and if that's all the god there is, that's enough. Parents were the kryptonite to the Superman of this incredible world though, and any sign of them could send it crashing down.

Men Don't Kiss Men

I was excitably running out the door with my Christmas roller skates to finally join the rest of the kids on that smooth paved road. As I'd always done, I went to give my father a kiss. He stopped me, holding me firmly by the shoulders and saying, "You are too old to kiss me now, don't do it again, do you understand?" I silently nodded, released myself from his grip, and ran out the door. It felt cold and wrong to me, and even at the age of six I knew it was a misguided concept of tough-guy machismo. I knew kisses were good.

I looked for kindness and approval wherever I went, yearning for affection. The empty space I wanted my parents to fill was a place I didn't understand, a room into which I was scared to venture. I felt connected to my father, he was my hero, but it became a more brittle and tenuous thing. It seemed he was away more often, and he and my mother argued frequently. As time went by, these arguments elongated and intensified. I lay in bed at night listening to them, bloody Christ, bloody this and bloody that, they would scream at each other. I knew my sister was over in her room listening to this same scary shit.

Mama Wanna Party

I didn't think of getting that love or affection from my mother. I never got that from her, and didn't expect it. Consciously or not, she thought that "children should be seen and not heard," and there is not one instance in my life where I can ever remember her holding or cuddling me. She was just kind of....there. I never considered that she was absent as a mother nor did I consciously feel any hurt. Mom wasn't a weak person, or a wisp of a domineered housewife who hid in the background. Far from it. She was a vivacious, funny, and smart woman who loudly voiced her opinions, and would've been a suffragette had she lived in the twenties. She was gorgeous, with shoulder-length brown hair and beautiful brown eyes. She was strong and was an athlete as a teenager. She smoked, drank, and laughed out loud. A vital presence.

She just never did understand or relate to children.

She left school as a teenager and worked full-time in an office, then married young and became a mother and housewife. Now she found herself in New York in the swinging sixties, and despite my dad's best efforts to make her the perfect square wife, she was energized, curious, and had time on

her hands. She took music lessons, looked longingly at the bohemian lifestyle, and went off alone to the Newport Jazz Festival to see Miles Davis. Not about to be the happy home-maker, she wanted to party.

Dad never became rich, and I've been told some blame fell upon my mom for failing to help him climb the career ladder. Instead of standing by her man, she acquired hippie habits, wore dashikis, and was a lousy teammate at cocktail parties.

Think Slow

The perfection of spacing out and doing nothing. Waking up at the break of dawn, putting my little hands and blond head against the warm radiator, rubbing the heat into my forehead. Calling out in a small Australian croaky voice, "Mummy, I dooon't feel well, I'm sick." Success! An entire day; free to talk to my imaginary friends and read my Wizard of Oz books, in which I learned of the word "Pyrzxyl," which if pronounced correctly, gives one infinitely magical powers. I've been trying to properly pronounce it ever since.

*

My sister freed herself of an annoying little brother and ran off with the bigger kids, so I walked the five blocks to Midlands primary school alone each morning. Hands stiff and red from the cold air and jammed into my pockets, choo choo train steam billowing from every breath, I loved feeling the ice and snow crunch the concrete under my feet. I invented games for myself, marching like a tin soldier and only touching the sidewalk cracks, and when the ice was smooth I practiced slid-

ing and spinning in circles until I fell on my face. I crammed words together, then said them quickly to make up new ones: "hatpigpot" and "nogluegood." Once I threw one of my shoes into the icy creek for no good reason other than the strange pleasure of watching it float away. I came home with only one shoe and no alibi to an infuriated father and certain spanking: "Do you know how much I paid for those shoes! Money doesn't grow on trees!" I knew I fucked up, but damn I loved those solo perambulations, and the freedom of letting my mind meander at its own cosmic pace.

Ho Ho Ho

If I was ever gonna turn to religion, it woulda been Christmas that dun it. The warm magic that took a hold of me at Christmas was palpable. In the days leading up to it I wuz a buzzin' and a tinglin'. Karyn and I watched the once-a-year Christmas specials each night after school, entranced by Rudolph's glowing maraschino-cherry nose and the Abominable Snowman's lurking violence in mystical northern icebergs.

My wide-eyed, sincere love for Santa was pure and true, as I sat vigil by the bedroom window, late as I could, to see his arrival. My sister once successfully tricked me by making fake reindeer footprints on our snowy porch, then waking me after I'd fallen asleep by my window perch, and telling me she had seen him land.

But after I got all the adult facts and logic straight and began sneaking into my parents' room to find the hidden presents, and even now when I Christmas shop with my cold plastic credit cards, the magic of Santa Claus has lost none of its empyrean allure. I still marvel at the presents under the tree, and when we all gather around it, the rest of the world is eclipsed by the loving glow of a Christmas light. I still believe in Santa.

Wild Walt

'Round the time I turned seven, things erupted more aggressively between my parents. It turned ugly, and I felt a net of grim tension tighten around us, made worse by the artificial smiles and phony optimistic behavior trotted out by Mom and Dad to their cocktail party friends. I thought they were full of shit. I lay frozen still at night while their yelling and screaming scared my imaginary friends away.

Dad was gone on a business trip when Mom introduced me and Karyn to a man named Walter, her guitar teacher at the local music school. He was a heavy-set and sturdy cat in a sixties-style paisley button-up shirt and bell-bottom slacks. He sported greasy and unkempt jet-black hair in some kinda weird overgrown bowl haircut, much longer than my father or any respectable man ever would have worn it, and a goatee too, his flat black eyes set in a round head. With an easy smile, he called me "man" and said "far out" a couple of times.

Not long after that, my parents informed Karyn and me that we'd be leaving Rye, my father would return to Australia alone, and the three of us were going to live with Walter in another part of New York.

Whoa.

For the next few days the combative yelling and screaming and thick gray feeling in our home reached its most fevered pitch, but there were also quiet loving moments with my father, who took time with me and Karyn to sit nicely in the living room together. He told me that I must always dress cleanly, work hard, be polite, and that I could have his stamp collection. He told my sister she could have one of his stocks that might be worth a lot of money one day.

Goodbyes and Hellos

The three of us stood on the doorstep of the family house for the last time, my father in the doorway watching us, he looked at my mother and said in a low angry voice, "Now get the hell out of my house." It scared the wits out of me.

Back to Australia he went.

I can only imagine the depth of his hurt, returning to his beloved homeland without his children. He loved us with everything he knew how. Damn.

The three of us walked to a waiting VW Bug parked in the street out front. Upon my query earlier, Mom had told me that Walter was not picking us up, but when we got in the car, the beige trench coat covering the passenger window came down, and there he was in the driver's seat, easy smile, beatnik goatee, and colorful African shirt.

I was confused but excited. I loved not knowing what was coming next, and I felt like I was being freed.

That was the end of the normal life.

I Say Thank You

People have expressed dismay and compassion to me when I mention how my father left my life at such a young age, but I feel gratitude about how it went down. He had definite plans about what he wanted me to be, what he wanted me to do with my life, and would have done everything he could to control its outcome. Like the beloved bonsai he's trimmed and groomed over a lifetime in order to control their growth, so he would have tried to do with me. As difficult as it was, I'm stoked I had the opportunity to forge my own way.

Many years passed before I learned to truly appreciate Dad's love.

When I first made money in my early thirties, I purchased a property and built a house in small town Australia, near where my father lives. I was seeing a lot of him for the first time since I was a little boy and we were attempting to navigate our father-son relationship. I'd been through a lot, had grown up without any parent's help, and had finally come to a place of peace, so I felt judged and disrespected when he told me how to live my life. It seemed to drive him crazy that he couldn't

control me. The cultural differences between us were many and there were plenty of misunderstandings and hurt feelings on both sides.

But on a trip there a few years back, I had a problem with my septic tank; shit had flowed up through a drain in the laundry room, covering the floor with a putrid, vomit-inducing liquid. I was going to call a repairman, but my dad, in true Mick Balzary fashion, dismissed the idea of calling a plumber, telling me, "Don't waste your money, mate, I'll come over and fix it."

Standing in my backyard, he diagnosed a clog in the outdoor shower drain, removing the drain cover and putting his arm deep down into it. It was filled with sewage. "It's shit, mate," he said. So here is this seventy-eight-year-old man, lying down on the ground, face smushed into the cement, his arm disappearing down the drain up to the shoulder. He took his arm out covered in slime, then he kept working and working till it was fixed. My girlfriend was standing there, looking at me and shaking her head in awe. That night under a supremely starry Australian sky, with a soulful truth that went right through me, she said, "Don't you realize how much your father loves you? Forget all this hippie inner-child bullshit. Your father would swim through a river of shit for you. That's what love is." I wept with gratitude.

I had funny ways of rationalizing Dad's departure. When I was about ten years old, I read a book by Hunter S. Thompson, *Hell's Angels: The Strange and Terrible Saga of the Outlaw Motorcycle Gangs,* and I had a recurring daydream of my mother saying in a serious somber voice, "Michael......your father is a Hell's Angel." I imagined being part of this dramatic

play, my father the motorcycle gangster, like Racer X in *Speed Racer*. I needed to invent a story because the adults never broke it down for me and my sister in a healthy way. It was just a lot of terrifying fighting, then an end, no explanation or acknowledgment of what we might be feeling. And no, I'm not making it up about reading the Hunter Thompson book at that early age. Everything on the living room shelf was fair game, and I read any book I could get my hands on. Even at ten, I was reading ones that included absolute pathos. I loved all those books, from the most innocent Roald Dahl to Mario Puzo's *The Godfather*, and I believe they were all good for me. No explicit art ever hurt me.

One notable exception.

I saw The Exorcist *as a preteen. Scared the holy fuck outta me. I was sitting next to an elderly and portly woman who wore a crazy curly wig and a big fur coat. At a certain point, during a peak moment of terror, the woman took her coat and placed it over my head, shielding me from the film. I was happy to hide under the coat for a minute, until I squirmed free and she gave me a matronly smile. Years later when I told this story to my best friend Anthony Kiedis, he said the exact same thing happened to him at the same theater! This woman on a mission went and sat next to kids to save their souls from the horrors of Satan.*

Rhythm Changes

Turn and face the strange.
— David Bowie

Walter Urban Jr., the man I called Wild Walt, lived with his parents in a small two-bedroom house in Larchmont, a suburb not far from Rye. It was about a third the size of my dad's house, and Walter lived in the basement. Walter's very German immigrant parents lived upstairs, Walter Sr. and Lydia Urban. My sister and I shared a room up in the main house next to their bedroom, but I never spoke to them beyond uncomfortable pleasantries. They were strange beings, like characters in a Tim Burton film. Walter Sr. and his son owned and ran a deli-liquor store. Walter Sr. was a thin, pale, gray-haired and balding man, sitting in the kitchen, glassy-eyed, with a bottle of booze, staring into space, who oozed me a delirious grin when I came into the room. Once I drove somewhere with him and tried my damnedest to think of something to say, but it felt awkward, and we never actually achieved conversation.

Lydia was sturdy and stout, a head of blue hair always in a hairnet, and a workwomanlike dress. She came shuffling into our room at night after lights out, muttering in her hard German accent, to give us candy. She seemed psycho and he seemed plastered, even though I didn't understand either of those conditions. I just wanted to get away. I found out later that Walter had suffered severe emotional abuse at their hands; degradation and brutality. Here he was, thirty-two years old, still living with his parents, and the shit they'd say to him, to humiliate him and make him feel like a loser, was fucking awful.

As soon as Karyn and I awoke we'd scamper downstairs to the safety zone, the basement. This was Walter's home, about the size of the kitchen in our Rye house. Mom and Walter slept in a bed in the corner, divided off from the rest of the room by some cheap imitation Persian tapestries hung from the low ceiling. On one side of the room was a stereo and shelves weighed down by hundreds of jazz albums, and on the other a small couch in front of a TV. The walls were covered with Walter's artistic endeavors — interestingly odd paintings of Eastern religious symbols, photographs of outsider graffiti art from around the city, and a photo series of cockroaches mating against a stark white backdrop. Music was always in the air, mostly jazz, but also Blood Sweat & Tears because Walter was friends with the band's trumpet player Lew Soloff (I believe they were junkie buddies together). When the Stones' "Sympathy for the Devil" came on the radio, Walter asked if I could guess who they were singing about. I couldn't figure it out, then he told me "The Devil HAHAHAHA!"

For the first few months, Karyn and I would just stay on

that little couch watching TV all day long, cocooned up in the comfort of the basement. Mom and Walter once talked to us about it, saying we needed to get outside and meet other kids, but it took us a good few months before we ventured outside. Sitting inside that little basement all day staring at the television was our way of dealing with the massive shift in our lives. They just let us do what we wanted — no Little League, no ballet class. No structure to hold on to.

Our lives were flipped upside down and we were expected to carry on like nothing had happened. Jesus, we'd just gone from living with a conservative Australian father in a big nice house full of rules, regulations, and schedules, to living with a beatnik tripper in his parents' basement! No talk of our fears or feelings.

I was hurt and needed some kinda guidance and nurturing, but didn't know it.

Basement Daze

Karyn and I were extensions of each other, though she was two years older and always more clued in about the goings on in our world. She was a wild child. With a face full of freckles she hated, her thick wavy brown hair waterfalling this way and that, she was a born rebel who couldn't be constrained by rules. Any way she could she would. She was short, fast, and strong like me and Dad. When things were pissing her off, she wasn't about to sit still, be a good girl, and hope for a reward down the road.

Her rebellious spirit often did not serve her. Karyn lashed out at parents, at school, and even me. With a hint of sibling rivalry, she thought I was the pampered favorite one, and it pissed her off. Yeah, I was the annoying little brother, and we had some full-on knock-down, drag-out fights. I once threw a vacuum at her from about five steps up and took her out, and another time pelted her hurtfully with a handful of pennies; she got her licks in too and beat the shit outta me lotsa times. But we were able to generate a unique brand of humor that I've never shared with anyone else. The funny chants we made up, the hysterical laughter we birthed, the wrestling in the bathtub

as tiny kids when our parents would stick us in there. In a lot of ways we were the same: She was me with a wig.

Karyn was a more advanced reader than me. One morning she was running around crazily in circles in the basement yelling "CHARLIE GOT THE GOLDEN TICKET CHARLIE GOT THE GOLDEN TICKET!!!!" I couldn't wait for my turn with the Roald Dahl. She always understood books in a deeper way than everyone else, getting all the heart and soul out of them. Literature has always brought us together.

We shared a book called *Nancy and Plum*, a story about two little orphaned sisters who had to deal with all manner of misfortune before finding their freedom. We loved the hell out of *Nancy and Plum* and talked about it all the time. I treasured getting lost in the story, and really identified with the little girls' bravery, integrity, and sense of adventure. I looked forward to the cozy and happy feeling I had when reading it, and marveled at writer Betty MacDonald's craftsmanship.

During those early basement days, we were great comfort to each other. Not like we talked each other through it or anything, we just silently knew that we were the only ones who understood. We bore witness together.

Up Up and Away

In our new life, we were the masters of our days. Us kids just ate whenever we pleased, whatever was around. When we started going outside, we ran the streets all day unchecked. Wild style.

Walter was up and down a lot, but fun when he was in a good mood. Early on in our relationship, I was thrilled to discover he was a pilot. We walked along the summer asphalt of a small New York airport, where I saw rows of hundreds of small planes lined up. They all looked the same, but then I noticed a bright purple one beaming in the sunshine, weirdly standing out from all the rest, and smiling at me. He walked up to it and opened the door. I couldn't fucking believe it! My heart leapt when we took off in his purple single-engine Cessna, rising up like the Wright brothers, cruising over downtown Manhattan and out over Jones Beach, marveling and daydreaming, my head out the window hooting and hollering, he and I laughing and slapping five. For a young boy it was the greatest. Had I been aware that it wasn't cool for him to be sucking on that pint of vodka in his lap while piloting the plane I might have been a little more hesitant, but hey what did I know!

We lived with Walter's parents for six months until we got our own place down the block. A nice little yellow three-bedroom house. Walter sold his plane to help get the down payment together and I imagine that my dad's child support payments helped too. One day I came home from school to find Mom and Walter sitting at the kitchen counter drinking beer. Walter was crying and looked at me lovingly, but like a vulnerable lost-puppy kind of love. "Walter's never owned his own house before," Mom explained.

No matter what Walter did, he always appeared unkempt, unruly, and slovenly. His round face was one that suffered much humiliation as a youth. It perpetually looked unshaven and pent up with heavy feelings, even in his cleanest and most serene of times. His black-lake eyeballs were wells of emotion.

Bop One Bop Two

I loved that Walter was loose. He was anti-authority, and talked to me like a friend, saying "cool" and "dig" and "motherfucker" while my real dad had lectured me constantly about acting properly. The walls of rules came a tumblin' down. But the thing about Walter Urban Jr. that changed my life forever was that he was a musician, a jazzman who played the upright bass and could walk that thing through bebop changes with the ferocity of a stampeding herd of elephants.

There are things in life that you remember with different senses, some by image, some by sound or talk, some by physical sensation. Some memories are so transformative, so laden with guidance, so blissful and/or violent, it feels like God speaking directly.

I'm eight years old. My mother and Walter are having a Sunday afternoon party at our new house. There's plenty of food and booze, the smell of weed in the air, and a crowd of folks carrying on having a good time, about half of them are black (the ethnic mix of people is a beautiful part of the big new change in our lives). There's a humble drum setup in

the living room where the coffee table usually sat, and next to the upright piano a bunch of horn cases. I'm running around, excited about all the different kinds of people, all of whom take time to laugh and joke with me. Paper plates lie around with my mom's mac and cheese on 'em, and forgotten lipstick smeared cups a third filled with booze. Then the men get out their horns, the drummer starts fiddling and tapping, and Walter picks up his big German upright bass. "Let's do 'Cherokee.' Fast. One a two a one two three four".....BAM!!! They take off and I am stunned, I'm FLOATING, waves of light are surging through all of me, I'm rolling around on the floor laughing, wall, carpet, ceiling, sweat, window, kick drum, shimmering golden color......like an old lady speaking in tongues at a Pentecostal meeting, except I'm laughing my head off, the bodacious rhythm throwing me around on the floor, I'm in an ecstatic trance and have never ever dreamed that something could feel this good. I get up and take a good look, Walter hunched over his bass, drummer swinging freely with laid-back cigarette smile, horn players sucking and blowing and concentrating in between sips and puffs, piano player vamping for all he's worth. If Moses had parted the seas right in front of me, or my dog started speaking the Queen's English, it would not have been this miraculous. This wasn't no fuckin' kids in an alleyway with brooms, this was real, and to this day, the feeling in that room has given me something to reach for.

A Dixie cup of cheap wine in her hand, my mom danced around the room in her favorite dress, ecstatically free to cackle like an idiot, or engage in fresh intellectual discussions with this multiethnic bohemian jazz crowd. Having grown up in provincial Australia, then chafing against the dinner-ready-

at-seven housewife life in New York, she relished and believed in this new sense of community. I can only imagine the flight of her liberation!

My strong adventurous mama. All set to live the dream in Australia, a world she knew, trusted, and understood. A safe, solid, and secure life laid out in front of her. A good husband and two beautiful kids, ice cubes tinkling in cocktail glasses, lamb chops barbecuing in the backyard.

Yet she chose to abandon it all and break the family bond. To run off with a junkie jazz musician who lived in his parents' basement, to hurt my father, to risk the happiness of her children, and to venture into the complete unknown where nothing was safe or certain.

I applaud her courage. She followed her heart against all common sense. God bless my beautiful mama, who engaged her whimsy and longed for a freedom she didn't understand. I don't know if her choice made her happy or not, but it was a bold and wild move.

She gifted me a legacy, an inherent freedom that courses through me vibrantly. Heart-following is a part of my DNA. Though the changes were weird and difficult, like all the challenges in my life, they served me in the long run.

Alchemy

The world's just a sphere,
No bigger than the balls that you suck.
— John Frusciante

When Walter rocked his upright bass, he attacked it with a primal intensity that shook me. Every time. He wrapped his body around it like a boa constrictor squeezing the life out of a warthog in the jungle, dug so deep into those hard bebop walking bass lines, and swung like his life depended on it. Burning a hole in the sky. Straight ahead, motherfuckers. The physicality of it. He played with a violent ferocity I've never witnessed since. Being a little kid and having never seen people play music live before, I assumed Walter's way was the norm. When I saw other musicians play with a more relaxed or jovial attitude, I arrogantly surmised that they weren't as good as him. Sweating profusely through his embroidered African shirt, his red face and overweight body contorted and flexed like a man in a rage. His eyes closed in rapture, he was gone. All the anger, bitterness, and frustra-

tion of his life channeled into making this incredible rhythm. I've seen a lot of amazing jazz bass players perform since, including Ron Carter, Charlie Haden, Ray Brown, and John Patitucci. And though they were all superior in terms of thoughtful construction, harmonic invention, tone, and the melodic arc of a solo, never in my life have I seen anyone play a fast hard-walking bass line with the driving intense swing of Walter Urban Jr. Of all the hardcore punk rock bands I later saw, where much blood was shed and tortured teen angst expressed in artistic and original ways, none of them could match the dark depths of his feral intensity either. Walter got gone. I was blasted into the stratosphere nanosphere any fucking sphere, Thelonious Sphere Monk! Walter was a madman. I fell in love with a madman.

This jazz they played was complex sophisticated music. Pioneered by Charlie Parker, it even challenged the great Louis Armstrong, who said bebop was "Chinese music" because it was just too damn weird. It was rooted in standard chord changes but then modified in every which way by the adventurous flights of a forward-thinking musician's fancy. A group of players communicating at the highest level with hair-trigger spontaneity, reacting to each other, one-upping each other, and being supportive of each other at the same time, turning songs inside out with often violent and revolutionary improvisations, or the most ethereal of contemplations, with nary a thought of ever kowtowing to an audience looking for a pleasant melody to hold on to. For little me, there was no confusion, it just felt awesome. I thought *This is where it's at*. It was a magic portal that opened a door to a place I had to go.

As dysfunctional, imposing, and wounded as Walter was, he was also my angel. No, he was not a strong guiding figure

who taught me to navigate through situations as they arose, who helped me transition from a boy to a man. He was just too much of a mess. I'd soon learn he was a drug addict and a drunk who'd never have it together enough to live his dreams, build his bridges, or connect his dots. He was not steady enough to be there for himself or anyone else in a consistent way, and he was violently unpredictable. But he showed me what it was to turn pain into beauty.

When I watched him play, I learned something he was never able to articulate verbally. Unknowingly, I saw him utilize the pathos of his life to create thrilling art. The anger and loneliness, the pain from feeling hurt and neglected could be fuel for the greatest gifts. Pain was something to be grateful for, not to be pursued, but inordinately valuable. Before Walter, I only knew anger and rage as my enemies and sources of terror. When my father was furious, or when kids in the street or school lost their tempers, I was scared. They were bound to do something ugly that might hurt me. Walter showed me that this tortured energy could morph into a love that would uplift the world. True alchemy, letting go and letting anger articulate a divine vibration. If only he knew how to apply that energy to his everyday life.

I loved Walter, I loved him so much. He had a wildness and a freedom I adored. He was not a safe person, and yes, I probably woulda been happier if I had a safe sanctuary to come home to, if he was someone I could trust to be there for me consistently. But that just wasn't Walter. He never processed what damaged him so he could get to the other side of it. But he was real. We saw each other. When I spoke to him it felt like my words had a home.

Walter's friends saw me too. They talked, laughed, and

joked with me, treated me like I was of value, were interested in what I had to say. They had long hair, drove funny cars, and had different-colored skin. Walter was my friend. A grown-up that didn't judge or put me down. He saw something beautiful in me, something waiting to come out.

*

The basement in our house was a cozy hangout, a multicolored shag rug on the floor, a little bar with stools set up against the wall. Sometimes Karyn and I would sleep down there, like camping out. One afternoon I walked down there and found Walter, in a state of upset. Perhaps he had an argument with my mother, or was fucked up about a lost gig, maybe he was just having a bluesy day, I don't know. But when I walked in the room there he was, sitting on a stool with a bottle of vodka in his hand, tears rolling down his face. He looked like the saddest person I'd ever seen, but thoughtful and sweet too. He gently took my arm and said, "I love you, man, I love you so much. You are what's beautiful, your light is always gonna shine over the evil and meanness in this world. You're special man, you have the gift. Dig it, man, dig it." He said it slowly and kindly through his boozy tears. We hugged warmly and I felt a lot of love for him, but it made me uneasy too. I knew he was a broken man and could feel the volatility under his sweet sadness. I felt a powerful urge to take care of him, to fix him. Maybe if he was right about me having some kind of gift, I could use it to help his tortured soul.

And in This Corner

A harbinger for the future, a clear vision, a foreshadowing of a danger zone. My parents got into an emotionally heated argument, and Walter became enraged to the point of insanity, a complete loss of perspective. He roared through the house smashing everything in his path, the TV shattering through the window, him yelling things that made no sense, my mom screaming in alarm, the house exploding with fear. The jazzman was on an out of control violent rampage, striking out, his arms and legs flailing and kicking wildly, and sobbing. The couch flipped upside down, glasses and plates strewn to the floor in little bits, a nice still life painting he was working on torn in half and hurled at the wall. He became an animal. Frightened to death, I ran outside to hide, down the street to the woods, where I sat huddled by a tree, shuddering and crying. I didn't understand.

I meekly came home a couple of hours later to find him and Mom sitting calmly on the couch holding hands. The house was still a disaster zone but they told me everything was fine now. My mother was nursing Walter and explained he was just a little angry and they had worked it out. I was just glad

it was over, and in an attempt to make light, I made a Mae West–style joke about them being lovebirds, and was angrily told to be quiet and go to my room, like I was being inappropriate. The scolding infuriated and wounded me. I was just trying to bring a little levity to this terrifying thing and be a part of the healing aftermath. There was my mother sitting there, cuddled up with Walter on the couch stroking his hand, letting him know everything was okay, and I was being told to fuck off. There was no consideration to the horror of what I just went through. I don't know where my sister was, but I went up to my room and sat alone. My mother was focused on patching things up with Walter, and we never spoke about it.

Walter's tantrums became a pattern, every few months or so the powder keg would blow. Something would set him off and he would go wild. Wild Walt. We learned to walk on eggshells around him, scared of triggering another blowup. I still felt love and empathy for him, but the love took a different shape and I began developing deep mistrust and resentment for both him and Mom. Things weren't safe. When times were peaceful I was grateful, happy, and did my best to keep the good vibes going, but always had a readiness to flee if it went bad, always the back door open, always subtly negotiating to keep the peace rolling, never completely relaxed at home. I began to X them out of my one-man inner circle.

It was as if I fragmented. An unconscious survival mechanism kicked in, a kind of separation of self. One part at home, one at school, another running around in the street, each different piece of me showing itself according to what and where was safe. I couldn't speak the truth to my parents. I would only ever really feel happy again when I was able to be whole.

When I see professional athletes talk about how much they love their moms after a big win, I often tear up. Partly because a raw and vulnerable display of love is just a poignant thing, but also, part of me realizes I missed out on something.

Not for many years did I begin to reckon with the void left by the lack of my mother's affection; to be brave enough to consciously feel and see this subtle and invisible fear, which had been influencing my movements until it was rooted out and exposed in the raw and naked light. Backstage at an early Chili Pepper show, my mom and I stood together. A few days later a friend told me, "I saw you talking to this woman and it struck me strangely that as she spoke you completely ignored every word out of her mouth. But she kept talking. I didn't realize it was your mom." My relationship with my mom improved with time, we had some great breakthroughs when I was an adult, but our disconnection was deeply entrenched early.

The Little Gymnast

Age nine. PE class. Jumping on the school trampoline. All the other kids standing around it, watching and waiting their turn, leaning forward, their arms and elbows splayed out on its gray matted edges. I was a natural at gymnastics, and god how I loved springing up airborne, getting the most joy out of my few allotted minutes. Ready to do all my tricks; seat drops, back drops, and my showstopper, the front flip. I jumped as high as I could, pulled a funny face, and flung my legs out at a strange angle, and all the kids started laughing. Egged on by their amusement, the entertainer in me came out. I jumped higher and higher, making loud high-pitched *OOH OOH OOH OOH* monkey sounds and itching my armpits. The kids were in absolute red-faced hysterics, happily pointing at me. I was hilarious! A huge hit! Confident that I would no longer feel like the new kid, my now burgeoning popularity a certainty, I prepared for my flip, the grand finale. I focused and jumped hard, but as I looked down to make sure my feet were squared I saw it. My little cock hanging out of my open zipper, flopping up and down and doing its own crazy little gymnastic routine. Oops.

Best Sneakers I Ever Had

or

What Kids Did Before Cell Phones

Flat on my back on the hard, worn field behind Central School. Feeling all my bones supported by the hard dirt, the gentle warm waves of the sun god vibrating through me, expanding and contracting, those nurturing undulations that get mixed all up in your heartbeat and go on forever. Gazing up into the soft blue and white, the infinite expanse cozying me close to her breast. Tightly scrunching my eyes closed to watch the odd-shaped amoebic DNA strands orbit aimlessly against the pinkish blackness. Breathing in the sweet smell of earth, the indecipherable yells of baseball kids in the distance, marveling over the invisible worm world below me, you could dig all the way to China ya know. Opening peepholes back to daylight to realize the brutal life and death struggle of the battling bustling black birds cawing in the trees above. Raising both feet to the sky, my incredible Peter Max sneakers grinning at the universe.

Okefenokee

I attended Central School in Larchmont. My third-grade teacher, Mr. J, had just moved up to New York from Florida, where he'd also taught primary school. He had an outdoorsman's adventurous charisma and the boys loved him. He spoke of the camping and canoeing trips he'd captained with schoolkids in the Okefenokee Swamp in Florida, where they reckoned with man-eating alligators, and camped out in the wild. Only the bravest boys would get to go. When the girls in class complained that only boys were allowed, unseeing of the future, he said, "When the bathrooms stop having boys and girls signs on them, then girls can come on my trips!" He spoke of one of his Florida students, Eddie Spaghetti, with glowing praise. Eddie could build every tent, tie every knot, get the fire roaring in no time, he was just the best camping buddy Mr. J ever had. Why, Eddie was such a riot he had everyone in stitches and could scare off a killer gator with his bare fists and wits! How badly I longed to be like Eddie Spaghetti, accepted by Mr. J, and invited on a camping trip.

Soon, Mr. J cultivated a group of boys who hung around

him after school. We edited his camping films with razor blades and tape and talked about the Yankees. Man, I was happy to be in the select group! The gnawing hunger I had for a stable father figure was subtle and way under my skin, but driving me.

After all this anticipation, we went on one camping trip in upstate New York for the weekend. It rained, the food sucked, he was too strict, it was no fun.

Mr. J's extra-curricular teachings soon took a new turn. He told us about n*****s, and all the problems they were causing. These n*****s were lazy, had smaller brains, wanted to ruin our lives, and take our parents' jobs. They needed to stay in their place, and the modern world just didn't understand, he was very concerned. I already knew this was all wrong, but I was terribly conflicted. I loved Walter's black friends, and they seemed as smart and considerate as anyone else. I didn't know what to do. I'd put so much energy into wanting to be the new Eddie Spaghetti, the wild man of the swamps, and to earn Mr. J's respect.

Then came the day the group of us walked outside after school, Mr. J in tow, and we saw a group of black kids playing in the outside playground area. One of the kids said, "Look! N*****s!" Mr. J stood proudly. I knew right from wrong, and I knew it was cruel and stupid. This moment is seared into my memory, and I feel a profound and burning shame. When I went home, I was too scared to tell my parents about it, so I told my friend Stephen's mom. I tried to play it off like it was no big deal, but she was a cool lady, and said it WAS a BIG deal. Infuriated, she marched down to school and spoke to the principal. Stephen's mom had an impact. The after-school meetings stopped, and so did all talk of camping.

Beyond schoolwork, we never spoke to Mr. J again. Yet, they didn't fire him and he remained our teacher. He was the man chosen to guide us by the powers that be. A stalwart in that noble tradition of handing down valuable knowledge to the children. He was active and engaging, and a needy kid like me could've been sucked into his philosophy. He was doing his best with his big-picture plan to turn us into white supremacists. We were nine-year-old children. Damn.

Just this moment, while writing this, I stopped being an author for a moment and searched Mr. J on my computer. He came up as a registered sex offender in New York and in Florida. He'd been arrested more than once on pedophilia charges. I'm looking at his posted picture now. A ninety-year-old bitter and sick predator, recently deceased. Yikes. Fuck his camping trip.

After night comes the morning, and the following year came Ms. Shapiro. She was spirited, charismatic and gorgeous, wearing a tight bright pink jumpsuit and long dark hippie hair falling to her waist. I was totally in love with her. Through drawings and text, she created a story of the egg. Her beautiful illustrations told a tale of how the yellow yolk and the egg white were at odds, having a long history of mistreatment, misunderstanding, and anger. But when the yolk and white began to learn about each other, they realized that maybe they weren't so different after all. If they could just get together, they could make an entirely wonderful egg. A perfect antidote for Mr. J's vile insanity. Ahh, she was so angelic and used to give me these awesome perfumed hugs! I was conscious of her bosom in my face!

Report Card

Underneath the skin
An empty place to fill in.
— Joni Mitchell, "Blue"

During my time at Central School I mostly felt alone. It was my natural state and didn't bum me out, but I do remember my mother once asking me why my report card said, "DOESN'T ASSOCIATE WITH HIS PEERS." I asked Mom, "What's a peer?" What the hell were they talking about? I thought I was normal.

1978. Fairfax High School. I was sitting on a bench outdoors at lunchtime, having polished off my sloppy joe and carton of milk, when a girl I liked approached. She was an intelligent and thoughtful one, a soft-spoken chick who played the hell out of the flute in our orchestra class. She said with kindness and sincerity, "Mike, are you okay? You look sooo sad there, like totally miserable, I worry about you." I was surprised by her query. "Yeah everything's great just sitting here relaxing." Truth was, I did feel totally fine, completely normal. But same

as back in Walter's parents' basement with my sister, or in my SOLITARY, NO PEERS days at Central School, I was acclimated to melancholy. My mellow median zone, the place I was accustomed to being. It was not strange to me, but others pointed it out again and again. I found much joy in life, but where there's smoke there's fire, and I guess I was just plain comfortable with being blue. It's what I knew. Doodalee doo.

2018 — Why do I cry at the drop of a hat when I read anything about kids having a hard time? Were there that many tears unexpressed when I was a child? Even in my happiest times there's a well of tears at the ready, triggered even by the most hack corporate tearjerker bullshit. I'll cry at a newspaper article, a TV commercial, anything to do with a kid's spirit being compromised.

Thwack Thud Swish

Arms akimbo then locking into the perfect pitcher zone like lysergic Doc Ellis acid-drenched no hitter, infinite strength surging from center of skinny little body, seams scraping over fingertips and hardest throw down Laurel Avenue then the sweetest sound THWACK into the middle of Battaglia's extended mitt. Hushed tones, "Okay down and out — tuck in behind the green car at the old lady's driveway"......run run pavement run THUD pigskin clutched tightly into my chest, hoots, hollers, and sparkle eyes. The warm ecstatic light of movement. Full speed and body aligning perfectly like a fucking Russian ballet master extended arm golden finger roll perfect arc and SWISH sprint back down the court hive five and satiated soul.

*

I fell in love with sports, playing them, watching them, and romancing their mythic heroes. I read Lou Gehrig's biography and flooded over with emotion. Earl the Pearl was a cosmic

being, and Mickey Mantle once walked this earth. These athletics are music to me, and a pillar of my life. A box score is the stability in our insane culture that keeps me sane. It started for me in Larchmont, and only deepened with each passing year. Joy. Satisfaction. Community and connection.

*

After a couple of years Walter and Mom came to me and asked me to call Walter "Dad." That felt uncomfortable and forced, but my real father was pretty much out of sight and out of mind, and I loved Walter, so I agreed. I wanted him to be happy. My desire for him to be happy was fueled partly by goodwill, and partly by the fact that an unhappy Walter was a scary Walter, and a sad Walter was an unpredictable Walter.

Out of the Mud

I became a regular shoplifter.

What can I say, I was a thief! I guess this coincided with the switch in fathers and lifestyles at age seven. I was good at it and never got caught, at least not as a child. I stole something most every time I entered a market, usually candy or something small I could fit in my pocket. I just wanted stuff. Trading on my little-boy cuteness, the ability to appear an innocent baby lamb. I found friends who also were willing to steal, and I kept it up until my late teens. I (we) stole from people, houses, and restaurants. I stole from my mother's purse, sneaking into her room in the dead of night while she was sleeping, to take a twenty from her pocketbook. My only mom, who worked full-time, day in–day out, to support the family. I saw no guiding light — no parent to help me understand that all are one, that to rob someone was to rob from myself. A confused pain muddied me up on the inside as a result of being a morally challenged person.

Love Streams

I looked for love in the faces of people I saw in the street. Unable to feel close to my parents at home, my friends meant everything. Something inside me was broken, I wanted someone to fix it, and lo and behold, I would soon find other people out there looking too. My yearning for love was overwhelming, and my instinct told me that to ignore it would be to shut it down. I had to keep my heart open at all costs, no matter the pain. But the love I thirsted for flowed so hard that I didn't know how to control it. I often found myself panicked and fighting to stay afloat in its wild current. It would be a long time before I'd learn to swim, float, or rest on shore.

When I made a "best friend," he was my family.

I did make a few friends in Larchmont. There was the Battaglia family down the street, with four boys, three of them around my age. They were rough-and-tumble kids and we got up to your normal rowdy boy stuff, running around in the woods, playing sports. It was not a close or affectionate friendship, just a lot of fighting, sports, and talking shit. Donny Battaglia, the biggest brother, threw me against a wall one day, which sent me to the hospital to get my head stitched up. We had a ton of laughs though. At a certain point they were for-

bidden to play with me, because I used foul language, and their folks just thought I was a weird kid. I had begun to get into trouble and was prone to bombastic outbursts and crazy cursing. An expert at profanity, I enjoyed its effect. It was as if I had something to prove — that I was the wildest one of all. I took pleasure in creating chaos and stirring the pot. When I was freaking people out, I felt joyful and free, delight and glee.

Then I made friends with Peter Appelson. Peter was short like me, and a wild, creative, and intense kid. When I first saw him about thirty kids were chasing him around the Central School campus trying to catch him; he was like a wild animal and couldn't be caught. His hunters were yelling, "Nobody can get him! He's like a little cheetah!" We made up choreographed dances and re-created the knife fights from *West Side Story* using pens as fake switchblades. We had a blast, but I was intimidated; Peter was the alpha in our friendship and hurt me on occasion when we play fought, once bombing me relentlessly with apples in his backyard. Another time, after some verbal altercation between us, his mother admonished him, saying, "Peter, you have to be nicer to Michael. He is sensitive!" I thought, *I am? I have my own unique way of being? I kind of like it.* Her words helped me value my feelings.

I fell in love with a book by Evan Rhodes, *The Prince of Central Park*, about a little boy who lives in an unhappy home in New York City. He runs away and sets himself up in a tree house in Central Park. I was amazed by his creativity and autonomy; the way he gathers the materials to build his own house, he and his puppy observing the world below them, his outwitting a malevolent drug addict who was after him, and his soulful friendship with an elderly woman. I dreamed of trying to pull it off myself.

The Sweetness

My last friend in Larchmont was Stephen Paul, who lived next door. His dad had passed away shortly before we became close, and I'd lost mine when he moved to Australia. Somehow we filled that empty space for one another. He was a warm-hearted boy, fair-haired and pale, and a year older. Not up until this point in my life, and until I met Anthony Kiedis a lifetime later, did I ever communicate with anyone so deeply. We shared a passionate love for reading.

All my other friends were rough. We played sports and farted and yelled, but with Stephen it was different. We spent countless hours sitting in his room reading, it was the sweetest thing. Nancy Drew, Agatha Christie mysteries, *The Hobbit*. There was an educational campaign at the time, posters, bumper stickers all around New York that said READ, BE ALL YOU CAN BE. We used to call each other up and say in funny cartoon voices, "Let's be all we can be!" Then I ran over to his house. We were in love with literature and could spend whole days together just reading books silently. It was a great hang at his house, no threat of the volatility that lurked in mine. We

had many a soulful talk and riotous laugh, such a beautiful and unique relationship for two young boys.

We sat and listened to the White Album, singing along while looking at his *Peter Max Illustrated Beatles Song Book*. We played "Cream the Carrier" and other outdoor games — also fishing and ice-skating at the duck pond. But the best part, the rare and beautiful part, was the sensitivity and kindness between us. It was so freeing to let our guard down.

Stephen's mom was of a political bent, and in line with her liberal leanings, loathed President Richard Nixon. She worked at the local campaign office for his opponent George McGovern, where Steve and I often went to throw darts at a Nixon face dartboard. When Nixon was campaigning, his motorcade drove through our town, and I was there on the side of the road in my ladybug bell-bottoms holding up a sign that said NO MORE NIXON. I didn't know anything about politics, just a smattering of Watergate information that filtered down, but it felt good to protest the motherfucker.

Punk Is Dead

When we were ten, Stephen and I were walking to the local public pool and saw a van-load of hippies driving by. The van was painted with rainbows and peace signs; long-haired bearded young men and hairy-armpitted girls hanging out the windows, Hendrix blasting. We loved hippies and yelled out, "Hey you guys! Hippies! Yay! Whoohooo!" The van screeched over to the side of the road, three of the dudes got out screaming, "You little fuckers! We'll fucking kill you!!!" They chased us, yelling bloodcurdling threats and violence. We knew a shortcut through the bushes and, terrified, ran for our lives and got away. So much for hippies and all their "peace" facade.

Growing up when I did, I was skeptical of the hippie movement. I was hanging out with Stephen and his siblings at the duck pond one sunny afternoon, when an older hippie kid came along; long hair, a peace sign belt buckle round his bell-bottom corduroys, and John Lennon eyeglasses perched upon his Ichabod Crane nose. He sat down next to me with a philosophical air, cross-legged like a Himalayan cave dweller, and said, "What do you believe in?" I meekly stam-

mered out some kind of I-don't-know reply, but he kept putting on the creepy hippie pressure, becoming more aggressive, "Do you believe in peace and love, or war???" he demanded. I managed to whisper, "Peace and love," but his putting me on the spot made me feel like shit. Like, just leave me the fuck alone and let me enjoy sitting in the woods.

I read *Helter Skelter* by Vincent Bugliosi when I was eleven, which freaked me the fuck out, and as I got into my early teens in the mid-seventies, hippies were in Coca-Cola commercials teaching the world to sing. Their clothes were purchased at local department stores by the kids at my school who made fun of me and called me faggot. Later, when I discovered punk rock and its anticorporate rock-star ethos and populist integrity, I found a real love and togetherness. That was a community where I felt I could be myself and contribute something beautiful. One had to pass through violence and pathos at the gigs to get to the center of it. It wasn't for sale. Both of those movements were antiestablishment, using great art to give voice to a frustrated youth, but I thought hippies were full of shit. I love sixties rock music, I know how great Dylan was, and I have a tattoo of Jimi Hendrix on my arm for crying out loud. But when I came of age, it seemed like the hippies had all sold out to the man and from within their safe little phony bubble couldn't handle the wildness, intelligence, and harsh truth of punk rock. Once in a blue moon I meet a real hippie and get my heart touched, but that shit is rare. George Clinton told me that Woodstock was the end of the hippie truth, after that, it was all for sale. He also said the song that summed up the sixties best was the Beatles' "She's Leaving Home."

That said, when I was a boy in New York, all my friends' older brothers were getting shipped off to Vietnam and coming back maimed, strung out, or in a box. It was a terrifying thing looming in my future, and paradoxically, I hoped the hippies would somehow get me out of it.

Squealing and Screeching

At times I felt the light of other music besides Walter's. The Beatles fired my imagination in a limitless way, triggering all kinds of cinematic narratives in my mind. I was scratching the surface of another world of music, but I didn't separate it out as such. I loved the Beatles, I loved Charlie Parker. Good music was good music.

A banging sound was coming from a house down the street. I walked down its driveway and peeked curiously into the garage window. Long-haired scraggly young men were bashing away on guitars and drums, singing something about bubblegum. I was fascinated, but when the wild-eyed singer, spitting on the floor in between phrases, swung his head around, looked up at me, and smiled, I got spooked and ran.

On another occasion — it was early evening and I was about to go next door to hang out with Stephen Paul — a friend of Walter's said he would drive me. I told him it was right next door, but he insisted. I liked the dude so I said okay. His name was Peter, a cool long-haired tripper, a Vietnam vet who would come over and get high with Walter. He once came over and filled the bathtub with scalding hot water, got in it, and lit

a joint. He left the door open and was yelling out jokes to me, telling me how great the hot bath was, and laughing hysterically while his entire body went beet red. On this night, we got in his car to drive the hundred feet to Stephen's house. He had a muscle car, the engine started its deep throbbing growl, he turned on his souped-up stereo and cranked his eight track to an ear-splitting volume. It was some wildly throbbing psychedelic rock music that made my hair stand on end. My eyes shot wide open like two fried eggs when he floored the gas and peeled out into the road at an insane speed, the g-force and the music pinning me back against the car seat. Down to the end of the block he went, where he swung a crazy squealing doughnut U-turn and floored it back up the block, coming to a screeching stop in front of Stephen's house. The music was blaring so thunderously I couldn't decipher a word when he yelled something at me and let loose a big wide-mouthed laugh. I got out of the car, exhilarated. I thought, *WOW!* For the rest of the time I lived in New York, whenever I walked down to the end of the street, I saw the twenty-foot-long skid marks in the road. A minute of absolute freedom! Rock music.

*

Five years later, I walked into the dining room where Walter was sitting at the table. He was on the phone speaking quietly in clipped tones. I was startled when he suddenly snapped, cried out in despair, and hurled the phone at the wall, breaking it into pieces. Peter had committed suicide.

Sharp Angles

There'd been talk around the house of us moving into Manhattan and that scared me — the idea of no woods to hide in, just steel, concrete, glass, an unrelenting mass of people, an overload of hard sharp angles with no escape. I had no idea what the future was like but I knew I didn't want to wear shoes. "Would it be like the apartment on *I Love Lucy*?" I asked, and was told that was only on TV.

But toward the end of 1972, the big stunner came, when Walter and Mom dropped the bomb that we were gonna move to Los Angeles for the sake of Walter's music career. We were heading west, where there was more opportunity for studio work and a fresh slate. Truth was he would never really have a chance for a fresh slate until he confronted his rampant drug and alcohol addiction. But we didn't figure that out till later.

L.A. was a huge concept to wrap my mind around, but I was excited, and embraced the change. My vision of an ideal life was running around outside all the time half naked (*that has not changed*) and it seemed like I would have a pretty good chance of it there. They also had the Dodgers, Lakers, and Rams, and that all sounded cool. California was another

world, palm trees, sunshine, beaches, TV actors, Jerry West, Anita-Bryant-Mickey-Mouse-Club-SUNKIST-Oranges, bears, and giant redwoods.

Karyn was devastated and let her feelings be known. She couldn't believe we were being fucked over like this. I came across her and a friend sitting in the parking lot of the local church, commiserating and cradling a bottle of Boone's Farm Strawberry Wine. She expressed her abject disgust with our parents' decision, that it was a thoughtless and mean-spirited attack on us.

Yet my heart felt happy. The only thing causing me melancholy was leaving Stephen Paul, whom I loved. I figured parents come and go, families are weird and undependable, but a true friend is a rare and beautiful thing.

Those five years in the New York suburbs, 1967 till 1972, shaped me indelibly. The first half was strictly paint-by-numbers normalcy. The second half flipped us right upside down, letting us loose in the world. I preferred the let loose in the world thing, though I coulda used a little more nurturing. But hey, what the fuck.

Part Two

Robbin' Time

The hot Hollywood sun beat down, cutting through the thick gray smog and onto my dirty blond head. My grubby twelve-year-old hands with their chewed-down fingernails explored searchingly over the wall, reaching up to the hazy sky, looking for something to hold on to. They latched on to a drainage pipe running along the edge of the rooftop. "Ow, fuck!" I exclaimed after scraping the skin off my forearm while squirming my body up and over, helped by the pushing hands beneath me, onto the rooftop. Then I got stable on all fours and reached back down the wall to help up Aziz and then Omar Shadid, the two curly-headed, olive-skinned Jordanian brothers I ran the street with. I pulled a screwdriver out of my back pocket, going to work on the fan vent protruding from the hot tar roof, jamming it under the metal frame and jimmying it with everything my wiry little body had. Ripping out the screws from the rotting wood, I loosened the whole contraption. The three of us gave it a few hard kicks and the whole thing toppled over, opening a big rectangular hole in the roof. "Mike, you get down there and open the back door," said Aziz. I lowered myself down

through the vent until I dropped the remaining few feet through the air, my red Keds sneakers touching down on the greasy burger grill. I hopped down into the empty diner, its unoccupied counter stools and dead silence feeling totally weird in the broad daylight. It was strange to be in this place now, where I had sat and eaten a club sandwich with my mother weeks before, the nice old guy in his dirty white apron serving it up, with an extra flirtatious smile for Mom. Now it was closed and empty. I was in a ghost town or a trippy dream.

Through the window, I spotted our two other friends, the Guadalajaran brothers Javier and Pablo Cervantes. They were riding their bikes around the building, circling the periphery, safely keeping an eye out. Javier had wisely said earlier, "I ain't going in there" and then stared authoritatively at his younger brother Pablo, saying, "You ain't either."

I let the Shadids in through the emergency exit back door. We puzzled over the cash register, pondering and poking, but couldn't figure out how the fuck to open it. After unsuccessfully trying to pry it open with the screwdriver, I got nervous and gave up. Omar found a bucket of change, and we started stuffing our pockets with candy from behind the counter, M&M's, Snickers, Three Musketeers, it was a treasure trove and my mouth watered with anticipation. Then before I could think of another joke to make and impress my cohorts with a devil-may-care attitude, came the shock..............

WHEELS SCREECHING TO A STOP BLARING SIRENSWHOOOWHOOWHOO MEGAPHONE VOICE "COME OUT WITH YOUR HANDS UP!"

Frozen in our footsteps. Terror. Fuck. Goddamnit. Busted..............Next thing our arms are uncomfortably

twisted behind us, handcuffs clamped on painfully tight, the three of us sitting in the back of the police car, driving down Melrose Avenue. Twelve-year-old Omar is crying, and in a high-pitched broken voice, he fearfully asks the cops sitting up front, "Sir, are we gonna be on TV?" I look at him disdainfully, thinking, *No, we're not gonna be on TV, you fucking idiot.* The intimidatingly large mustachioed cop looks back at us like we're the most pathetic creatures he's ever seen, his deep voice bludgeoning me. "No, ya little bastard, but none of you are ever gonna get a decent job as long as you live."

That hit home hard. Karma. For the first time it dawned on me, Lesson # 1: What you do now can fuck you up later for real.

Best Coast

Six months earlier, on November fourteenth, Nineteen hundred and seventy two A.D. we had left New York and moved to Los Angeles.

We moved into the Nutel Motel, a low-end joint on Temple Street, a dirty city road that ran up a hill into downtown L.A., miles away from the beaches and orange groves I had fantasized about. The Nutel Motel wasn't a spot for the discriminating traveler, stocked with hard-luck types, small-time hustlers, junkies, and hookers. The smell of nefarious acts lurked behind every door. But it didn't bother me. I was blown away by this new world. On our first morning I went for a walk, and even though there were no nice houses with swimming pools or any bikini-clad beach girls, I was wowed by the palm trees and distant hills. I found coconuts and pineapples in the grocery store. Before this, I'd only ever seen a pineapple sliced up in a Dole can full of sugar syrup. It felt exotic; everything tripped me out; I was filled with a sense of mysteries unsolved.

On that day I began a lifelong fascination with the discovery of a new culture. It's the mundane things that intrigue

me — seeing someone walking down the street with weird hair and ill-fitting pants, or the way a shopkeeper sells me a can of soda. I love it; I love how we are all the same, eating, pooping, fucking, and sleeping; yet the way we feel and act is profoundly different from place to place. I'm driven to try and understand the hidden differences in what motivates us, to crack the code. I'm amazed when I experience humans living in different rhythms. They have not yet violated my trust, and I yearn to connect. It seems like anything is possible in a new place. So much potential, like a newborn baby.

Driving around searching for an apartment with my family, we happened upon the television program *Adam-12* being filmed. There were the actors right there! I know those guys! This was a show I'd watched in New York and I couldn't fucking believe it. I was in the center of Hollywood, the inner sanctum where it all happened.

We stayed in the Nutel Motel for a few weeks before moving into a two-bedroom apartment in the Miracle Mile district, on Orange Grove Avenue near Olympic Boulevard. My parents slept under a lush fake-fur comforter in their absurd king-size water bed in the living room, while Karyn and I took the bedrooms. It seemed pretty nice, palm-lined streets and sunshine in December. I was wide open and ready to party.

New Friends

Right away I started in on my walks. I wasn't gonna start school until the New Year, so I would just wander from morning till night, my head in the clouds, seeing how far I could drift into the depths of my daydreams.

On my first stroll up to Wilshire Boulevard (which I had heard mentioned on *The Beverly Hillbillies*), I had some change jingling in my pocket as I walked into a liquor store to buy a soda I'd never seen before — Strawberry Crush in a shockingly pink can. It looked so vibrant and alive, tasted zingy and explosive, and I stood savoring it in front of Johnny's Steakhouse, basking in the glory of its massive neon sign. Two kids walked up to me, maybe a year or so older. Feeling the magic of the pink pop in my hand, I was excited to make friends, and readied myself to be funny or talk about the Dodgers. They were unsmiling though and one of them said menacingly, "Lemme get a nickel." I was stunned and confused. I had about fifteen cents to my name that I wasn't eager to part with and I stammered. I got a little scared. They edged closer and the talking one said with more urgency, "This is Dog Doug, punk! You want me to fuck you up?" Then I

was officially scared, reached into my pocket, and gave him a nickel. They both sneered at me and walked off. I realized I was dealing with a more dynamic situation than I had anticipated, and I still hadn't seen any beaches.

I befriended two sandy-haired freckle-faced brothers my age who lived in an apartment upstairs, the Browns. Tom and his younger brother Tim were a funny pair, we started playing catch in the driveway and running around the block seeing what we could get into. A few days into our friendship they told me that we could go see a man around the corner who'd give us five dollars to rub his dick. It'd only take a minute. I was taken aback, it sounded like an awful and terrifying plan. They started arguing about whether or not we should do it. I got the impression they'd done it several times before and disagreed as to its merits. The argument quickly escalated and they started fighting, beating the shit out of each other, and smashing each other's faces into the sidewalk, blood everywhere. I had never seen this kind of violence between kids before and it frightened me.

I was freaked out by their animal behavior, and completely against meeting the five-dollar penis man, but I was still grateful to have a couple of friends, troubled twosome that they were. A strangely thin and quiet younger boy made a daily appearance on our block. For some reason the Browns looked down on him, but he was always trying to get in their good graces. He'd bring them candy, and silently hold it out for the taking, hangdog expression on his face. I ate the candy but felt like I was in an insane asylum, this strange cast of characters embodied a new kind of neurosis that was unfamiliar. West Coast crazy is different than East Coast crazy. Everyone was on edge about the big earthquake that had rocked their world

a few months before my family arrived. I was uncomfortable, restless, and itching to connect with something or someone.

Was at the Brown's house the first time I realized what weed was. Mom and Walter were testing out a friendship with the parents over at Chateau Brown, hanging out and blazing a jay. We were all sitting around their living room, and Tim told me it was marijuana. I associated that fragrance with the transcendently fun jams we had at the house in New York. A lightbulb moment, *Aha, that's what that smell has been all this time!* But that day it did not seem fun or celebratory, it was grim, quiet, and uncomfortable. My mother seemed agitated and inexplicably got up from the couch, pacing around looking nowhere in particular for no reason, saying things that made no sense in the flow of conversation, non sequiturs that raised eyebrows in the room. Her discomfort with the Browns' overall vibe was heightened by her own pot-induced insecurity, and she probably felt weird about smoking it in front of me too. I never saw her smoke weed again after that day of paranoia; she did better with booze.

Pee Boy

G oddamnit!" Mama Brown was screaming in the morning. "Fucking kid sleeps here and pisses in the bed?? What is he? A little fucking baby?? Someone clean that disgusting mess up!" I'd slept over at the Browns' the night before and wet the bed. I was horrified. I'd snuck out of the brothers' bedroom in the middle of the night to put my pee sheets in the hamper and remake the bed, but because I didn't know where anything was, I failed to pull off my cover-up job. In the morning their mother discovered what I'd done and was unsympathetically infuriated. I wanted to disappear into a hole in the fabric of the universe.

I've neglected to mention that I peed the bed......perhaps out of vanity?.................But, I was a bedwetter. All this time I'd been peeing the bed like a maniac. A terrible *Groundhog Day* experience for me; embarrassing, inconvenient, and smelly. I went to bed at night praying that the urge to urinate would wake me up, but inevitably I woke up in the middle of the night in a sea of urine. I had a recurring dream where I was getting up to go to the bathroom, feeling so proud of myself that I had conquered the problem, standing over the

toilet a mature and happy young man, but then I would wake up in soaking-wet sheets, covered in piss. I often had nothing to drink from the afternoon on through dinner, and suffered dehydration — damn, it weighed on me all the time. I always had an underlying anxiety that my friends would find out about it, and occasionally suffered humiliation when they discovered my secret. It's one thing when you are a wee tyke and just pee a little puddle, but when a dude gets to be around ten and is waking up in Lake Huron, it's really a fucking bummer. For the most part, people were really understanding about it though. A little after I turned twelve, I just started waking up at night when I had to pee, and the saga ended. Whew!

After a few weeks of hanging with Tim and Tom, we got into trouble, caught shoplifting or something, and the Browns went bananas. I can still hear the anguished screams that came from upstairs as their parents beat the shit out of them. The tortured howls came in waves throughout the afternoon. Definitely the scariest kind of beating I'd ever heard. My parents looked at me with raised eyebrows, their expressions saying *See, we ain't so bad*. Mom and Walt were weird, inattentive, and preoccupied, but the Browns seemed sick, sending their kids on an express path to a troubled destination.

I still felt like I was going someplace good. Man, I can't even explain it, but despite the weird shit that had been going down, I still believed in a light I felt glowing within me, I was unfazed. I felt good inside, like I could rise up and fly where I wanted.

In a Circle

I n the New Year I started Carthay Center Elementary School in the Miracle Mile district of L.A. Back in Larchmont, school had no fences, big open fields, and a baseball diamond. It was ninety-five percent whitey. Carthay was way more ethnically mixed and there was talk of "Crips" who would fuck me up. The school playground was a fenced-in block of asphalt. I was used to open space, this enclosure felt so militant and alien.

I was out of place and didn't understand what was going on, always standing outside the circle, watching. On my very first day, a boy in my class named Jack Irons drew a picture and passed it to the person sitting next to him, who giggled and then passed it to the next kid, the next and so on, it was surreptitiously passed all around the classroom, everyone getting a kick out of it. When it got to me, I saw a drawing of an ugly distorted face covered in boils and scars, snot dripping from its nose. The caption in the cartoon bubble above said, "Hi! I'm Michael Balzary!" I wasn't gonna act hurt on my first day, so I chose to see the humor in it. Jack Irons was a fighter, everyone would gather around after school and watch him take on

the toughest guys. I was impressed with Jackie, but the fighting also freaked me out, I couldn't imagine doing it.

To this day, I've never been in a fight. I mean, a few little kid scraps here and there, but not serious fisticuffs. Partly because I'm scared of getting hurt, and partly because it's the stupidest. So many times I've seen people start fighting at gigs, bars, and sporting events; they always seem like complete morons engaged in an ill-conceived attempt to prove their manhood. Peace and love, dude. The world is cruel enough as it is. Everything that is not love is cowardice.

Shortly after I arrived at Carthay, I auditioned for the lead role in a production of *Oliver!* As the days passed after my tryout, I started to fall in love with the idea of acting as a way to connect with the world. I thought they made a massive blunder by casting Geoffrey Nightingale, that little fuck. I imagined myself as a good entertainer and a perfect Oliver.

I surmised that the black kids were the cool ones, the ones to emulate. I wanted to wear red, black, and green tube socks too, and be accepted. I decided that playing basketball would be my only way to make friends, so I started playing every day.

After a couple of months I made friends at Carthay. J. D. Cooper and George Roberts were good dudes, even though they sometimes made fun of me for being white. George said, "Man, when I was in my mama's stomach, there were two choices, chocolate milk and white milk. I chose the chocolate milk that was the good stuff! What happened to you, fool!?"

That would be a great animated short film, little George in there, thoughtfully choosing between the different milks.

J.D. was of Jamaican descent and his mother was Groucho Marx's night nurse. I saw a note in his house addressed to her

from Groucho. It read, "Dear [J.D.'s mom], You are so dark but you make my nights so light!" Is that racist? I don't know, but I loved Groucho and his genius Marx Brothers.

J.D. and I had a great gig. We went up to Hollywood Boulevard and played trashcan lid drums with our hands and blew the kazoo. We rocked tunes and put a hat on the sidewalk. We played Benny Goodman's "Stompin' at the Savoy," and Three Dog Night's "Black and White," and Glenn Miller's "Chattanooga Choo Choo." We must have been cute as hell, two eleven-year-olds, one with a more melanin Jamaican style, and one little blue-eyed blondie, earnestly jamming like little rascals. We got up enough cash to see a movie or dine exquisitely upon some pizza.

We were two tiny little dudes, the shortest kids in school, but a year or two later, in junior high, we entered the two-on-two basketball tournament. We started raining jump shots, vanquished all our much taller opponents, and won that thing. That's right. Yeah. Champions.

Church

I went to church with J.D. and his family. I found the service tedious, but the food party at the end was bangin'. Fried chicken, potato salad, and scrumptious pies. We stacked our paper plates high.

My only other church experience had happened at age six. My parents had never spoken about religion before, but strangely and out of the blue I was forced to attend Sunday school. We sat in a circle for story time, the stern teacher lady brandishing an ominous-looking black book, telling us, "This is the best book ever written!" I was wide open to all manner of story and myth, and ready to rock the best one ever. The stories were interesting, but every time she got rolling, she stopped to explain everything like we were a bunch of idiots, sucking the magic out by trying to prove that it was all so real and important. Boring.

Confused after the story session, I stood alone in a brightly lit hallway, taking solace in an awesome box of animal crackers my mom had given me. Just as I was biting into a perfectly delectable lion's head, an older girl in a bright pink dress and bobby socks came marching down the hallway. She stopped

and stared me down for a moment, then abruptly smacked the box of goodness from my hands, the cookies falling all over the floor. She sneered and walked off. I thought, *Fuck church.*

Time traveling to the hardcore punk rock days of the early eighties, I had a friend who would take me to church in South Los Angeles. She knew when the best touring gospel bands were coming through, and though I had absolutely zero interest in the concept of god and an open disdain for religion, I went for the music. The bands were on fire, the singing made me shiver with emotion, and the crowd was crazy into it. More intense than any punk rock concert; elderly women jerking their bodies around like wild, people yelling stuff out, the band thumping away like mad, and everyone in the room just absolutely focused, gone into it, believing. I loved it. On one of those Jesus Sundays I got to talking to one of the parishioners, and when I told him I didn't believe in the Bible, that I was just there for the music, he was totally cool and welcomed me back the following week, even though I was shabbily dressed and the only white person in the place. That's the first time I considered that church could possibly be a good thing.

As sixth grade wound down, my half year at Carthay ended and my parents purchased a house in Hollywood on Laurel Avenue. It was a fine home, a three-bedroom Spanish-style stucco with a backyard. Typical L.A. crib. This is when I started living the life of a street kid. Not a homeless kid, not an uneducated kid, but a street kid.

Mom and Walter just weren't paying attention to what I was doing. They checked in once in a while out of some remembered sense of duty, and I painted for them any picture I

chose. I stayed out all night, went where I wanted, and did as I pleased. I had 'em wired.

Age eleven = massive change. I was excited about everything in front of me, bereft of a constricting moral judgment, open-minded, and on the cusp of full-blown sexuality. I was fascinated by girls, and waiting excitedly for this beautiful mystery to reveal itself. I woke each day ready to go all in, feeling like I had something beautiful to offer. I didn't know what it was, but I knew that it was a thing completely protected from the outside world. Full of emotion, a romantic kid, my nose deep into the stimulating fantasy and craftsmanship of books, getting out and into the street and everything it had to offer. In Hollywood that was a lot. I had a good sense of self, yet I was often inexplicably blue, reaching hard for camaraderie, love, and understanding. I was ready to get crazy to prove I was something real. *I freak out the squares, therefore I am.*

Haydreaming

I had just turned twelve when my sister got me high for the first time. I was reading in bed and heard her and her boyfriend giggling in the other room. They came into my room and showed me how to smoke the lit joint staining their fingertips. I took a few hits successfully, sucking hard to impress them. I tried to act cool with the older teenage boy for a few minutes, then they disappeared again. I lay back in my bed and it dawned on me I was deeply stoned. I stared at the ceiling. Whoa...........this is what it is to be on marijuana. That floating feeling felt so good. I cuddled into my blankets wondering about Dizzy Gillespie and the Beatles, if girls liked me, if I could shoot a good jump shot. Laying there tripping out, drifting, feeling so fuzzy and good, enjoying the shade of light in the room, thinking in a new way. I consciously decided right then, *Yes. This is for me.*

After I'd been a pothead for a year or so, Mom got all authoritarian and shit, barking, "If I ever catch you smoking marijuana I will beat the hell out of you, you will lose every privilege!" I was probably stoned when she said it and thought she was being ignorant. A while after her proclamation, she

found Polaroid pictures of me and my friend Pepper Jones brandishing giant pot plants we'd stolen from someone's yard. We had freshly rolled joints sticking out of our ears, lit ones in our mouths, and were sporting big, ebullient, stoned grins. In an attempt at parenting she asked, "What's this?" and then tried to feign concern before she went back to dulling her spirit with a Benson & Hedges, Coors Light, and gossip magazine.

What's worse, gossip magazines or pot?

Whenever I laid eyes on those gossip magazines, they looked like death, like the worst possible fate was to end up reading that bullshit. A harbinger for an even more pathetic celebrity-centric reality show future, these magazines are designed to make you feel ugly and inadequate, or in turn, encourage a hollow sense of self-worth.

For the next eighteen years, I smoked weed on the regular.

Shenanigans Revisited

Wandering up to Hollywood Boulevard late at night, hanging out till three in the morning, looking for the hustle, tripping on the scene. Many spooky solitary walks going home late at night. Like being in the jungle; lay low, stick to the shadows, and walk quickly. If I traveled by the main thoroughfares men often propositioned me. That scared the shit out of me and I ran the other way. I came home and got into bed close to sunrise, yet Mom and Walter never said a word.

Me and my friends would steal anything that wasn't nailed down. We learned to get the money out of Pong machines, the early video game found in malls and arcades. We shoplifted the days away, anything we could. Little petty thievin' street rats.

I once tried to rob an old lady by running up behind her and grabbing her purse, but the old fighter had an iron grip on the thing, and started screaming "HELP!" at the top of her lungs. I sprinted away ridden with guilt. Though I robbed all the time, I had a code; I stole from businesses that seemed wealthy. So preying on a vulnerable old woman violated my half-baked

ethics. It hit me square in the heart that I'd made someone feel bad. Even though I'd failed, I felt terribly ashamed.

*

I was sitting alone at a bus stop in Hollywood. From out of nowhere an elderly hunched-over man approached, hobbling along with a walker. He came to a pause in his slow stroll and stood right next to me. His face deeply crevassed, eyes yellowed and covered in a murky film, he looked straight into my preteen baby blues and unprompted, said dead seriously, "Listen to me. Now is the time to be healthy. Treat your body and soul well. You can't see the damage you do to yourself now, but when you get old you will suffer. Give yourself a chance to be in perfect health. Be an honest and kind person. It is the only thing." I told him okay and he walked on, fading away down Fairfax Avenue. A guardian angel giving me a heads-up, but alas, I took no heed, and later paid the price accordingly. Foreshadowing.

*

I had a crush on Kate Trujillo, a Chicana tomboy who ran the streets with us. When one of us got chased for committing a petty crime and we ran like frantic antelopes from a lion, she stayed in the pack, not acting the Goody Two-Shoes girl off to the side. I loved her show of solidarity, her long black hair, budding breasts, and raspy voice. I'd known her just a few months when she moved to South Gate, in East L.A., and my stomach grew tense with the fear I'd never see her again. A yearning loneliness quickened my heartbeat, and I saw her

beautiful face floating in the darkness of my bedroom. I had to take action. Next weekend she came to visit, and I managed a moment with her away from the others, on the hot asphalt of Laurel Elementary. I asked her if she would "go" with me, be my girlfriend. One of my friends had tipped her off to my impending courtship, and she was prepared. She matter-of-factly told me she needed precisely one week to think about it. I barely slept for the forever week, fantasizing about an actual French kiss and the pride of holding her hand in public. I tried but failed to think of a way to sway the decision-making process in my favor.

A week later, I sat on the handball court waiting pensively, like a little politician on election night. After she stood in caucus with the rest of the guys over by the basketball court, she walked over with the verdict. She told me that I had once said something she found offensive, that I could never take it back, and as a result, she would never be my girl. She then boasted that she knew guys in South Gate who had shoulders nearly twice as big as mine, showing me the actual size by spreading out her arms and naming their gang affiliations. (I never even knew that shoulder size was a criterion!) My dreams were shattered.

*

We got into some wild climbing and jumping scenarios — me, the Shadids, and the Cervantes challenged ourselves to travel down entire blocks without ever touching the ground, leaping from one apartment building to the next, roof to roof, sometimes using tree branches, fire escapes, or people's balconies to assist us. We were early innovators of parkour. Such a

blast.........jumping across the gap by getting a running start and sometimes barely making the landing on the following wall by arms only, hanging on to the roof's edge. Feel the thrill!

Our games did not always end well. *Enter the Dragon* was a huge movie, and we idolized and imitated Bruce Lee, play-fighting each other. It sometimes turned ugly. I once took a nunchuk in the face from Aziz and my forehead split open.

From that early Laurel Avenue crew, the one I liked and respected the most was Javier, the elder Cervantes. His family had moved to L.A. from Guadalajara, Mexico. Javier and Pablo lived in a small East Hollywood apartment with their mother, another older brother, and two sisters. Their mother worked as a seamstress at home, set up with her worktable in a closet. I felt a beautiful sense of family. We ate yummy snacks, corn tortillas heated over the fire, then sprinkled with salt and rolled up to be grubbed. When they could afford chicken, their mother made it cosmically well.

Javier was a soulful, intelligent kid who was like a big brother. Once, without asking, I sneakily stuffed a piece of chicken in my shirt when I was leaving his house, wedging it under my armpit. As I walked out he asked me what I was hiding. "Nothing," I said. "What about that piece of chicken in your armpit?" he asked. I flushed with embarrassment. Kindly, he let me off the hook, telling me I was family, all I had to do was ask. "Grow up," he said, "think more and free yourself from your baby mind." He said I was smart but headed for trouble if I didn't start taking control of my life. He was thoughtful and caring, offering better advice than I'd ever gotten from anyone, parents included. I walked home through Hollywood that evening, munching the delicious drumstick, feeling a lot of love for Javier.

We snuck into the Fairfax Theatre by attending the synagogue services on Saturday mornings, then running upstairs to hide in the bathroom after the religion ended to wait until the matinee triple feature began. Movies like *The Life and Times of Judge Roy Bean*, *The Sting*, *Paper Moon*, *Jeremiah Johnson*, and *The Poseidon Adventure*. I loved whiling away my days in the cinema, losing myself in alternate worlds.

When we sat through the Orthodox Jewish services, they told us we had to cover our heads, but since we didn't own yarmulkes, they put napkins on our domes. I laughed my heart out at seeing Javier's younger brother Pablo with a napkin on his head. He purposely put a hole through the center of his napkin so a big lock of hair stuck out like a plant growing out of his head. He then said in his Mexican accent with no Js. "I'm Ewish, I'm Ewish!" It was hilarious, Pablo was a sweet, funny kid, and those two brothers were great blessings in my life. Whenever the Red Hots play Mexico, I always treasure the gigs in Guadalajara a little bit extra, remembering my dear friends the Cervantes.

*

A zillion years later, I got in touch with Javier, who'd begun his own auto repair business and had lots of loyal clientele who loved his honesty and dependability. He told me that Pablo had been riding his motorcycle in Griffith Park in an illegal area. The cops spotted him, and over the bullhorn demanded he pull over. Not wanting a ticket, he made a break for it. They shot him dead right there in the park. It didn't even warrant a mention in the newspaper. Crack in my heart. I love you, Pablo.

Stone Age, Bronze Age, Iron Age, Teen Age

— The Weirdos

I n 1973, I started Bancroft Junior High. Like Carthay but bigger, another institutional setting, a spartan fenced-in block of asphalt with no field or lawn to run on. A two-story building full of classrooms, a gym, a buncha bungalows scattered around campus, great areas for creepy crawling and hiding behind. Outdoors an eating area, basketball, and handball courts.

It lay smack in the middle of Hollywood, near the intersection of Santa Monica and Highland, where one could pick up a male or chick with a dick prostitute any time, day or night. Any drug could be purchased with little effort.

As always, I was still the shortest boy in my grade. I had two matching corduroy suits that I wore in different configurations each day, giving me four different looks. I kept a brush in my back pocket, shampooing and conditioning my thick wavy hair every single day. I kept my shit tight. I had two life goals — to look cool, and perfect a wicked jump shot.

Bancroft was economically and ethnically mixed and I loved it. Nowadays, if a family has any money, the kid's going to a private school, but back in the Flea days, it was common

for wealthy kids to attend public school together with kids from the ghetto, and everything in between. Thirty-one flavors of kid. Asian kids, black kids, Mexican kids, Russian kids, Orthodox Jewish kids, rich kids, and kids who lived below the poverty line. Every kinda kid. Lots of cholos and cholas, who were the sexiest girls to ever walk the earth. The cholos and cholitas liked oldies, fifties rock and doo-wop. A group of black kids dressed like the dance group the Lockers lined up and did the robot at lunchtime to P-Funk jamz. A freaky clique of weird white kids deep into Bowie carved his name into their arms. And Jesus, don't forget the Zeppelin white kids with feathered hair dropping ludes and snorting blow. The middle-of-the-road kids were writing "Boston" and "Journey" on their notebooks and hoping it made 'em look cool. A large variety of nerds crossed all economic and social boundaries, and of course there were the assortment of freaks like me who didn't fit in anywhere.

Bancroft also had its Hollywood film industry kids. I was pals with Billy Dee Williams's son Corey, and Tierre Turner, who starred in one of my favorite movies ever, *Cornbread, Earl and Me*. (That movie also starred a man with the most beautiful smooth-like-silk hoops game, the beloved Jamaal Wilkes, who didn't attend Bancroft.)

There's the big fish from the small pond who enters the lake and is humbled by his smallness, until he adjusts and finds his way. Then there's me, a small shy fish from a little puddle, entering the lake and becoming an amoeba awash in an infinite sea of behemoths. I kinda dug it. No pressure. Never had any chance of being cool or popular. Never had to suck up to the in crowd, the cool tan shampoo hair dudes in O.P. shorts, or the pretty Vidal Sassoon Chemin de Fer ass wearin' camel-toe

girls who cavorted with 'em. They were aliens to me, calling me FAG and making fun of my clothes. I was not of their world, and didn't give a shit. I've never felt part of any social clique, and certainly not in my school daze.

I ran with the cholos for a little while at Bancroft, joining some kind of fake-ass gang, meaning that Javier and a bunch of other kids beat my ass one day to "jump me in." Javier said sorry after he busted my lip open and I believed him. I started wearing sharply creased khakis, Easy Walkers, a Pendleton with just the top button done up, a wife beater underneath, and a blue knit cap. We didn't do much besides go around at night and spray-paint walls. I tagged "El Gringo," which an older dude had written for me, but I was a ridiculous excuse for a gangster, and after a few months went back to my regular corduroys.

LOVED TO HOOP! I got up at six each morning, so I could get to school early and play basketball for an hour. Being four foot ten didn't help, but I developed an unorthodox yet sometimes reliable jump shot, and to this day one of my most fulfilling pleasures is lining up just right, in deep rhythm, absence of thought, and draining a sweet jumper. That sound! The clinking note when the ball passes through the metallic chain net. Lost in hoops, I feel a profound joy, just like disappearing into music, the infinite possibilities, the poetry unfolding, the unspoken conversation between the dudes I'm playing with. Running, flowing, and reaching.

Like a dog itching to go on a walk, yearning for that freedom in movement — a pelican flying just over the waves, a mangy coyote opening into a full sprint, a body doing its cosmic thing. I'm always reaching for that. Feeling a part of the magic.

And a fan. The beauty I see in the arc of a Kareem Abdul-Jabbar skyhook or a Kobe Bryant pull-up jumper with the game on the line. Twenty thousand people in the arena all hoping and praying for the same thing to happen like a giant group meditation, the expansion of time when the lightning-fast sprinting slows down into an infinite second. Like a Jimi Hendrix solo or a realized moment by a hundred-year hermetic Himalayan cave monk, all is in the now as electric happiness surges. With all this evil in our world, the cruel violence and prejudices we bring, I can always count on basketball to lift me up. Nothing more reliable on earth than a box score. The personal travails of my tattered heart rise and fall, but the poetry of movement on the hardwood has never failed me, even in the worst of times.

So there I was — at school early to shoot hoops, at lunch, after school, under the lights at night. I dreamed of playing like Laker Norm Nixon and I wore a fake gold chain identical to the real one Stormin' Norman sported.

I befriended some older and bigger ninth-grade kids, who called me Little Man and had my back. Some were gangbangers, but they were cool and made me feel safe. It was a great feeling when they picked me to play: "Yeah, we'll take the little white dude and we'll still beat your ass, come on, Little Man."

Practicing my jumper alone after school, a couple of rival gangbangers from a different neighborhood show up on the courts, throwing up signs, talking shit, and hassling me, they take what little money I have. Then — Baam! Out of nowhere my friends appear and are all over 'em in two seconds. I feel like I belong, I feel love. I understand how good-hearted kids end up in gangs. We all wanna be loved.

The Warmth

C ouldn't concentrate in class. I was occasionally motivated to succeed by a fleeting interest in the ego boost of a good report card, but always ended up spacing out in the stream of meandering thoughts or playing class clown. I loved to read, but the books they gave me were wack.

We had a book at home, a pictorial history of jazz by Joachim-Ernst Berendt. I was cozy and happy hidden away in my room leafing through it, looking at the photographs, reading the short bios, and falling in love with the great jazz heroes like Charles Mingus, Richard Davis, Bud Powell, Dizzy Gillespie, Lester Young, Bunk Johnson, and Count Basie, before I knew what any of them sounded like. The trumpeters were royalty to me. When the opportunity came to play a trumpet at Bancroft, I went for it.

The trumpet, an incredible brass invention, is the king of instruments. This wild machine, its curved pipes, valves, and flowering bell. A puzzle of cold metal and grease, but when placed against the lips of a human being, and love is blown into it, it becomes warm and alive, a conduit for god, a spokesman for the divine. The more love in, the more warmth out, its finger-propelled pistons changing the shape and speed of the

rainbows of curved air blown through its passageways. The expansion and contraction of lip muscles a feat of strength. From the first second I put that cold mouthpiece against my chops and started blowing warm, I yearned to create a beautiful sound, to feel my whole being vibrating one with a tone. I wanted that same oneness I felt when I hit a sweet jumper, or when I euphorically rolled on the floor as Walter and his friends jammed the hard bebop back in New York. When I played it right, I was living in the infinite present.

I listened to the Clifford Brown and Max Roach Quintet over and over. The sound of Clifford's joyful horn went right through me. I danced around my room to "Sandu," and "Joy Spring" turned my little bedroom into a limitless paradise. It filled me with hope. His sonic power, the sweet melody in his unbridled virtuosity, his clarity. A mountain of inspiration. I knew these were the great men, he and Max and the boys, the best kind of men, and I cried when I learned how Richie Powell's wife crashed her car on that cold and wintry night on the Pennsylvania Turnpike, sending Clifford, Richie, and Nancy Powell to their early deaths. They were driving through the night to do a benefit concert for a friend in need. Brownie was twenty-five, Richie, the brother of Bud Powell, twenty-four.

Louis Armstrong was huge for me too. I rocked that shit every day. I was carried away back through time and space to New Orleans in the early twenties. When he sang "All That Meat and No Potatoes," he was singing directly to me, to comfort me, make me laugh, let me know all was gonna be okay. I couldn't have loved him more.

From the start I made a sweet sound on my school-issued cornet. Not that I had better technique than any of the other kids in band class, but I was determined to create a beautiful

tone and I knew what it was. When I found that tone, all the discordant chaos within me was calmed.

Inspired by Walter's hard-core jazz collection and the jam sessions at our house, I kept blowing. I put my horn on the bed at home and left the room. Then, pretending I was in the Beatles, I walked back into the room and I thought: *That's just how it would be for a Beatle, they'd walk in the room and see their horn lying there.* I had the same life as a Beatle! I was ignorant that they didn't play the horns on their records, but still....

The cardinal rule at home with Walter's instruments, his acoustic and electric basses, was don't touch them......ever. Period. He never showed them to me or explained how they worked.

Rebelling against Walter's hands-off policy, I treated my trumpet terribly. I threw it high into the air in the school parking lot, catching it when it flew down out of the sky, thunking into my hands. I threw it higher and higher each time to impress my friends, until inevitably it crashed down, dented, damaged, and destructed. I had to find the thing that would freak people out. I could never leave well enough alone. I felt the need to show I didn't care and was no square.

For all my apparent talents, I didn't concentrate, focus, or practice like I should've.

The only time Walter ever gave me a lesson was about rhythm. He put on a metronome, with its repetitive *click click click* sound, and told me to clap along. If I could make the clicking sound disappear with my perfectly timed claps then I'd have achieved good rhythm. This was the only time I ever shared a working musical experience with him. He never invited me to jam. He had every opportunity to mentor me, but it never happened.

Little Lame-O

I was completely out of touch with the pop culture other kids shared. A girl sitting next to me in social studies class had written on her notebook the word "STYX" in large ornate lettering, so when no one was around I wrote the same on the front of my notebook in a lame attempt to be a part of. I had no idea what it meant. Ha.

Dizzy

Men have died for this music.
— Dizzy Gillespie

Mom took me to Royce Hall to see my greatest living trumpet hero — Dizzy Gillespie. I was thrilled. I'd spent endless hours listening to his records, just in awe that a human being could flow with that kind of intellect, humor, and physicality. I loved the look of his modified horn, the bell poking up to the gods in the sky, his cheeks and neck popping out like a bullfrog's when he blew.

On the night of the show we took our seats. I was bursting with anticipation to see the mythic being as a real-life man. I couldn't believe we were going to be in the same room, let alone the same earth together. I had to pee and wasn't sure what to do, but my mother told me to hurry and go, so I jumped out of my seat like a jackrabbit and ran. In my excitement I ran the wrong way, toward the stage instead of the lobby bathrooms. Somehow I found myself backstage, people all around. Then I saw him standing there in the wings, magic

trumpet in hand. Man. It was Diz, busy chatting with some-
one. I was stunned. Without thinking, I ran up to him and
stood awkwardly, just staring. He looked at me with a sweet
warm smile and I nervously said "Mr. Gillespie, I — I — I...."
I clammed up, too starstruck to talk. Dizzy put his arm
around me and pulled me in tight, my head wedged into the
armpit of his sharp double-breasted suit, holding me there
and resuming his conversation. This went on for a couple of
minutes, he held me close, and I was quaking with happi-
ness. He then finished up his conversation, let me go, gave
me another incredible smile, patted me on the head with a
magic touch, walked on stage, and started playing "A Night in
Tunisia." Wow.

Riot Girl

B and was the one class where I could relax. That music room was a cosmic place, stocked full of instruments for any kid who cared to play them. Those were the days.

I improved on the trumpet and was encouraged to enter a citywide competition for the National School Orchestra Award. I played the Hayden trumpet concerto and won. I was awarded a scholarship for private trumpet lessons, and began studying with a woman named Jane Sager. I took the bus to her little cluttered apartment in a rough part of Hollywood (Selma, just off Highland, next to a rock rehearsal studio *where I'd later go on insane meth-shooting binges*). Miss Sager was in her mid-sixties, a rotund pale woman with big thick eyeglasses and brightly colored quirkily coordinated funny patterned polyester outfits. Such a character, in her dark little apartment, with unorganized stacks of sheet music, trumpets, and other musical equipment taking up every inch of room that wasn't a chair or a music stand. She was a disciplinarian and an eccentric, and I might have thought she was crazy if I didn't know better. She put that horn up to her wrinkled cig-

arette lips and freely blew a mighty clear sound that lit up the room. She took no shit, admonishing me if I hadn't practiced enough, which was the usual. I was always running off to play basketball or smoke weed. She had played with Count Basie, Rex Stewart, Roy Eldridge, and toured with the great all-lady orchestras led by Ada Leonard and Rita Rio. Those female orchestras were full of serious musicians, but were encouraged by the audiences to "take it off!" and were often solicited for prostitution.

This was before Riot Grrrlz.

Jane Sager was a beautiful teacher and I am eternally thankful to her. She is the only private music teacher I ever had (except I took a bass lesson once and the guy told me to play "Take It Easy" by the Eagles, and I said fuck off). If Jane Sager had been a man she'd be acclaimed as a great trumpeter, but sexism is a bitch, and she lived in that little apartment on Selma teaching the likes of me.........

Winning that award grew my confidence. I started thinking I could be a real musician. Mr. Charles Abe, my school band teacher, began giving me solos. He asked me to conduct the orchestra and encouraged me to be a leader. I often think about what a better player I'd have been if I was diligent. But then I wouldn't be the animal I am. ·

Rapid Transit District

I was completely absorbed by Korean karate classes. I rode the bus three times a week to the dojo. I loved the snapping sound the uniform made when I threw a hard kick, the humble spiritual feeling of bowing before entering the mat, the dance of the long-form movements, the climbing of the ladder of belt colors, and the sense of community. Karate's discipline satisfied an unrealized but deep desire for structure in my life.

I was eighty-seven pounds of fury, the little king of the sparring sessions, fearless and charging, I never lost. Until one day a new boy named Damien appeared, and when I rushed him with a flying side kick to show him what was up, he deftly avoided it, punching me in the chest so hard I fell back in shock, doubled over gasping for air, while he stood there calmly in fighting pose with a slightly discernible smile. Ha, sparring was never the same.

I felt special when I was one of a select group chosen to do a karate demonstration at a Boy Scout Jamboree in Palm Springs. My gig was to run across the stage and break a board with a flying side kick. It had rained, though, and the stage was slippery. When I ran and took off for my kick I slipped and fell flat on my back, to the tune of uproarious laughter from

two thousand Boy Scouts. My instructor implored me to redeem myself and do it again, which I did to an even harder and higher fall, and even more obnoxious guffawing from the little militant fucks in the crowd. An unintentional Buster Keaton, I was the slapstick comedy portion of the program.

I had a similar experience at a surreal Alateen/Al-Anon convention talent show a few years later, where the board was held incorrectly; I failed to karate chop it in half and nearly broke my hand in the process. They didn't laugh at me there though; it was a quiet sympathy.

*

Due to one of Walter's manic episodes I'd had a sleepless night. My escape was an entire day at karate class, and I was exhausted by the time I boarded the bus home. It was late at night, there were only one or two people riding. As I walked onto the bus, three young men appeared, coming in behind me. They were straight gangbangers, dressed in a uniform darkness, fedoras, and bandanas. They were high as fuck, maybe just stoned but it seemed more intense, like coked up or maybe dusted. They glided and swaggered down the bus aisle like they owned it. They were not to be fucked with but I didn't feel threatened, they were on their own trip.

One of them was singing boldly in high falsetto, the refrain from Parliament's "Night of the Thumpasorus Peoples." He had a beautifully haunting voice, and sang the nonsensical syllables slowly and drawn out, the ghostly high-pitched notes echoing around the empty night bus as it headed up toward Hollywood. It was scary sounding; I think he enjoyed freaking people out with it and in any event, he didn't give a fuck.

His liquid vocalizations gave their hard gangster vibe a mystical quality. Not only did the sound make them appear like they operated in an otherworldly dimension, music took on a meaning that I had not before considered.

When he sang those notes, he rebelled against the whole wide world.

I sat there listening and staring out the window, lost in my thoughts as the bus rattled away. I realized that music was a force that brought people together and gave them power. People living outside society need a sound to believe in. A sound that cannot be owned or emulated by squares. It inspires the marginalized and the rebels. It gives a soundtrack to their walk that only they understand. It speaks for people who might not otherwise have a voice.

It dawned on me that music was not just a fun-to-play-beautiful-thing to trip people out and make 'em happy. I thought of the old jazz guys I knew who couldn't catch a break, and how the music they played was a personal voice for each of them, one that no rich person could ever silence. I had a deep desire to connect with it, I knew there was no faking it, you had to live the notes. The bus rode on.

When preparing for the test of seventh-degree blue belt, my teacher instructed me to eat healthy breakfasts. "Steak and eggs!" he exclaimed in his Korean accent. I convinced Mom and Walter of the crucial importance regarding my special food in the weeks leading up to my test. Up at dawn each morning like Kwai Chang Caine while all normal people slumbered, I prepared my sacred training meals. In the dead quiet of sunrise I watched the butter melt in the pan and proudly admired the breakfast steak sizzling on hot metal. I took charge of my destiny. Fancying myself a Zen karate master, aiming for something higher, cherishing the meditative moment.

The Talent Scout

I was nearly thirteen, and doing my paper route in run-down East Hollywood. Low-rent apartment buildings soldiered on through the smog, block after block. Old red brick ones, stucco Spanish-style single stories, some with a faded Hollywood grandeur, courtyard apartments like the Dude's in *The Big Lebowski*, old dilapidated chipped-paint houses peppered in between. On this day, I was knocking on doors in a mostly futile attempt to get people to pay.

One door was opened by a cheerful man in his thirties, red curly hair, glasses, stocky build. He told me to come in, he would write a check. After striking out all afternoon I'd finally found someone ready to pay.

Three or four other boys my age were hanging around the apartment. They were neighborhood kids, not his. We were all friendly. The man said he was a talent agent who worked at Paramount with child actors. He was chummy and paternal. Pleasant and easygoing. Evaluating me for a few seconds, he got excited, like a lightbulb went off in his head. "Hey, you've really got a presence," he exclaimed. "A one of a kind look, I could work with you, you're a natural for the movies!" With

that, he paid his bill, gave me a generous tip, and handed me a business card, telling me to call him. I rode away on my bike, dreams of movie stardom inspiring me to pedal hard and pop wheelies all the way home.

I told my mom about it that night, and she was like "Well, whatever." Turned out he did work at Paramount, but in the mailroom.

Movie star dream alight, I was back at his apartment the following weekend. I got to walking and talking with the kids; one of them told me that the man — let's just call him Elmo — had contact with alien beings and was capable of telepathy. He swore Elmo was on the up-and-up. I was excited and skeptical. I knew it was bullshit, but the rational voice in my head was overwhelmed by my showbiz aspirations. When I left that day, Elmo invited me to come back for a slumber party with the other kids, before going on a group outing to the Simi Valley swap meet.

In retrospect, it is absolutely fucking insane that my mother had no objections to me going and sleeping at this unknown man's house.

The following weekend I showed up again, hung out with the kids, Elmo, and his brother. The same boy, the alpha of the group, took me aside and told me that Elmo could read all their minds. This was how Elmo could tell who was going to be a famous actor. He had access to the quality of their thoughts. This boy claimed he could hide his bad thoughts so Elmo couldn't read them. He also said that Elmo was preparing for a biblical apocalypse by storing thousands of gallons of water in an underground shed. More insane bullshit yet I stayed along for the ride.

That night Elmo cooked up delicious biscuits and gravy.

As darkness fell, it dawned on me that the other kids had quietly left. It was just Elmo, his brother, and me. Things started to feel spooky. They got out a box of photos, and told me that I must never under any circumstance tell anybody about this collection; it was top secret. They were pictures they'd taken of real spaceships when they had met with the aliens in the desert. The brother somberly said, "Next time we will show you the aliens." Now I just wanted to go home. I was scared.

Bedtime. I saw the living room couch as the safest place, but Elmo said no. He took me into his own bedroom. It felt disgusting, and I felt trapped. When I climbed into his bed with all my clothes on, he told me that was unhealthy and that I must take them off. I stripped down to my underwear and lay down on my stomach. He told me that "the black spirits" enter through your back when you sleep, that I should lie on my back so only the "white spirits, the good spirits" could enter me. I turned over, trembling with fear. Elmo and I lay there in our underwear, I was frightened of everything, his repulsive racism, the entering of spirits of any color, the aliens, the mind reading, and the possibility of having to physically defend myself at any second. I imagined diving through the bedroom window to escape. I also felt completely duped; like an idiot, a sucker. I was terrified at what might come next, yet somehow I fell asleep.

When I awoke the next morning, the kids were back. We ate a big breakfast and headed out for the swap meet. I was straight trippin' in the wake of the previous night but trying to act normal until I could get the hell outta there. Afterward we had a barbecue at the park, the happy family. But I now knew this was some fucked-up shit. I saw them all in a differ-

ent light. Elmo and his brother were twisted and sick, and the kids seemed lost and desperate.

The second we got back to Elmo's, I got on my bike and sped home. I was shaken, but never told anyone about it. I never saw Elmo again and never told this story until now.

There I was again, a boy looking for a dad, nearly seduced by another predatory racist pedophile scumbag. God knows what he was doing with those other boys, who were convinced he could read their minds. I hope he didn't jack off over me while I was sleeping.

I got out lucky, making it through childhood on the streets of Hollywood without ever getting molested or raped, but man, I came close that time. Lucky I didn't end up in that underground apocalyptic water shed.

Open Sky

That summer after seventh grade, Karyn and I flew to visit Dad in Australia. We called the plane food "chicken feed" and couldn't stop laughing. We laughed even more when Karyn found a half-smoked joint in her pocket mid-flight. I was thrilled to be getting together with my father for the first time since I was seven, and I'll never forget my eruption of joy and love, disembarking from the plane and seeing him down the other end of the long cavernous airport terminal. Arms outstretched, I sprinted toward him. Dad broke character, busting out of the prison of his proper businessman's suit and gleefully running at us, weaving through the crowd of people with a huge grin on his mug. He met me and Karyn in a massive loving hug.

Dad now lived in the Australian capital of Canberra, where he worked in the government customs offices. He had remarried. His new wife Margarethe was a kind and friendly German woman, and they seemed to have a lovely life, working hard and spending weekends camping and fishing at the coast with their two Labradors.

We loved getting into nature with them, taking bushwalks along the Murrumbidgee River and warming up by a campfire

in the sand and roasting sausages after a romp in the cold bois-
terous ocean. When we stayed in a small cinderblock cabin
in the small coastal town of Dalmeny, I woke up early while
everyone else was sleeping to walk through the morning still-
ness of the forest, eager to see a wallaby. Ahh the *koo koo
koo* of the kookaburras and the dew drops on the beautiful
banksias flowering in the rising sun! Karyn and I frolicked
freely through the bush and beaches with the dogs, discover-
ing secret places and tripping on the glimmering swirly pat-
terns in the abalone shells.

As part of a crazy Australian ritual, Dad won a meat raffle
at the local pub and came home buzzing high and happy,
cradling an enormous quantity of sausages and chops. He bar-
becued 'em up in the backyard, his pet mallard dabbling ducks
skiffling around and quacking at his feet. He would also pre-
pare a tantalizing fish soup that we sopped up with thick
hunks of sourdough bread.

Everything was so comforting, normal, and good in Oz
compared to the confusing chaos of Hollywood.

There was one testy evening in Canberra when Karyn and I
were watching the TV news. U.S. President Richard Milhous
Nixon was resigning before he could be forcibly impeached,
and we were laughing and cheering that the evil weirdo was get-
ting the hook. Our father walked into the room sternly scolding
us, saying we had no idea what we were carrying on about.
"Richard Nixon is a good man, being railroaded by the system
and it's sad," he said. I didn't buy it; I was convinced Nixon was
a lying racist who'd been busted cheating the American people.
Despite all my youthful naiveté, I was convinced of that.

Political differences aside, it was a great trip. I knew I'd al-
ways be an Australian and my father's son.

Sex

I was always the shortest kid in my grade and that was fine with me, I took pride in it. Little and wild. But at thirteen when teenage sex entered the picture and it was time to start making out with girls, something changed. I turned terribly shy and insecure — *Oh shit, I'm little!* — worried that I was too short and skinny for girls to like me. Up till this point I'd worn my outsiderness as a badge of honor, but now I felt uncool and freaked out in fear of being ridiculed. I froze up in any social situation involving a girl I was even remotely attracted to.

Like many thirteen-year-old boys entering puberty, I masturbated constantly, entertaining every kind of fantasy I could possibly imagine, which weren't many, considering the limited scope of my romantic experiences (none), and having never seen porn outside of a few peeks into a *Playboy* magazine.

I jacked off to the photographs in my mother's *Cosmopolitan* magazine. Fully clothed women looked out seductively. They were occasionally scantily clad, but never a butt crack or a nipple, let alone the readily available gaping assholes and cum shots of present day. I invented the most romantic nar-

ratives and indulged my imagination in the funniest ways: Me and my dream girl would spend the day building snowmen in some remote forest, we connected in a deep and loving way, she whispered magic words to me, she indulged me in the sexiest foreplay — all leading up to this mysteriously rare and sacred exotic act. It was beautiful! I loved jacking off, it engaged my imagination, like the time I'd spent with my imaginary friends under the covers as a five-year-old.

I was obsessed with sex, hypnotized by girls at school, and in mortal fear of them. I was awestruck, their otherworldly little breasts popping up, Californian hair falling on tan collarbones or Afro-ing above sexy brown eyes.

Sidewalk Surfer

Ty was my skateboarding buddy. We ran the streets smoking weed, talking about girls and sex, and looking for empty pools.

Ty's father was a classic seventies Hollywood pimp who'd roll up in a brand-new Cadillac, dressed to the nines, with a dope fedora, gold cigarette holder, sweet sunglasses, and drop off a pack of hot dogs for Ty, food for the coming days. His mother was the equally classic prostitute in the passenger seat, incredible bombshell body, teeny brightly colored skirt, platinum-blond wig tickling dark brown cheeks. I knew the score with his folks, but it didn't seem stranger than many other family setups I'd seen. I had met other families who seemed respectable and straight with normal jobs, but if you pulled back the curtain on the wizard, there was all kinds of weird shit lurking. I had another friend whose mom would run up to Vegas to turn tricks once a month to cover the rent and grocery bills. She used to do the guy at the doughnut shop on the corner too. We'd stop in for free doughnuts.

*

That summer before eighth grade, I got really into skateboarding. Ty and I skated over to Laurel Elementary School where some kids had built a plywood ramp atop the angular embankment and attached to the fence above. The ramp had a broomstick for "coping" at the top, and we rode that ramp all the day long. In 1974, skateboarding was a whole different thing. There were the geeky skateboard-riding kids, nerds with their new toys. Then there were street kids getting wild, the ne'er-do-well misfit geniuses who began the culture that would sweep the youth of the world and become a zillion-dollar business.

The kids that hung out at Laurel Elementary were straight drug-taking troublemakers. We smoked weed, hustled beer from the local liquor store ("Excuse me, sir, if we give you three dollars would you please purchase us a six-pack of Michelob?"), and skated. I had never really skated before, just a few sidewalk trips on a clay-wheeled Black Knight a few years earlier. The new urethane wheels and colorful GT decks were a whole new world of excitement. That feeling of gliding, floating, the weightlessness at the top of the ramp.

The Dogtown boys sometimes rolled through and awed us with their skills. I knew they were cooler than I'd ever be. Ty and I discovered empty pools around the city to skate. Looking down into an abandoned swimming pool for the first time, that subterranean blue cavern alive with fear and potential, I was thrilled. It reminded me of the empty swimming pool I saw in Australia when I was three. I was never a good skater, but it was my summer of skateboard love.

One day I was drunk at Laurel Elementary, and I took a younger kid's skateboard when he wasn't looking and threw it in a trashcan. It was a stupid shitty thing to do. I then forgot

about it and left to score weed with Ty. The next morning I was skating down the sidewalk when a white pickup truck screeched to a stop at the curb next to me. Out of the car sprang a man in a red-faced fury. He grabbed me violently around the throat, cutting off my air, and slammed me up against the stucco wall of a house. I was scared shitless. He yelled back to the truck, "Is this the kid!?!?" I saw the silent nodding head of the kid whose skateboard I had deposited in the trashcan the day before. "You stole my kid's skateboard, where the fuck is it?? I'm gonna make you bleed!" He loosened the grip on my throat, I gasped for breath and stammered out something to the effect that I didn't steal it. The man then punched me hard in the stomach, the wind went out of me and I crumpled to the ground. As I collapsed, he punched me again in the face, blackening my eye before driving off. I was a small skinny street urchin, but I guess I had it coming.

After trying all summer, I finally skated to the top of the ramp, grinded my trucks on the coping, and made it back down nice and smooth. I did it about fifty times that day, again and again. I was ecstatic. The next morning I awoke before dawn, obsessed and excited about my skating breakthrough. I rushed over to Laurel to find that the ramp had been taken down, I felt sad and empty. Shortly after that, eighth grade started and I never skated again.

The Great Outdoors,

or

Waited, Waded, and Weighted

Things were getting pretty crazy at home, my sister was off partying and then suddenly left; gone back to Australia to try out living with our dad. Walter had been having more and more of his violent episodes. Something would tick him off and he would just erupt; demolish the house, break all the stuff in the kitchen, smash the TV, a wild rampage through the entire abode crashing and bashing and breaking everything in his path, kicking down doors, laying waste, each episode more psychotic and scary than the last.

There was the night he kicked in the record player that we weren't allowed to touch, then grabbed a little statue off the mantelpiece, a carved wooden head my mother bought during a ship stopover in Fiji, when we moved to America. Cowering and crying in the corner, Mom jumped up and yelled "Please, not that!" Walter gently returned it to the mantel and then went back to kicking and cursing and breaking shit, throwing his amplifier into the yard. That kind of absurd, almost comic pathos highlighted the ridiculosity of these drunken tantrums, but it was absolutely fucking terrifying. He was a big guy with

tons of scary energy recklessly moving at a fast pace in a harmful way.

On any given night, a fit could happen suddenly. He would throw a book or something, and start pacing like a caged animal. At any hint of an impending episode, I'd get a shaky, nervous kind of feeling and then quietly slip out the back door, sleeping in some old rolled-up carpet behind the garage so they couldn't find me.

I imagined I was like Huckleberry Finn or the kids in *The Night of the Hunter*, I could slip away on a moonlit river and float into some beautiful starlit world away from all fear. Little Michael Balzary was not wrapped in those old dirty rugs in the carport, but on a raft drifting downstream to an incredible adventure of the unknown.

I didn't understand about alcoholism yet, how booze and drugs fed the wounded animal in Walter, I just thought that's how life was. Unpredictable and insane. I'd show up to school the day after one of his episodes feeling shell-shocked and spaced out. I don't know how I manifested this stuff outwardly, but I never talked to anyone about it. I just wandered around in a daze, stuck in a severe hangover. I had no idea how to deal with it. I was very conscious of the things I loved about my family — the freedom of all of us walking around the house naked, Walter being a musician, the amazing jazz I heard, the well-stocked book and record shelves, the bohemian aspects of our life. But I'd lie in bed at night and wish that I had a boring, normal, dumb family. One with no creativity. I wished my dad worked in a factory, and my mom was a conservative housewife who wore ugly pantsuits. I wished they'd have petty arguments and watch TV; the way Archie Bunker and Edith behaved on the TV show *All in the Family*, or like

the Battaglias back in Larchmont. I equated creativity with insanity.

If Walter got particularly crazy, threatening to kill my mother or himself, Mom would take us to a motel for a couple of nights. That felt like a vacation. Room service and swimming pools were the consolation prizes for losing the happy home contest.

The police would take Walter away sometimes, but he would always come back, and we would always go back. Mom said, "Michael, Walter is just so smart he can always outwit the police and convince them to let him go right away!" I didn't give a fuck how smart he was. Shit was volatile.

Trick or Treat

Halloween night. I was still thirteen and at the end of my trick-or-treating career. It was just before I stopped following the candy and started following the hope of teen romance. I was out with my pals the Cervanteses and the Shadids, candy gathering and creating trouble. I like to think that the other kids' mischief was more mean-spirited, and mine was more innocent; like Omar was the one who would approach the door of the nice lady with a tray of choice candy, then quickly and violently bash the tray out of her hands, the candy scattering everywhere, grabbing everything for himself, the lady crying out in despair, and Omar running off cackling into the night. And woe to the benevolent lady who gave out quarters from her bucket of silver coins. But I grabbed the stuff too when it went flying.

I thought of myself as a nice person. When I took the bus, which I did constantly until I perfected my hitchhiking skills, I'd always give my seat up to a woman or an elderly person. I'd offer kindness whenever I could, helping people out with things or being sweet to little kids. I knew the peace and satisfaction that came from being of service. I wanted to be good so

bad. But my moral compass was just so damn wacky, I veered from the path of kindness into dishonesty and exploitation with just a modicum of provocation. Like I had something to prove to my friends.

Halloween has been a night of much tumult and trauma throughout my life, and this particular one was no different. We'd been trick-or-treating for a couple of hours when we came across a group of kids we knew. They were wide-eyed and walking quickly; alert and tense. They informed us that a scary man had gone crazy. There was some sort of a lunatic mental institution escapee on the loose. He was firing a gun into the street and screaming like a crazed animal. They were visibly shaken. It wasn't safe and all the kids were hurrying home. In our ludicrous costumes we all ran in different directions to our houses.

As I approached my house, I noticed the front windows smashed, glass and debris all over the lawn. Without thinking, I flung open our front door to tell my parents about the madman on the loose. I saw the house was demolished inside, the entire floor was covered in broken and thrown stuff, everything obliterated to hell. In the corner of the room, in the TV Barcalounger chair, sat a slumped over Walter. He was clad only in his underwear, blood smeared about his face and torso, a pistol on the floor by his side. He was exhausted and formless, completely spent, his eyes flat black holes. Becoming conscious of me he slowly raised his head and croaked out, "Go find your mother." I turned and ran, filled with shame that it was my dad who was the gun-shooting lunatic. I shoulda known. As I ran down the block, I heard sirens and saw cop cars screeching up in front of our house. I ran into the night.

The domestic chaos continued: It was a Saturday afternoon and my mother was off work from her full-time job as a legal secretary. When I walked up the pathway to our front door, she was standing in the living room holding a beer. As soon as she saw me she dropped the beer to the ground, the bottle shattered. She grabbed me by the hair yelling "And you, you little fucking bastard! You too! Fucking asshole!" She held me tightly by the hair and began punching me in the face while she screamed obscenities. I managed to free myself and ran back out the door, blood on my face and scalp.

She was super apologetic about it the next day, explaining how she was drunk and angry and now felt terribly about it. She said that Walter pulled this act all the time and that she thought she would try it, but it was a moronic thing to do and she begged my forgiveness. I told her I understood and that it was okay. I really did forgive her; I knew it was a onetime momentary collapse and not who she was. I felt sad for her. She never did anything like it again.

I had a harder time forgiving her for staying with Walter, always letting him come back when he did these things that traumatized the hell out of us over and over. That was the truly fucked-up thing. She was blinded by her fear of being alone. A common tale, I guess.

The Professor

Perhaps I forgave my mother so easily because I'd tried out being a mean-spirited jerk myself.

I'd always been at the bottom of the totem pole at Bancroft; been called names and pushed around many a time. But much like my mother taking it out on her son, I decided to fuck with Irving Pretzel, an easy target. Irving was small like me, but dressed poorly in ill-fitting pants and dorky bargain-basement shoes. He had weird greasy hair and skulked around, a solitary figure. I started making fun of him in between classes. "Look at Irving Pretzel's pants. Ha Ha Ha." I did it for a week or so, until one day I was leaned over at the water fountain against the red brick wall of the gym building enjoying a big drink in between basketball games when.......BAM!

Something slammed into the back of my head causing it to ricochet off the fountain, blood spurting outta my lips. Shocked and dazed, I sprang back and BOOM a fist in my face, then another hard blow in the stomach, knocking the wind out of me. Doubled over and gasping for air, I looked up to see Irving Pretzel's enraged face, his fists clenched tightly.

"YOU WANT SOME MORE?!!" he screamed, his eyes on fire. "No," I stammered.

Next thing I knew, we were both sitting in the principal's office. The principal blathered on in a *Peanuts* adult voice, "Bwah wah wah mwah...." He then told us to shake hands and make up. Even though I was embarrassed that I had my ass beat by Irving Pretzel, it wasn't cowardice that dissuaded me from feelings of vengeance. I knew Irving was a hundred percent right. I should've known better than to be a bullying asshole. He knew that I knew that he knew that I knew better.

In the Sandbox
with the Octopus

I had a sweet friend named Pepper Jones, the youngest of four brothers, all tough street characters. Pepper was the one with the mom who arranged the free doughnuts. He had a heavy stutter, infectious laughter, and was down for fun. We'd always share our meager resources. Smiling now remembering the sincere joy in Pepper's bodacious laughter when we saw *Escape to Witch Mountain*. I thought I was too cool for that movie, but he took a break from acting tough and let the little kid in him fly free.

We rolled through Hollywood peeking into all the backyards, and peering over fences to search for pot plants. When we found 'em we'd steal 'em. A few close calls with irate dogs and homeowners ensued. We'd take the plants home to dry out in the toaster oven before rolling them all up and smoking every last crumb. You'd be amazed at how much hippie weed was being grown in Hollywood backyards.

One day in the street, we ran into one of Pepper's older brothers. Pepper told him about how a few days before, he had been mugged by some black kids who took his wallet. Pepper had never expressed racist sentiment to me, but to his older

brother he said, "Hey, some ni-n-n-n*****s got me and took m-m-m-my muh-muh-muh-money yesterday." His brother burst into action, violently grabbed Pepper and threw him up against a car, hurting him, holding him by his collar with both arms, and screaming, "YOU FIGHT, PEPPER! YOU FUCK-ING FIGHT, YOU HEAR ME!!! I NEVER WANT TO HEAR THAT AGAIN!!! FUCKING N*****S!" I was shocked by the sudden cruelty and stupid white pride. Pepper was meekly apologetic to his big brother, saying, "Okay, okay, I'm s-s-sorry." A short time after that, I was making eggs with Pepper at his apartment when one of the brothers walked by, and witnessing our cooking technique said, "Pepper, you idiot, that's how the n*****s do it." The racist talk bummed me out and I couldn't pretend it was okay. It's so hard when you know someone is sweet and beautiful inside, but they can't outrun the demons and ignorance of their family culture. It would have been a herculean effort for him to travel through his pain and best the evils of his upbringing, I don't know if he ever did it. When I heard stuff like that it sickened me. I thought of Dizzy Gillespie hugging me into his armpit, and the cool jazz guys who hung out at my house. These were the people I really respected.

Raoul was a cholo with the most impossibly gorgeous cholita sister named Elena, who dated Thunderbird, a scary gangster dude. I'll never forget the fear I felt the day I threw a water balloon from the second floor of the Bancroft building to hit some regular kids, but accidentally hit Thunderbird. I knew I was dead. Word came that he was looking for me. I hid from him for days, until a week later he and some of his homies caught up with me in the school hallway. There was no escape. I had disrespected him badly and knew he was the

kind of guy who wouldn't think twice about using a knife. They cornered me up against the wall, swallowing me up in an impregnable semicircle. I froze like a deer in the headlights, anticipating the impending beatdown.

Time stood still for an eternity as I shrunk under their heavy stare. I wished the lockers behind would swallow me alive. In his perfectly pressed khakis and cozy-looking Pendleton, hair slicked back, Thunderbird took a long thoughtful moment and then said, "I know you didn't mean it, I know you're cool, homie, so it's all cool." Phew! A beautiful reprieve.......

Raoul proved to be less thoughtful than Thunderbird. He once embarrassed me terribly in front of Elena during a family dinner at his house, loudly declaring, "I peeked over the bathroom stall and saw Mike peeing, he was playing with his balls! I think he was looking for pubes, he's got no pubes! HAHA-HAHA!" I blushed and shrank into my chair. It was true too, I was late to the pube party. In seventh grade when we started mandatory showers after PE class, I saw that the nerdiest kid in the whole grade, Eugene Trout, had a full-on bush. I did my best to hide my baldness for years, but was still pubeless in ninth grade. I thought, *Fucking Eugene Trout had a bushel of pubes in seventh grade!* Not till tenth grade did mine sprout. Pubes or not, I spent many an hour thinking of Elena, but she was out of my ballpark.

Raoul introduced me to my lowest high. We smoked angel dust (PCP) bong hits and I've never been more out of it. We listened to KISS's "Detroit Rock City" over and over; Raoul telling me you could hear the sound of an authentic car crash in the recording. He excitedly insisted it had caused real fatalities. We then tried to take the bus to a park a couple of miles away, but ended up utterly confused on the complete wrong

side of town. Raoul was a bad egg. The kid showed no pretty colors.

Angel dust is like smoking death. As you inhale the shit, you feel your brain cells dying in real time, important cellular stuff popping and fizzling. Your heart light is dimming, never to be quite as bright again. Even the most secure and worry-free person starts panicking over the bottomless void. It sends you numb and spiraling down a hopeless and never-ending vortex. I don't know the pleasure or benefits in that one. No joy, no doors opening, no nothing.

Ran into Raoul on a bus a year or two after Bancroft, and he had gone all the way criminal, gang style, talking about some nefarious robbery shit involving violence that he was up to. He was also telling me that I should always put cocaine on the tip of my cock before having sex, it was the best way to do it, makes you fuck for hours. We were fifteen.

Then there was Freddie Gold. His two older sisters were both friends with my sister at Hollywood High. Freddie was my first rich friend. When I went over to his house, I discovered an opulence previously unknown to me. A big spread up in the West Hollywood Hills, in the Bird Streets up above the Sunset Strip, including the famous Blue Jay Way ("There's a fog upon L.A. / And my friends have lost their way" — The Beatles). A big swimming pool, two well-stocked refrigerators, a Salvadorian housekeeper named Bessy in a white suit and hat, everything clean, immaculate white shag rugs, massive aquarium that bubbled its modern convex way out of the black tiled wall. Freddie always had weed, we'd smoke it, go in his pool, then the sauna, listening to loud music, the popular stuff, which being a jazz nerd, I knew very little about. Peter Frampton, P-Funk, Zeppelin. Living it up. His father

took us to the Dodgers game in his giant new Mercedes limo, and we stopped and had French dip sandwiches somewhere fancy along the way. Freddie's stepmom, Tiffany, was a hot blonde, and her nipples would poke through the top of her pink velour tracksuit. I heard my mother yelling about her to my sister once "That Tiffany is nothing but a high-priced whore!"

On an evening walk through the Bird Streets of the upper crust, my sister Karyn compared us to the Golds, venting frustration. She angrily voiced that we had such a shitty life, our parents were losers, the Golds had everything and we had nothing. I didn't feel that way. It was fun to swim in their pool and be served fancy food by their bikini-clad stepmom, but I didn't covet that stuff. I enjoyed being a little rascal and hustler; I took a pride in the struggle. Besides, we never went hungry. What I wished for wasn't a fancy house, but just simple peace and harmony at home.

After we devoured huge helpings of a lasagna dinner, Bessy removed our fancy plates and bone-handled cutlery, bringing us baby-blue bowls of strawberry ice cream, and a delicious spoonful of it got my taste buds happily tingling. "I wish they had ice cream like this at school!" I said. Freddie opined, "Yeah, the food there sucks." Freddie's dad chuckled, "You kids are lucky they feed ya at all! Pizza day? We never had that when I was a kid." I piped in, "Oh there's money to be made on pizza day." Freddie's dad looked at me curiously. "Yeah?" I went on to explain my lunch ticket hustle. Since my family was at the lower end of the economic scale, I received free lunch tickets each week. I discovered that if I gave the lunch servers a little sob story about losing my lunch tickets, they'd usually give me lunch anyways. So I stockpiled my tickets,

selling them to rich kids who wanted extra on pizza day, and there were takers on sloppy joe day too, and some who coveted certain desserts on other days. The lunch tickets were a currency, I created a black market where I bartered, put a few bucks in my pockets, and always had a bellyful of lunch. Being a hustler himself, Freddie's dad was impressed with my entrepreneurial spirit, and frowned at Freddie. "Why can't you do that?" I felt bad that Freddie got upbraided, but I was proud of myself too.

Working little hustles like that made me proud. I enjoyed the feeling of success when things clicked, but more than that, I was connected to something. There were legions of scrappy hustlers out there getting by on the lames, and I felt part of a time-honored tradition. I was a Little Rascal.

Transformation always comes when you least expect it. It happened on a night Freddie and I were in his tricked-out room playing records on his fancy stereo. The lights were out and we were blasting the Ohio Players at mega funk volume. We started playing air drums and guitar. I was on drums. I became utterly transfixed and transported. I WAS Diamond on the drums, hitting every note, feeling it, driving the rhythm. Gone, in a complete sweat, an ecstatic trance, imagination and the music had completely overtaken me. I felt complete. Never before had I felt this way playing music, it didn't matter that I was miming. Beating the air wildly in the dark, the combination of over-the-top physicality and heartfelt groove, both those parts of me satiated in unity, brain and body. Incredible fantasy, time travel, and shape-shifting, I coulda gone all night long. But the song ended and the lights came on.

And.........

Thus my lifelong meditation on the concept of groove, what it is to make deep rhythm. This becomes a huge part of my life, as a musician of course, but also the question of how it relates to all of existence. When I'm rocking a groove, there is only nature working, ain't no one gonna rock it harder than me. Free from all prison of my mind's construct, I am a fucking mama grizzly bear protecting her cubs, and I don't care if I die. I trust my animal instinct completely. I let go of every thought, let go of all the world, and KILL the groove. The hurt and pain in my heart is my ticket to fly, I surrender all earthly desires in the moment, when it's time to rock and tap the source. I gotta be the groove and nothing else, fuck the world so I can uplift the world. To all you kids out there hurting like I hurt, I'm gonna be with you there in the magic place.

I was googly-eyed attracted to Freddie's two older sisters, especially the eighteen-year-old bombshell, Vickie. She took us to a nude beach one day. When she shed her clothes it was beyond incredible. She took a cold ocean swim and came back wet, tan, athletic, and happy. Every little drop of ocean water sparkling on her unbridled and explosive nakedness was an infinite universe. Her nipples could have taken an eye out. I was embarrassed by my hard-on and lay on my stomach to conceal it. We then got stoned as fuck (*see book cover*) and swam in the ocean. My head is still swimming thinkin' about it, the naked girls, the sun, the ocean, lying stoned in the sun. Damn, it was a fine day.........

When the parents were out of town, Chez Gold turned into a party palace. The older kids would pair off and go have sex in the bedrooms. I'd get super drunk and stoned, wondering

when my time would come with the girls. This phenomenal, unimaginably unattainable thing was right there in front of me. I felt small and inadequate. How would a girl ever like me, ever relate to that broken part of me that I felt so acutely? In their presence, I'd go mute. I got a peek-in at how the older cool kids did it, but I was way out of the loop and not even close to cool.

A while later I ended up at a cool kids' party of my own age group. The girls were beautiful and well dressed, the guys handsome, tan, buff, witty, and perfect. They lived in houses in the Hills. They drove their parents' sports cars, took Quaaludes, and had sex. In this foreign world I had no idea how to behave. And as much as I wanted them to like me on that night, which didn't happen, they seemed weird and disconnected, like they were in a bubble. I saw them as short-sighted, and I judged them for living a life of pretend. I had no faith in them and went my own way. Sour grapes? Maybe.

Freddie and I were tight for most of ninth grade, until one night when his asshole friend Dean, who had a connection to the Classic Cat club on the Sunset Strip, said he could get us in; his mom was a stripper there. We could go watch the famous Kitten Natividad get naked in a giant champagne glass. We arrived at the back door in the alley behind the club. Freddie and Dean went in ahead of me, telling me to wait while they sussed it out, and closing the door behind them. I waited about an hour for them in that dark back alley, frustration building. *Motherfuckers.* I didn't even have bus fare. A weird man was creeping me out till I got scared and ran down some side streets and walked the few miles through Hollywood to get home. Freddie explained to me later that I was too short and would have ruined it for both of 'em. Why the fuck didn't

he tell me before they went in there? It's a special kind of pain when a friend betrays you, but never actually a surprise. If you're paying attention, they let you know long before they do it. Never be seduced by a Dodger game and a fancy French dip sandwich.

Blondie lived in a fancy house in Brentwood, a wealthy enclave on the Westside. His parents were separated and his dad would see him every other weekend. Once his dad took us to Magic Mountain, an amusement park. His old man smoked weed, and shared it with us on the drive. He had some strong shit, and I sucked it deep into my little lungs, getting particularly, wickedly, high as fuck. We were laughing hysterically when we ran into Magic Mountain, gassing on the impending roller-coaster rides we were gonna rock all day. As we waited in line for the first ride it was hot and crowded, the temperature over a hundred. I was so stoned I began to feel light-headed. Next thing I knew I was emerging from a dream, I opened my eyes to see the circle of concerned faces above me. I heard voices, "He's coming to!" and "Someone called the medics, they'll be here in a second!" I realized I'd fainted and hit the ground. The medics took me to the first-aid center, putting an ice pack on my head. I told 'em I was fine, it was just hot and I'd been running around like crazy. Poor Blondie's dad, his terror-stricken visage, frightened that I would rat him out, the middle-aged man giving drugs to young children. I saw comedy in his fright, but of course I did nothing of the sort. I liked Blondie's dad and I knew the score.......Onward to the flying upside-down Colossus ride of doom!

Interlude

The great jazz pianist Freddie Redd came to live with my family. He was the real deal. Poor Freddie was going through some changes with his girlfriend, a Japanese jazz club owner, who'd kicked him out before taking a pair of scissors to his clothes, cutting them all up into little pieces and throwing them in the street. I loved Freddie. When I got up in the morning to go to school, he'd be sitting at the piano, having been up all night, a joint hanging out of his mouth, playing some beautifully mysterious chords. It was inspiring to see the peace in his soulful, brown and bloodshot eyes when he laid into the ivories. Wasn't till later in life that I realized his legendary stature as a pioneer of hard bop, playing with Charles Mingus, Jackie McLean, and Oscar Pettiford, and making the timeless album, play, and film, *The Connection*. His stay, while only a few months long, was a beautiful interlude in my childhood.

*

My grades at Bancroft were up and down, mostly down. I didn't concentrate well; I would get behind, then just give

up. I didn't mind when I was blowing it, I would just clown around and go get stoned, play basketball or trumpet. But come report card day, my Ds and Fs would make me feel bad and I got down on myself. So, in the second half of the last year at Bancroft, I decided to play their game.

I aced everything they put in front of me and got straight A⁺s that semester. I told my parents, "See?" I conducted the orchestra at the school concerts, wore a blue polyester suit with big gold buttons down the front, and took grandiose trumpet solos. At graduation, I was bequeathed the Herbert Solomon Award, a plaque bequeathed to the most improved student. I also won the award for best musician, which went on an immortal plaque. Wasn't that immortal 'cause years later I went back to see it and no one had even heard of it. But no matter, academically I ended on a high note. Probably like a high E flat at least. Like Cat Anderson.

During this final semester, my "good student" period, I hung with a new group. A crew of nice kids, Tony Shur, Boaz Storch, Paul Hicks, the two Soybean brothers, and a few other wholesome youngsters from good families. I was the bad kid gone straight, and they were just nice, good kids. No drugs, well err umm except Boaz and I smoked a little herb. No stealing, and lots of sports all the days long: hoops, baseball, football, roller hockey. These kids had a higher moral standard than I was accustomed to. The Soybean brothers were funny nerdy dirty kids. Prototype nerds, Coke bottle horn-rim glasses straight out of the geek wardrobe, pale skin, greasy hair, the whole bit. Sartorially they were astonishing, always donning the same getups, one wore red and the other green. We called them "Soybean Red and Soybean Green." I once found Soybean Red in his living room, wearing a red velveteen

robe, down on his knees scrubbing the carpet with a soapy toothbrush. I tried to get them high one day, but they blew on the joint instead of sucking in.

A lot of the crowd that I'd hung out with before were known tough kids. Street fighters. I played this up to Boaz, Tony, and the new crew. I would lord it over them whenever I had the opportunity. If things got testy I would puff up my chest and put my nose in their face, pretend I was ready to unleash a violent hell upon them. I let them know I'd kicked a million asses in crazy gang fights. It was especially silly, considering what a skinny little runt I was who had never actually even been in a real fight. I did this for a good solid six months, until one routine afternoon Boaz and I were playing this Nerf basketball game in my bedroom and got in an argument. I jumped in his face ready to scare him down, but he held his ground and was ready to fight, told me "Bring it." He'd seen through my act. I backed down and things were never the same again. He found me out and I was thoroughly deflated. Like pack dogs establishing a hierarchy, we are animals, we are base.

Boaz's family was Jewish. His father drove a Mercedes. He had been in a Nazi concentration camp and had the numbers tattooed on his arm. Such a heavy thing that was hard to fathom. At that time we were just thirty years removed from the horrors of the Holocaust. When I met people from Germany, I imagined that they had all heard the screams. Too much.

My Little Homies

I read and reread J. R. R. Tolkien's *The Hobbit*. In the sanctity of my quiet time I disappeared into its world of teas, cakes, and breaking through to the other side of self-imposed limits that constricted adventurous spirit. While reading, all my confusion and hurt dissolved, and when I reentered reality, I was a little bit better of a person, a little bit more capable of learning from my missteps.

The Loudest Silence

The world moves on a woman's hips.
The world moves and it swivels and bops.
— The Talking Heads

I was a wide-eyed little motherfucker showing up at Fairfax High School in 1976, our great country in the midst of celebrating its bicentennial. I was the single smallest, littlest, teeniest kid out of all the 2,500 of 'em. Girls were grown and I was amazed. They were developed, with hips, lips, and tits, and it was all packaged up in the inimitable style of the era. They commonly sported skintight bell-bottom jeans, the waist and crotch so snug that you could easily make out the shape of their pussies, a phenomenon known as camel toe. It was of cartoonish proportion, and I have never witnessed the likes of it since. *Here is my pussy, do you see it? That big crack in the middle? That's it!* Holy fuck.

When we had sex ed and they showed the medical chart of the uterus, the one that looks like a cow skull, or more specifically the Texas Longhorns logo, I thought, *I just saw that*

whole thing walking down the hallway before class in a tight denim suit! I'd never seen or touched a pussy, but my little mind boggled at the thought. Shirts were loose-fitting sheer silky things, worn with no bra, and nipples on display. It sent my imagination reeling.

I flashed back to my earliest contemplation of a pussy at the age of eight in Larchmont, New York. Walking down the street with an older cooler kid, he was speaking about his sleep-away summer camp.

> **Older Cooler Kid:** *(With an air of ennui) Ahh summer camp, there's nothing to do there but screw.*
> **Me:** *What? What do you mean screw?*
> **OCK:** *You don't know? Oh Jesus. Fuck. Make babies.*
> **Me:** *(With an air of expertise and knowledge) Oh yeah, yeah, of course.*
> **OCK:** *You put your penis in the girl's vagina hole.*
> **Me:** *Right.*
> **OCK:** *But you have to make sure you get the right hole. There's the pee hole, the butthole, the period hole that blood comes out of, and the hole where you put your penis. Ya don't wanna get it all wrong.*

I walked on in a state of utter confusion, certain that if I ever screwed I'd have no idea what to do with all the complicated holes and whatnot. I worried that if I ever slept next to a woman, I'd pee the bed.

My tenth grade was pre-AIDS seventies L.A. culture, the end product of, and the exploitative reveling in, the hippie sixties sexual revolution. Disco, the mighty Led Zep, P-Funk, Frankie Smith's "Double Dutch Bus" — it was on. There were older girls, twelfth graders that I tried not to stare at, but I was

hypnotized. They were of mythological proportions. I was swept away by the waves of their womanly figures.

I became friends with a group of gorgeous twelfth-grade black girls for a little while. I was an inoffensive and cute little white boy, and they were big sisterly to me, joking around and giving me hugs. I would have done anything to be taken seriously as a romantic option, but I was happy to be liked, even as a mascot.

I felt completely out of the league of any hot girl. As the first couple of years at Fairfax got under way and it became more expected to start dating, I had nary a speck of confidence. I became more and more embarrassed of my zero count of romantic experience. My mute shyness around girls was the loudest silence on earth. I thought everybody could hear it.

About Kilgore Trout

I fell deeply in love with the books of Kurt Vonnegut Jr. They parented me, and gave me a sense of what it was to be a decent person, without any of the usual hypocritical rhetoric. They fired my imagination and opened me up; I read them all one after the other, *Breakfast of Champions*, *Cat's Cradle*, *The Sirens of Titan*, *Slaughterhouse-Five*, on and on they go, they gave me the soul nutrients I needed. He was bitterly funny and awakened in me a morality that lay dormant and unarticulated. He taught me that it was fun and beautiful to be humble, and that human beings are no more important than rutabagas. That we've got to love with all we are, not for some reward down the line, but purely for the sake of being a loving person, and that creativity was the highest part of ourselves to engage. He pointed out the frivolous and insensitive attitudes that birthed the absurd cruelty of war. His humorous detachment from the world's insane and egotistical violence — "So it goes" — my first hint of a spiritual concept. To this day, his books inform my political and social views, my sense of humor, and touch me deeply. KVJ changed my life, he never gets old.

The Park

I've walked every fucking block in Hollywood and know its streets inside out. I was always going somewhere, to school, a movie, a friend's house, a record store, and I never had a ride. I came eye to eye with every kind of street freak you could imagine, and my mind did a lot of unwinding, a lot of healthy thinking, whilst being hypnotized by the cracks in those sidewalks. I often walked across town to hoop at West Hollywood Park on San Vicente. That was always a great run, and I played with a zillion dudes also looking to let go and get lost in the flow of the game. Some hoopers of note at that park were Denzel Washington, Lawrence Hilton-Jacobs, and Duke, aka Lequient Jobe, the great bassist of Rose Royce. I also hung with the Chicanos at the picnic table area, smoking weed, listening to oldies, and quietly harboring crushes on the black eye makeup cholas.

Michael-E-O Andretti

In a rare attempt at bonding, Walter took me out for a driving lesson. I'd never driven before. My friend Javier was with us, chuckling at me from the backseat as I strapped into the driver's side. Walter instructed me through every move, explaining all the pedals and gauges. I grinded and jerked our way back out of the driveway, fumbling awkwardly with the stick shift, clutch, and gas pedal, slowly figuring it out. Walter exercised remarkable patience, and I achieved second gear as I drove up the street cautiously, approaching the first stop sign and coming to a stiff halt. We made a right turn and my confidence grew as I cruised down the center of the road. An oncoming truck appeared and Walter instructed me to slow down. "Step lightly on the brake," he advised in a mature and teacherly voice. My foot-to-brain connection faltered and I stepped on the gas and accelerated a little. "The brake," he said a little more urgently. My brain felt a little freeze as I stepped on the gas harder and felt the car surge out of control. "STEP ON THE BRAKE STOP THE CAR!" he yelled. I panicked and floored it, steering wildly away from the oncoming truck, plowing into a row of parked cars, and finally

coming to a stop by ramming headfirst into a concrete wall. The front of the car was smashed in and a hissing steam rushed up from under the accordioned-up hood. The three of us sat in stunned silence. Walter's leg shot out angrily, kicking in the already shattered windscreen. Javier said quietly, "Uh, I gotta go," and disappeared down the street. That shit was crazy. At least I made it a good solid block.

Animal Nature

*F*rozen tundra and bitter cold feels so good......the
two bull moose face each other, eyes ablaze, the rest of
the world disappearing........every atom vibrating, they
charge crashing heads entangling antlers crackling rhythms
crackalabackalabop they pull back and bash again, for love
they engage, for respect they untangle and charge again baaam
slam wham damn that shit is hard charging, it hurts but they
are so intensely alive and their legend rises with every collision,
thrown back up on to their back legs by the force of their violent
dance, they fly back down, becoming who they are, one with all
the energy of the universe...........the sound of it is thrilling,
the spectacle unparalleled...........only the wild animals
know their own story, but it is not knowledge that drives them,
they are beyond thought, they can only feel the purpose from
the power of nature driving them to crash again and again into
their beloved brother, their family in these desolate northern
wilds, they have to do what they do, they have no choice, for all
of history has brought them together in the now. There are no
questions. It is what nature has done.

And so it is with me and Anthony Kiedis.

On this ride together, the energy that keeps us here is bigger than we understand. No matter the discomfort, there's no use fighting it. This is our magic carpet ride and burden to bear. Yin and yang, light and dark, beginning and end. In perfection. I've had to learn faith, honesty, and forthrightness to survive it, for until the universe decides to change it up, this is our lives. It's not a matter of career, money, love, or even history. There are no questions or explanations. It is what nature has done.

*

Though Boaz had found me out as the wimp I was, I still had the edge on Tony Shur, and one day, during the first week of Fairfax, I had Tony in a headlock, delivering him a "noogie" (an act of grinding your knuckles into the top of your victim's head until they beg for mercy). A crazy-looking kid ran up, he was sturdy and muscular, with a flattop haircut. NOBODY, except an old man with his belt up above his belly button, had a fucking flattop in 1976 Los Angeles. His intense eyes bore into me. He said, "Lay off him." He was a new kid that Tony had befriended: Anthony Kiedis.

Anthony was strange. I released Tony from my grip, and with an awkward red-faced post-noogie smile he introduced us. I liked Anthony right away. I could tell he was a misfit like me.

The universe gives us the ones we need. And the ones we deserve.

Later that day I showed up for my driver's ed class, and lo and behold, who's sitting next to me but AK. The teacher, a red-nosed rummy with a greased back comb-over, a skin condition, and a sippin' flask in his desk, stared us down, and in a whiny voice began to expound about the evils of graffiti. "If

I ever catch one of you kids writing on their desk you will instantly fail the class and be suspended, is that clear?" His pet peeve about desk graffiti was to be taken seriously, as getting a driver's license was the pursuit of a holy grail. Fifteen minutes into the class, Anthony asked to be excused to go to the bathroom. As I watched him exit the room I deftly leaned over to his desk and wrote on it "ANTHONY KIEDIS WAS HERE." He returned, saw my artwork, complimented me on spelling his name correctly, and came for my desk with his pencil. It was on.

The next day, it was raining outside, so for physical education class we all sat in the gym bleachers. Anthony and I sat next to each other and began a conversation that continues forty-odd years later.

Writing this book has been a flow. I love stories, I love books, and I've always wanted to write one. I had always imagined myself writing a soulful fable of fornicating fauna and I never thought I would write a memoir, but a publisher asked me to. Fable later. Sometimes I worry about it sucking, but I don't feel too precious about it, I just write, come what may. However, as I start to write about my relationship with Anthony, I've had to pause and walk away from my desk. The pen weighs about twenty pounds and my brain thuds to a sluggish halt. Our friendship is complicated and many layered. I must write honestly about how it has affected my life or else why write at all? I'm scared to poison things between us, or scare the magic out of it by trying to understand it, but so be it. Here I go.

As we rapped the day away, we were looking down from the bleachers to the gymnasium floor below, at the gymnastics

kids. There was one gorgeous girl in a leotard doing some stretches. We were taken with her, going on in detail about how hot she was. To me, she was untouchable, unapproachable. I knew a girl like that would never talk to me nor would I have the nerve to try. She hung out with the cool kids, the ones with perfect baby-blue Izod alligator shirts, feathered hair, and tanned muscles, those who partied at their houses in the Hollywood Hills.

Anthony gave me a look, then just marched down to the gymnasium floor, got down on one knee in front of her like some crazy-ass Casanova and started talking. I looked on in amazement. The thing is, she probably thought he was crazy, he didn't dress right, and he hung out with weirdo geeks like me and Tony Shur, but Anthony didn't give a shit. He made his move.

It'd be easy to say that he is an alpha and I'm not, but it's much more nuanced than that. Anthony lived with the same fear and separateness that kept me totally disengaged from the social process. But he was able to turn it inside out. It drove him to do shit I would never dare. Nothing was gonna keep him from going for what he thought he deserved. His disdain for the popular kids only motivated his actions. He went hard and challenged the external world. I went hard the other way, slipping deeper into an interior world. Two sides of the same coin.

I came home from school that day and said, "Mom, for the first time in my life I've found someone I can talk to." Anthony told his mom, "I've found someone who will try anything, I've never had a friend like this before." My relationship with Anthony is something, well.......I think if I really understood it, the cosmic energy might leak out,

but there's really no danger of that because it remains incomprehensible. The pendulum swings all over the fucking place.

When I met him, my whole life changed, by virtue of a chemical reaction, of our intensely bonding and oft-dueling natures. I'd found the perfect partner in crime, a guy like me, who just didn't give a fuck about any sort of convention. Anthony was a handsome devil. I, a quirky and ghostly Gabriel, a sprite, a Puck, a Pan.

We'd been friends for a short while when we planned a ski trip to Mammoth Mountain. I'd never skied before. Anthony said it was fun as hell, he'd done it with some rich friends. So we plotted this adventure, managing to scrape together the cash, ignoring the fact that we had no lodgings there, and planning on sleeping in a laundry room.

When we got on the Greyhound bus to the mountain, I got some insight into my new friend. We took turns going into the bus toilet to smoke a joint. He went in and smoked half of it to his head, then I went and did the same. I glided back to our seats stoned out of my mind, tripping out pretty hard. I looked into Anthony's bloodshot eyes, him in his flannel shirt and jeans, realizing he had a lot of Midwestern hick in him that I hadn't noticed before. He'd seemed like this totally underground Hollywood tripper dude to me before that, like he'd gotten high and let this other part of him come out. We sat there talking about stuff, and with the most earnest truth from his core he said, "Ya know when you read about an airplane crash, and everyone gets burnt to smithereens, but there's one survivor? I'm the one that survives. It's a simple truth. I know it." That's Anthony. It's true too.

The skiing, incidentally, changed my life. I've loved the

transcendent sensation of floating, sliding, and recklessly speeding amongst our mountain's majesties ever since.

I was always looking for love, looking for family, someone to help guide me through the maze of being a young man, someone to be a father, brother, coach. Unbeknownst to me, I was desperate for it. Friends weren't just friends for me. For kids from stable, loving homes, a true friend is a beautiful thing and part of an extended family. But for someone like me — and it's no coincidence that all the kids I became close to also hailed from broken homes — a friend introduced the possibility of true family. The Dead End Kids, the Bowery Boys, the Little Rascals, these were the families I envisioned for myself. The way I bonded with my friends had always been intense, but with Anthony it was next-level shit — the spirit of adventure, the street hustle, the getting high, the art, the philosophy, the burning desire to make something happen.

Nothing I did freaked him out, and I'd freaked out every friend I ever had. I was an expert at it, always taking things too far. Neither of us had any money, but damn we could hustle! From the get-go, we plotted, planned, schemed, and dreamed. We were gonna get over no matter what. Trips and heists. Abbott and Costello, the Two Free Stooges, the Sisters Brothers.

You know I liked to smoke weed, but when I started to hang with Anthony, it was a different vibe. We had to get it every day, it was a mission to make it happen the second we walked off campus. The inner engine that drove him to get high was relentless, it was ungoverned, all fuel, full throttle all the time. It was rare that I didn't go along with him, because I loved getting high, but I was different in that way. I considered other options, like go shoot hoops, practice trumpet, or

read, but with him it was always get high first, then figure it out. I didn't have that hard-core addict gene.

That rainy day in the gym I found a brother, the convex to my concave. We did every drug, chased every girl (I was more likely to meekly stay on the sidelines and daydream about her), stole and scammed at every opportunity, took any risk that might provide a rush of some sort, and plotted every plan that might have an exotic payoff.

Yet none of that is the most intense part.

When I say I loved Anthony, I don't mean this beautifully pleasant, supportive togetherness, laughing and being there for each other, helping each other through all the hardships of life like in the movies. I mean love the way two dysfunctional street kids running amok in Hollywood loved. Inseparable, down to party, ultimately having each other's backs, but hurtful to each other. Betrayal, fear, passive-aggressive emotional blackmail. I have never felt more hurt by anybody than Anthony, and we have spent huge swaths of our friendship in states of distrust and anger. Is that what having a brother is like? It's what I know.

Never in my life have I seen fate play such a strong and clear hand. Not the band-career thing necessarily, but the universal powers deciding we would be brothers/partners. We have no choice. Maybe it is past life influences, maybe an interlocking neurosis of some Jungian, Freudian, or Marx Brotherian variety, maybe each of us looking for the promise of a fulfillment that exists in the other. I just knew in my heart that we would always be close, and that neither of us belonged in that society circle that I saw from afar, pretend as we might.

As different as we were and are, and we are polar opposites, we were destined to go rock this life together. Our friendship

has been contentious, but the love between us and our true nature always rises to the top. There is no denying it, two negatives make a positive, north and south magnets create energy. We were a couple of freaks, always have been, always will be. The crazy thing about freaks, and like Jimi said, I always wave my freak flag high HIGH **HIGH,** is that no matter how much freaks love and respect each other, they are just always too damn freaky to really unite.

Being a freak is a solitary thing, too often exploding in all directions to be closely like-minded with others, or embrace any set of rules. I can't tell you how many times Anthony's friendship has given me heart, helped me to believe in myself, and how many times what seemed to me to be his quest for power, to get his, has repelled and hurt me. The blatantly intense duality of our relationship, us pushing each other along by a wild energy that we have no control over, must be a new psychological theory that I've never heard. We are a fucking study in contradictions. The combination of sincerity, hypocrisy, and true devotion to beauty that I see in him — and he sees in me — is wild. I've been a complete asshole to him a million times, and I love him as much as anyone on this earth.

As our friendship blossomed, I drifted away from the world of my other friends. Anthony and I just got up to too much weird shit for other kids. Tony Shur was an absolute sweetheart and we spent a lot of time together until his parents forbade him to hang around me anymore when Anthony and I teamed up, because we were a bad influence.

Tripping our brains out on acid at my house one evening when my parents were out of town, we decided to go throw eggs at a kid from school we didn't like. He was just a normal

dorky kid, but we felt like he thought we were weird, and that he looked down his nose at us. The kid lived about five blocks from me. We decided to get stark naked and paint designs on our bodies with my mom's lipstick. We set out into the Hollywood night wearing only the bright red lipstick, our hands clutching eggs. We ran down the street, covering the blocks, laughing our heads off, and approached our target's home. We rang the doorbell, standing there naked, ready to throw the eggs at whoever answered the door THIS'LL FIX 'EM FOR THINKING WE'RE WEIRD! No one answered, so we ran back to my house, people shouting things at us in the street, we might have thrown the eggs at some random passersby, I can't remember. It's a wild feeling when you get a few blocks away from home, in the city, naked. We just didn't give a fuck.

We just couldn't sit still without making some attempt to fuck with the sane world. Whoever, whatever was around. We wanted to stir the pot, to try something unexpected to see what would happen. We were nonstop about it, day in, day out. Wherever we were, we were gonna try to freak out the scene.

If a day came at school when Anthony wasn't there, I'd walk around aimlessly at lunchtime pretending like I had somewhere to go.

AK and his dad shared a West Hollywood apartment. First time over there I was taken aback. It had an underground arty kind of minimalism that I'd never seen before, avant-garde posters and mementos from his dad's acting career on the walls, everything perfectly in its place, things meticulously and artistically in order. I had never been in a house so militantly clean. I had no idea how to act, I felt like anything I did would be uncool or break some kind of unspoken code. I was stiff and silent.

His dad Blackie was lean and muscular, handsome in a villainous kind of way, jet-black hair combed back hard against his head. He looked at me, sizing me up, and gave me a perfunctory hello, then picked up some dumbbells and started pumping iron in the living room.

I was happy to take refuge in Anthony's room. Blackie had made some art on the wall in there. At head height were foot-tall angular black letters cut from duct tape that spelled the word "SKILL." It was stuck in the corner of the room with the "S" on one wall and the "KILL" continuing on the next ninety-degree wall, so that from the most commonly viewed angle you just saw the word "KILL."

Anthony and Blackie used to frequent the Rainbow Bar and Grill nightclub in Hollywood. An infamous hangout for rock stars like Zeppelin, the Who, and others of mythological stature, it was a notorious epicenter of the Sunset Strip. One night Anthony invited me to go with them. He told me about meeting girls and getting laid. This was a place where that could happen. I was fifteen years old, five foot five, weighed about ninety pounds, and was painfully shy, but I was down for the cause.

He and his dad wore some sharp outfits, they would even sometimes match, and he told me to dress slick. I wore my best clothes, the department store suit my mother got me for the Bancroft graduation ceremony, a square navy-blue polyester three piece with big fake gold buttons down the front. Since I was a short kid, it was made for twelve-year-olds. I spent extra time brushing my hair.

To greeze the skids, Anthony and I chugged a six-pack of Michelob in his bedroom before heading over, and I was spacey and stumbly when we arrived. I quickly found myself

alone and wandering around, looking at the hot girls on the dance floor, doing my best to look grown-up and cool while feeling like an idiot fish out of water.

I was dizzily drunk and awkwardly stuck in a crowded spot in the club, a little kid lost in a sea of adults, when I began to feel alcohol nausea. Oh shit, I was about to throw up, so I walked quickly to the bathroom, but the door was locked and people were lined up waiting to get in, glittering coke spoons around their necks. The prospective puking became more inevitable and I ran for the front door. I couldn't find my way, I felt trapped, I started puking, and in a drunken desperation I haphazardly ran figure eights through the crowd, projectile vomiting as I tried to escape to the great outdoors. The sick wouldn't stop coming, I puked my guts out everywhere as I ran, onto the hip clothes and into the drinks of several shocked and disgusted rock and rollers as I ran by in my frantic delirium. I finally found the front door and exploded into the parking lot, freaked out, vomit all up and down the front of my polyester suit and dribbling down my chin. Still expelling from the depths of my system, I fell to my hands and knees behind what was probably Keith Moon's Jaguar, and puked some more. Shaky and hollow, I ran across the street and sat in an alley by myself for a half hour to gather my thoughts, and watched the crowd stream out of the Roxy nightclub. I was embarrassed, freaked out, and scared to show my face back at the Rainbow. Using my jacket and vest, I did my best to wipe away the rest of the liquid stench from my pants, shirt, and face, then threw them into a dumpster. Goodbye graduation suit. I returned to the parking lot to find Anthony working his suave magic on a three-nippled girl he liked, and angry with me for ruining his reputation at the Rainbow, from which

he might have been eighty-sixed due to my immature antics. Can't take me anywhere.

Becoming a part of a grown-up Hollywood nightlife became de rigueur. Getting ready to go see a band one night, I had on my favorite corduroy outfit that my mom bought me at the department store. I said, "I look cool, right?" to which Anthony replied, "You know, Mike, you look cool, but the thing is, anyone can dress like that. You're a unique person, you should express your own self in the way you dress, not be like anyone else." That really hit home, not just in the way I dressed, but in all forms of expression. I'm grateful to Anthony for encouraging me to embrace my own freakiness.

*

I'm so fucking grateful for his existence, for being my brother, my true family. Now's not the place in my story for this but shit, damnit, fuckit, when he started writing lyrics over my bass lines his artistry gave me new life. My heart grew a couple of sizes. The color of his words, the sharp sound of the syllables cracking together. Both his lyrics and my bass lines pulsed together, same as the heartbeat of our friendship. It was the conversation we'd started in the Fairfax gymnasium translated into music. When his words met my grooves they flowed together unconsciously, like they'd always been together, like baby wolf twins bursting out of the dark den of their infancy, joyfully embracing the infinite light of the outside world for the first time. When he wrote "Green Heaven," a long and dynamic rap narrative over our hard funk, I was on the phone for hours, trembling with emotion, calling everyone I knew and excitedly reciting the entire song.

Trippin'

I nventing adventures. We couldn't stop doing it. We weren't going to let our measly quantities of dollars stop us from enjoying the world's wonders.

First was the aforementioned skiing trip to Mammoth Mountain.

We slept curled up on top of a washer and dryer in the dank and mildewed smelly laundry room attached to the underground parking lot of a condo. Despite our shoddy sleeping arrangements though, nothing could dampen our enthusiasm bubbling up, brought on by that mighty snowy mountain in whose shadow we dreamed.

We went into the ski lodge to rent me some skis. I was armed with my mother's credit card, which, after much cajoling and begging, she had kindly parted with, for ski rental only. But when I tried to pay, the man told me unequivocally that I needed my mother's ID or no deal. I told him to hold on and I'd get her. I told Anthony of my predicament. He went to a woman and asked if he could borrow her large pink ski coat, mauve ski hat, and absurdly large turquoise sunglasses. The eccentric woman acquiesced, and Anthony disappeared into

the bulbous pink and puffy snow jacket into which he stuffed several pairs of socks to approximate breasts, put on the sunglasses and hat, then returned to the ski rental cashier with me. Appropriating a ridiculous high-pitched British accent, he said, "Hello sir, is there a problem with renting my son these skis?" "No problem, miss, we just need to see your ID." With a feminine flourish he reached into the bright pink coat pocket searchingly. "Oh my goodness! It seems I have left it in my other parka! My goodness....[exasperated sigh]......oh young man, is there any way I can avoid having to brave that DREADFUL traffic and cold weather traveling back to the condominium to retrieve it?" "Well, okay, miss, just this once, but if you can bring it by tomorrow it would be much appreciated."

Remarkable. I've been witness to some great actors doing their thing in my life, but never have I witnessed a performance of that magnitude. A stoned fifteen-year-old boy, pulling off my British mother, and coercing the staunchly businesslike rental people to give me skis. It made me feel like anything was possible. We went on and skied the days away, laughing our heads off, no ski clothes, just jeans and sweatshirts, Anthony knowing how to ski and taking me up these steep mountains, and me having no idea how to do it, falling all the way down, slowly putting it together.

Sometimes we laughed so hard we just couldn't stop. We fell into fits that transformed into out of control episodes. Beyond funny, it might happen anywhere. We'd start chuckling about something, looking into each other's souls, and a wild purging of all the tension in the world surged through us, absolute hysteria to the point that I was in abject pain on the floor of a restaurant, unable to breathe, turning beet red due to the uncontrollable laugh spasms, rolling on the floor, seeing

Anthony in the same state, with people walking by looking on in alarm and quickening their step. We were possessed, taken over by these insane fits of laughing, like we were exorcising the demons within. We were, we really were.

On the way home from the trip I tried to steal my rental skis, but I got clocked in the bus depot and someone called the cops. We were both apprehended, but talked our way out of it, gave up the skis, and got on the bus home. However, a month or so later we both received summonses to appear in court for robbery. We had to appear in court up in Bridgeport, California. Our parents had to make the six-hour drive up there and were none too pleased.

Interestingly, in a rare display of fatherliness, Walter decided to use the trip as a bonding experience. He and Mom concluded that I needed some good parenting. I can just imagine their conversation. "Jesus, is the little guy becoming a hoodlum? We better do something." Instead of being angry, Walter was attentive and engaging on the trip up there, telling me how to drive above the speed limit without getting busted, making plenty of bad jokes, and we stopped to have strawberry shakes at Bobo's Burger Bonanza in Bishop. The court hearing, for which I put on the starched white shirt and tie of contrition, went quickly. I got a slap on the wrist. Then in an unprecedented display of overt parenting, Walter whipped out some fishing poles from the trunk and started talking about a rainbow trout breakfast. Neither of us had any idea what we were doing, we stopped on the highway and wandered through a random field to find a creek where we got our fishing line all tangled up in the bushes for an hour or so. I took off my clothes and jumped in the freezing water, laughing and splashing Walter. I appreciated his effort.

Come summer, AK and I hit Yosemite. We had little back-packing equipment, just a couple of canteens, some brown paper grocery bags of food, and a couple of sleeping bags. No actual backpacks, boots, or anything. We got hold of a map and headed out into the backcountry. First day we hiked to the top of Yosemite Falls, a good few miles straight up some switch-backs, our arms wrapped around the grocery bags. When we got to the top, some nice hippies saw us with our ridiculous grocery bags and took pity, sharing their watermelon with us. That watermelon on a super-hot day, looking out over the expanse of the viscerally thrilling Sierra Nevada mountain range from the top of those waterfalls, was the single greatest food I have ever eaten in my life.

Anthony and I slept out in the backcountry for five mind-blowing days, making campfires, hiking the trails for long miles, marveling at the infinite star nights, smoking our weed, feeling alive. We wrote our first-ever song, a kind of a limerick, full of nonsensical made-up words, called "Himi Limi."

Our map skills were amateurish, one day after a long hard mountain hike we ended up stuck with a crummy camping spot on the side of a hill. I took our canteens down to the river to fill with water. I took off the tops of our canteens, set them on a rock, then crouched down to dip the jugs into the pristine flowing river water, excited for a long cool drink. An unexpected current came, I slipped, and the top of Anthony's canteen fell into the river, washing away, lost for all time. I returned to our lame campsite with the water, feeling badly about the top, and explained to Anthony how I lost it, and that he could have my canteen. He was furious, telling me he knew I would fuck it up, that's just the kind of person I was, an idiot who couldn't get things done right. His words

crushed me. He then froze me out, stopped talking to me until the next day. Him ghosting me out with silence like that, while I lay there in my sleeping bag staring up at the stars, was a power play punishment that made me feel like shit. I counted on his love. It was a painful pattern, a dynamic that repeated between us in many contexts for years to come. I was needy for stable support, and he was needy for the stability of control. Symptomatic of my fragility, my yearning for familial comfort. Light does not exist without darkness. The shadow side of our friendship.

Whether it was rolling a huge tractor tire down the steep hill of Palm Street and causing havoc when it careened into the heavy traffic on Santa Monica Boulevard, or walking backward into movie theaters to outwit the ticket takers, or skipping the bill at Canter's Delicatessen with waiters and busboys in hot pursuit, we egged each other on, each scam and absurdity creating a stronger bond between us. Ours was an intimacy born of the hustle. We were closest when we had nothing.

We spent so much time together, retreating into our own world from which others were excluded. It was a sanctuary.

Things got deeper.

Hear No Evil

At Fairfax High, I went back and forth between being an interested and productive student, to a distracted and shiftless one. I was unable to concentrate for more than a couple of minutes before drifting off. I was a terrible listener, even when I wanted to be a good little learner. I'd start class by paying attention and understanding the algebraic equation, but then fall into a daydream, and twenty minutes later, realize the class had gone on to an entirely new mathematical concept. Once I got behind, I'd just give up, stop showing up, and fail the class. I was teeming with insecurity about my place in the world, my energy frenetic and uncentered.

I was in the NOW when reading, playing basketball, or playing music though. I loved English class, loved reading *The Painted Bird* by Jerzy Kosinski, *The Jungle* by Upton Sinclair, or any quality book they threw my way. Pure pleasure to be lost in a book. Book love put me in the moment, where all the satisfaction in life lay. I was full of confidence in band class too, sitting in the first trumpet chair, going for the beautiful tone, and it always feeling natural. Once again — breathing in

the moment. Same with basketball. Even though I was never great, I was present and connecting.

In another duality, without doubt my pot smoking contributed to my inability to concentrate well, but also expanded the richness of my daydreaming world and informed my desire to find a freedom, one apart from the rigid competition of a public school education.

If only the schools had the time and energy to tailor the classwork to each kid's particular intelligence. If they took the time to develop a way to teach math to the kids that excelled in music and reading, and a way to teach literature and art to the ones for whom math was a natural inclination. Man, only the rich private school kids get that kind of love.

I dug playing in the Fairfax marching band; we had our own low style. All the other school bands were outfitted with big furry hats, epaulets and shit; looking like the changing of the guard at the Queen's palace. They marched around in formation all militant and precise. We just had T-shirts that said FAIR-FAX BAND, and didn't really get around to any proper marching; we just kinda moseyed out onto the field in a crowd and commenced to rocking. But we had deep groove! With Jack Irons and Harold Rose laying down the beats, we played Herbie Hancock's "Chameleon" and Stevie's Wonder's "Sir Duke." We were into it. During the second quarter of the game, to grease the skids for the halftime show, fellow trumpeter Patrick English and I always snuck down underneath the bleachers to smoke a jay of primo Thai stick. Woohoo! Go Lions!!!

At the Fairfax-Dorsey game, some meddling asshole parent ratted us out and we got busted. Our band teacher, Mr. Brod-

sky, took us into his office for a stern talking-to. He asked us what the hell we were thinking? Doing drugs before stepping out on the field of honor to represent our school??? I was stoned and sheepish in my response, but Patrick stepped up with a confident smile, and suavely uttered the immortal phrase, *which was nearly the title for this book*, "It seemed like a good idea at the time."

Anthony and I continued our antics as the school year rolled around, always fucking with the program, always trying to get one up on the squares. We were in Westwood, an area of West Los Angeles near the UCLA campus. A place full of movie theaters and restaurants, the streets were bustling on weekend evenings. It was the popular hangout for high school students to stroll around, hope to maybe meet a romantic partner, see a movie, get stoned, and eat doughnuts. On this particular evening, we had managed to get a hold of some Quaaludes and we were feeling the effects as we approached the intersection of Wilshire and Westwood boulevards. One of us mentioned the trivial fact that this intersection was the busiest in the entire world. We pondered this bit of trivia as the river of cars flowed by in all four directions, and the bigger than life enormous billboard advertising *Close Encounters of the Third Kind* loomed above. Anthony mentioned that it would be wise if we scaled to the top of this billboard, stood in front of it, and whipped out our cocks and wagged them at the world. So we climbed up there and did it, engulfed by our own laughing hysteria once again. We'd have preferred to have been successfully romancing some Westwood girls, but this was pretty good. Fuck the world anyways.

333

November 21, 1978. Woke up at six thirty, just after sunrise, a clear sky morning, the smog washed away by recent rains, the air cool and crisp. Walked the mile to Fairfax High bouncing my basketball, right hand, left hand, nonstop all the way, the peace sign I drew on my ball popping up between potholes and sloping sidewalks. Met the early morning ballers at school, going hard in three on threes till the homeroom bell rang, sat in class deeply relaxed in my post-hoops sweat. For social studies class I delivered an oral report on composer Hector Berlioz and his *Symphonie Fantastique*, I loved that jam, my voice rang true, I received an A⁺ and a warm nod of appreciation from my teacher. Was first in lunch line for pizza day; Anthony and I excitedly plotting a beach trip for the weekend. Rose Cha, a girl I had a crush on, spoke to me in the hallway, relaxed and easy, we laughed about the movie *Animal House* and planned to go across the street for a fried rice lunch in the coming week. Shot more hoops after school, MY SHOT WAS SO ON, then ran home, ahh the house all to myself, practiced trumpet out of my Arban book, the trumpeters' bible, the classical

melodies resonating through my cranium and echoing around my bedroom, then cooked myself a delicious spaghetti dinner. Lay on my bed satiated and content, reading Richard Bach's *Jonathan Livingston Seagull*, watched the Laker game happy and cozy, before falling into a deep and restorative sleep.

Trumpet in the Berry Field

Summer after tenth grade, Anthony invited me to visit him in the small town of Lowell, Michigan, where he went to stay with his mom's side of the family. He flew there, but my family couldn't afford the plane ticket, so I rode the Greyhound bus for 2,200 miles. My first solo journey.

The world of Greyhound was a shady one, a black hole in a universe all its own. The longer you ride, the deeper you get into this shifting culture occupied by a strange nomadic tribe. All of them coated in grime from an enveloping omnipresent Greyhound fog. It's an oily and dusty excretion that takes over the traveler and his meager belongings. No physical act can free you from the smelly and repugnant malaise. This sedentary purgatory has swallowed alive many a better man than me. Your only chance to avoid serious psychological damage is to create a fantastical paradise life in your own mind and exercise imaginative mental gymnastics on a par with the greatest thinkers on earth. I went days on end without sleep, squished in next to the most improbable of obese drunken traveling partners. I had sex often with my main companion Annika, the mysterious Russian lover in her

Penthouse magazine pictorial, we fucked like rabbits, every hour on the hour in the bus toilet, but even that could not free me, but for the minutes leading up to ejaculation. Woe was me, but I survived the four-day ride and approached Zen monk–like levels of focus.

One memorable stop was at five a.m. in Cheyenne, Wyoming, where I sat in a coffee shop with a crowd of rodeo cowboys who were beamed in from another time. A parallel universe to the one I lived in Hollywood. They languidly poured whiskey into their coffees, passing a bottle around the breakfast table, tanned forearm muscles rippling under checkered shirts, and muttering sparingly, their slow wise drawl. These dudes were hard. I vicariously roped wild steer and seduced sexy blond cowgirls while we silently ate our ham and eggs and pondered our future.

Then Omaha, Nebraska, where I had an hour or two to mosey about town in the early evening. I strolled about with my fifteen-year-old self, peering into shop windows, puzzling on the qualities of a small-town life, when I came upon a crowd of teenagers a little older than me. Long-haired and loose, they were all walking in one direction. I followed behind, wondering what the excitement was about, noticing more and more of them appearing, walking in bunches, all magnetically pulled somewhere. I soon realized they were all headed for a theater a few blocks up the street. As we got closer the crowd increased and came together, more long hair, bell-bottoms, pretty girls, random yelling and singing, I saw it was a rock concert at the theater. We were a few hundred yards away when, violently bursting through the crowd, knocking people out of the way, ran two young men; bandanas and long stringy hair, wild-eyed, unshaven and desperate, sprinting with abandon, the

nine-second hundred-yard dash. They were pursued by a pair of infuriated policemen hotfooting it with their nightsticks out, screaming "STOP! POLICE!" as they all disappeared around a corner. I was blown away, it was all so sudden and crazy, and the huge crowd of teenagers still happily absorbed themselves into the theater like ants in honey. In this little cowboy town? Rock music could make this kind of crazy shit happen? I wondered what was at the center of it.

<div align="center">*</div>

The day I arrived in Lowell, we still didn't admit to each other that we masturbated....

Anthony: Dude, the pages in this *Penthouse* are stuck together.

Me: I know, isn't that weird? Bo lent it to me; I hope he wasn't jacking off into it.

Anthony: Whatta weirdo!

Me: I know!

Michigan was a blast, his family was kind and welcoming, his mother, Peggy, taking care of me like I was one of her own. Picking berries and practicing trumpet in the field. Floating down inner-tube rivers. Listening to the Beatles' *Let It Be* album in Anthony's room. Smoking weed and hanging with the locals, laughing in the park, swimmin', grinnin', hangin', and sangin'.

Above the Evil

Walter supplemented the scant income he earned from music gigs by fixing cars in our backyard. He was always back there getting his grease monkey on, knee-deep in carburetors and alternators, half his time spent doing favors for friends who couldn't afford a pro mechanic. He and his buddy Michael Citron were hanging out back there one afternoon when Anthony and I moseyed over to see what was up.

Michael Citron was a saxophonist from New York who stayed with us during his L.A. trips. Fit as a fiddle, bearded and bell-bottomed, muscles rippling under a purple mesh tank top, he was a NYC hippie street tough, a strong dude. He loved basketball and was a huge Knicks fan; we'd talk hoops and play ball at the park. He always had time for me.

Whenever he was our houseguest, weekend parties happened. All-day-long jam sessions with Walter's crew, Michael C. always right in the middle of it, wailing away on his alto, his neck veins bulging from the pressure, while he dug deep into the tunes, tapping the source.

On this day, AK, Walter, Michael, and I were hanging out

back shooting the shit, talking about Michael's cross-country trip out to California. He'd driven in his Volkswagen van, which was parked out in front of the house. When I commented on the beauty of his van, Michael, much to Walter's consternation, offhandedly tossed me the keys, saying, "You dig the van? You guys take it for the day, go have a good time."

Whoa!

Our unpolished driving skills on display, Anthony and I wildly careened the cool old hippie van around Hollywood, giving each other bad driving advice, cranking the FM radio, singing songs to people on the sidewalk, and grinding the gears all herky-jerky with awkward clutch feet. We tilted the thing up onto two wheels at one point when squealing around a sharp corner. Whooooooo! We took turns piloting the bus till not a drop of gas was left, luckily getting it home without killing anyone. Michael was wild, just giving us the car like that.

I once overheard him talking to Mom and Walter about me in the other room. He told 'em they should get me some weights, that I'd feel better and gain confidence if I muscled up a little. The parentals thought it was a silly idea; they said I was fine. I don't know if I would have been happier or not buffed up, but I appreciated Michael looking out. He saw the vulnerable shy part of me, cared, and wanted me to feel empowered. He was kind like that.

A few years later the bottom dropped out and all the happiness got sucked outta me when Walter told me Michael got on the wrong side of some mobsters in New York. They tied him to a chair in his apartment, then slit his wrists and let him bleed to death.

I saw his spontaneous sparkly eyes smiling when he said "Face!" before stepping back and swishing a jump shot on me, and I hoped he was able to access his loving and generous spirit, to be above the evil, as his life drained away. Man, the legacy of his kindness stays with me. I love you, Michael Citron.

It's a Po Mole Ain't Got But One Hole

By my junior year, Walter's career as a wild drunken lunatic was nearing its end. Though I still viewed home life as a thing that could explode in my face any second, things were calming down. There were a few more horrific episodes, but he finally hit his bottom, and he'd found the Alcoholics Anonymous program and gotten seriously sober.

Strangely, even though things were safer at home, and what I had wished for years had come to pass, domestic life was oppressively bland. Walter had been scary and unpredictable before, but sometimes hilarious and inspired too, and he was always passionate about being an adventurous jazz musician. Now he just seemed bored and sad. I didn't see him finding joy in anything besides AA, and his relationship with my mother felt dead. Long after she'd gone to bed each night, he'd be sitting up on the living room couch staring blankly at the TV. I swore I'd never let that happen to me.

Truth is, by this time I was so disenchanted and disconnected from him and Mom that it didn't matter what the fuck they did. For a long time our home had just been a place to crash anyways, and I was permanently pissed. I had moved on

from them and judged them coldly. I found hypocrisy in all their moves.

Buoyed by all the self-righteousness of a newly sober person deeply into AA, Walter regularly preached its slogans. I was forced to attend his AA meetings; I woulda rather sat in a Russian gulag staring at the wall watching paint peel. Then they told me I had to get on board and start attending Alateen meetings, a support group for children of alcoholics. Even though I did actually get some meaningful lessons from Alateen, I never let them know it, and it was the last fucking thing I wanted. I sometimes got stoned before I went, and when I attended a three-day-long Alateen/Al-Anon retreat at Pepperdine University in rich white Malibu, I found some like-minded kids. We holed up in our hotel room the entire weekend getting drunk, smoking spliffs, and playing poker. I only came out of the room to do my failure of a karate chop at the talent show.

As I was just beginning to romance the idea of being a professional musician, it seemed like Walter was losing the hope and desire to delve deeper into the cosmic mystery of creative expression.

Violet Crumbles Fish and Chips Saltwater Lakes Meat Pies the Smell of Eucalyptus Heart Cockles a Tick on Your Testicles Burn it Off with a Lit Cigarette Shellshock Shellfish

Christmas 1979 I went to visit my dad in Australia. He'd left my life when I was seven, and I'd seen him only once since, for a couple of weeks when I was eleven. Now I was sixteen, and excited to show him all the things I'd become. My sister Karyn was living with him then, and I yearned to experience a soulful reconnection, and feel my Australian roots. Leaving the weirdness of Hollywood for a while afforded me a certain lightness of being.

I was so happy to see Karyn, who'd grown from a teenager to nearly an adult. She was into the Australian new wave/punk scene and took me to a party of older people with safety pin earrings, leopard-print shirts, skinny ties, and wraparound sunglasses. They played Ian Dury and the Blockheads, LOUD, "Hit me slow hit me quick, hit me with your rhythm stick!" I've loved Ian Dury and his absolutely fucking stellar band ever since.

The trip was going swimmingly, literally. We swam and fished in the life-giving waters of tide-fed saltwater lakes, took long walks through the thick bush of the southern coast of New South Wales, and warmed the cockles of our hearts by eating the Australian food of our childhood. I loved feeling the Dad connection, I looked up to him so much and craved the simplicity and sanity of life there. Karyn and I could let go of trying to be cool, and just enjoy our absurd childhood humor, talking shit and inventing funny chants.

'Twas a few nights before Christmas when we were at my dad's house in Canberra. He was in luxuriating evening mode, having showered, put on cologne, a nice white sweater, and was comfortably enjoying a glass of whiskey in a leather bean-bag chair that sat on a pristine white shag rug. Together with his loving wife Margarethe and both of his kids, it was everything a dad could want. I loved us all together too. We were sitting around talking amiably about old times, when Dad said something demeaning to Karyn, accusing her of being unkind to another kid, ten years ago back in New York. I don't know what the dynamic between Dad and Karyn had been before I arrived — I'd sensed some tension regarding her late teen wild-oat-sowing — but whatever it was, Dad's comment cut her to the quick. She yelled out, burst into tears, and stormed out of the room. I sat frozen. Dad became equally upset, marching out into the dark backyard to busy himself, grabbing a rake and working at the woodpile. He was inebriated, angry, and muttering to himself. Karyn was crying and hysterical. More things were said and more things were misunderstood, and it escalated even further, the fury heightening exponentially. Profane screaming and yelling flew between the two of them before Karyn grabbed some belongings and fled

out into the night. A melancholy pall came over the house, and I did not see her again for the rest of my trip. The air tasted and smelled the same as in my memories of Rye, New York, when Dad and Mom were at their end, when a similar heavy gray cloud had enveloped us. My stomach was in knots.

Dad and I went on a wee jaunt to the coast, just the two of us. Despite the post-drama melancholy, there was a loving soulfulness about it; Dad teaching me about the local plants, birds, and fish, walking the beaches, prying pippies (a type of little shellfish) from the low-tide barnacled rocks, then bringing them back to our rented cabin to boil up in spaghetti. I felt for my father; he really wanted to connect with his kids and was met with one problem after the next.

Back in Canberra, Dad, Margarethe, and I had a muted Christmas without Karyn. Family vibes sucked no matter where I went in the world. I just wanted to get back to the streets of Hollywood and run wild with my friends.

A Slovakian Influence

As eleventh grade careened its way along a path of acne and masturbation, Anthony and I remained inseparable. We were out in the Valley one day skulking about, riding the bumper cars in North Hollywood. Stoned as fuck, we approached cars at stoplights, attempting to convince them to give us a ride by talking to 'em with a personal touch. "Excuse me, ma'am, we are trying to make it over to West Hollywood, could you find it in your heart to give us a ride?" A little innocent charm went a long way, quelled the fear of the driver, and was a communicative and effective method of hitchhiking developed through oodles of practice. That's when we saw Hillel Slovak drive by in his green Datsun 510, cranking Rush's "La Villa Strangiato." We yelled to each other, "That's that dude Hillel, he's in my social studies class, he's cool! We know him!" We ran him down at the stoplight and he graciously gave us a ride.

It was a marriage divined in the cosmos, and it was not long before our twosome became a threesome.

Hillel.

Zillions of powerful memories flow through me, and I'm lost

in a thick forest of feelings when I write his name. I'm incapable of directing the ink in this pen to make the marks that describe the deep and complicated young man he was. Smart, handsome, soulful, romantic, creative, and funny as hell. A skinny Israeli boy with a slinky and obscure way of dressing, he knew how to lay back, way, way back in between the strange dances, the deep paintings, and the shiver-your-timbers sense of humor. What a beautiful boy he was, what an artist he will always be. The arc of his life went by in a flash. But it didn't seem too fast at the time, and we savored every minute of it.

Overwhelmed now, I cannot help but drift..............my dreams are haunted.

Looking longingly at the silhouette left behind
barren space that could have would have thrived
all colorful and vibrant and
an immaculate group of grays
alive with all the gorgeous art created by him...........we
only eyeballed a glimpse of an iceberg tip, the behemoth of a
psychedelic glacier hidden for all time
had those drugs not set off a fatal explosion in his full heart
acid, weed, heroin, freebase, meth, cocaine, MDA, mush-
roomz, some weird opiates that you stuck up your ass, and
whatever else we could get our hungry mitts on.
it was damn fun and free for a while.
until the heroin sucked everything dry.
Learning, trying still, to not brutally flagellate myself. 'Cause
as his unexpected death approached, I was unable to be there for

*him in a nurturing helpful way. I miserably watched him de-
scend into the false Eden of junkiedom and didn't think enough
about his pain, but instead about what was important to ME.*

*Self-righteously I judged. The pretense of the junkie lifestyle
being a romantic thing pissed me the fuck off. He thought he
was being an artistic and mysterious poet when he was strung
to the gills, and I thought he was being full of shit. Me, with no
pale, skinny, hypocritical leg to stand on.*

*I did it myself, a once-in-a-whiler, a weekend warrior, I
never got strung out.*

I understood only to push forward with the funk,
DUDE ARE YOU WITH ME OR NOT
*I saw his drug-self go weak, hollow, and dishonest. I felt
abandoned. I didn't understand why he and Anthony would
become addicted like that. I blindly saw a traitor to the cause,
my hurt feelings, my severed connection. I, Me, My.*

*If only I'd been strong, rid myself of all petty distractions
my bull-in-china-shop ego....... been naught besides a mighty
presence of love. Shed a brotherly light to show him he was
killing himself, so he could get back to being the Israeli Cow-
boy, the Messiah, the one and only Pick Handle Slim.*

Maybe, maybe,
*I coulda saved him. He coulda figured it out. We were all
of us bungling and banging foolishly through the danger zone,
time yet to teach any of us...............*

one less one of us

*Long as I live, I will know I failed. Please forgive me, Hillel,
I knew not, I was blinded by the only thing that gave me sight,
and polluted with arrogance and ambition. If only. If only I
knew what love was.*

As it stood, in the broad and baking L.A. daylight, while I shoveled dirt down onto the cold darkness of his coffin at the Mount Sinai cemetery, his grandfather sternly asked me in his thick Eastern European accent, "WHY DIDN'T YOU TELL US?"

*

Long before this tragedy smacked me about the head and heart, when we first bonded at Fairfax High, things were lovely and hope abounded daily.

Hillel and I had gone to Bancroft Junior High together. He was just on the periphery of my awareness then. I first really noticed him when he and Jack Irons showed up to school one day dressed as KISS. Hillel was Ace Frehley, and he blew me away because it didn't feel like a goofy Halloween costume. He transformed from a geeky kid·into a bigger-than-life rock star. I was impressed, and I didn't even like rock music.

With the type of arrogance that only a teenager can muster, I judged it. Rock music seemed silly, a dumbed-down form, for people who didn't really care about music, just a bunch of haircuts and advertising. I didn't feel KISS at all (except for the one time when Raoul and I listened to "Detroit Rock City" on angel dust). I understand they mean a lot to many people, and I'm happy they influenced so many of my respected colleagues, but I missed it. However, when he and Jack and a couple of other kids enthusiastically lip-synched some KISS songs for the school talent show, pursing lips and high-kicking, their commitment affected me. That talent show was also the time Hillel and Jack decided to start playing real instruments, a decision I gratefully applaud.

I was in love with Hillel. His Picasso face, long curly hair and slim physique, the red Messenger guitar slung over his shoulder, his rock star aspirations. Man, he was awesome. He was a great addition to Anthony and me, a little more poetic, flowing with pen, paintbrush, and guitar. Anthony was the tough handsome actor with the contrarian confidence, I was the shy insecure crazy one with the funky groove, and Hillel was the artist. Hillel made me feel like I was a part of something special, that we shared magic bonded by a secret understanding. I knew something exciting was in store. We all came from broken homes and lower-middle-class backgrounds.

While waiting in line at McDonald's, a large man ordering at the counter became argumentative and angry. He was a furious psycho, he snapped and lost it, his anger escalating insanely, spinning around to the rest of the patrons and yelling, "I'M GONNA HAVE TO HURT SOMEBODY!" Fear shot through the fast-food crowd. He stared at Hillel, who calmly deadpanned, "How about Mayor McCheese?" pointing at a standing cardboard cutout of said character. The maniac's hardened face softened and the situation defused.

We became "The Faces," a kind of inside joke of a gang. Hillel was not a thief like me and Anthony, nor was he willing to take the physical risks we took daily. But he sure liked getting high with us, listening to music, long deep talks, acting the theater of the absurd, and chasing girls.

Sugarhill

P E class one morning on the Fairfax asphalt. All of us lined up in rows, wearing our maroon and gold shorts and T-shirts. Jumping jacks and touching our toes; some kids jumped and touched, others insolently slouched and stared into the distance. The girl standing behind me started rhyming....

"I don't like to brag I don't like to boast but I like hot butter on my breakfast toast."

It was so funky and good, she kept going *on and on till the break of dawn* with her beat-driven narrative about a funny dinner, rocking her body to the rhythm. I peeked back at her but was too shy to ask her what it was, did she make it up or what? Man, it felt so nice. It was the first time I ever heard hip-hop. I never knew the girl, but I still see her glowing brown face, bright and clear. The first MC.

Sugarhill Gang was blazing a trail. Little did I know it would change the culture of music forever.

Anthym

Hillel, who hailed from Haifa, Israel, was in a rock band called Anthym: him on guitar, my sixth-grade classmate Jack Irons on drums, Todd Strassman on bass, and Alan Moschulski on guitar and vocals. Hillel was occasionally the lead vocalist too, but even though his soulful and arty guitar styling rocked righteously, he was a terrible singer. Almost as bad as me, and I'm awful.

I'd seen them do gigs at school and been to watch them at band practice once or twice. As our friendship deepened I started to soften up to rock music. I liked that they just played the stuff without any teachers around, and they didn't have to read music. They just did it on their own. Hanging out with them sweetened my sour grapes.

*

Here's your ticket
Hear the drummer get wicked
— Public Enemy

On a stony rainy Hollywood night, Hillel and I sat in his Datsun 510 out in front of his house, listening to KMET on the radio. A lightning bolt lit up the sky, a startling crack of thunder banged, and then with perfect timing, DJ Jim Ladd started playing the Doors' "Riders on the Storm." Hillel said, "Jim Ladd is so rad." I lay back in my seat, sharing his appreciation for the moment. Then Hillel, speaking of Anthym bassist Todd Strassman, said, "Mike, you know I don't get along with Todd so great. I just don't think he's that into it, he doesn't take the jams seriously. He's not willing to give his life over to the music." He went silent for a long moment while Jim Morrison crooned, "Into this house we're born / Into this world we're thrown......." Then Hillel said, "What do you think about learning to play bass and taking his place?"

Yes.

In that moment I felt completely loved, maybe more than any time ever before.

Excitedly, I ran out and got a hold of an inexpensive little Fender beginner bass and started banging away at it. There was one awkward moment at my first Anthym practice in Jack's bedroom when I was playing through Todd's amp and he showed up. Not knowing they had fired him, he stood disgruntled in the doorway and fixed me with a concerned look. I disappeared into the backyard for a few minutes and heard those guys muttering some tense words. Todd left. I don't know if he ever played bass again.

Sand Heart

The bass engaged my imagination so differently than the trumpet. Blowing the trumpet, I dreamed of playing with the jazz greats, being in a majestic symphony orchestra, growing into a respected man, cool and distinct. But as soon as I picked up that bass I was an animal. Well............ kind of a poser at first, but underneath, an animal.

I didn't have to be anything other than the street rat I was. I turned so fast, and became consumed with romantic dreams of untold rock star mythologies. From the first second I was ready to give my life to it, to bleed for it, to shoot myself into the heavens. I had no idea what I was doing, just pressing down on the string and fret at the right time, in a paint-by-numbers kind of way, but I pulled it off. I earnestly played Anthym compositions "One Way Woman," "The Answer," and "Paradox," with every ounce of misguided and immature rock star energy I could muster, well practiced in front of the hallway mirror on Laurel Avenue.

I had one bass lesson with Hillel. He told me to use the two first fingers on my right hand as the plucking ones, alternately, like they were walking. I only had to walk a few

blocks to his house where he lived with his mother and little brother, who drew the most creative cartoons. Hillel and I spent hours and hours listening to his rock records; Hendrix, the mighty Led Zep, Rush, Jeff Beck, the Doors. I was such a jazz geek it was all new to me. I felt the Hendrix deep inside my little heart. Lying on his living room floor, I fell in love with rock music — listening to *Houses of the Holy* and leafing through his mom's M. C. Escher book, the rhythms morphing in and out of each other. I imagined them throwing me around like a ferocious wave, contorting me into new shapes and giving me wings. I started looking at music in a new way, seeing color and attitude instead of notes and scales. Hillel's rock star dreams beamed around the room; they were infectious, his yearning hitting me in the chest.

Walking around Fairfax High together, I was proud to be his friend. One funny nerdy day, Hillel told me he wanted to change his name, to have a rock star name, and he was thinking of David Sandheart. DAVID FUCKING SANDHEART!!!! I nodded seriously in response and pondered a rock star name for myself, Dash Macallister, Giuseppe Von Skylark or Sigmund Salamander.......Flea? Ahh, the awkward beauty of the blossoming and dorky kid. All the time we spent pulled over to the side of the road in his car, listening to music, imagining fingers to strings, skin to stick, in sheer awe of it.

*

Jack.....Always been able to count on him as a friend. One of the only.........he has walked through the fiery furnaces with his demons and come out the other side, the kindest and most compassionate, insightful person I know. Fuck, I love him.

*

I'd known Jack Irons since that fateful first day of sixth grade at Carthay Elementary, but never did I imagine that he and I would be unified just five years later, pursuing this limousine teen dream. Fuck, it's wild how consequential the years when you're a wee one. We were buddies in tenth grade when we sat next to each other in AP English class (the only subject I was good in besides music) and when the teacher spoke about Oedipus and the "Oedipus complex" (some sort of sex-with-your-mother neurosis), Jack yelled out "Eat a puss!"

Alan Moschulski, the main singer and other guitar player in Anthym, was an interesting chap. He was from a Chilean showbiz family, a safe kid, a homebody, one who had spent a lot of time in his bedroom honing his guitar skills. I went over to his house for a day of instruction. He was adept with virtuoso-type abilities, and super into prog rock. I'd never even heard of prog rock. He played me Allan Holdsworth, Brand X, Pierre Moerlen's Gong, Genesis, Weather Report, Yes, and Bill Bruford. It had the sophistication I admired in jazz, and helped me to see how I could hope to fit into rock, and what was possible on the electric bass. That day, Alan showed me a variety of technical exercises, scales and patterns, to help me gain bass proficiency. They enabled my hands to grow strong, and soon the bass started feeling natural under my fingers. He helped me develop the physical ability to play the rhythms in my heart. The exercises he taught me are still the ones I play before every show. Alan later changed his name to Alain Johannes, and still has a vibrant career in music. I'll always be grateful to him, that day was magic. I was chomping at the motherfuckin' bit with a bass in my hand, rarin' to go.

Electrical Shockinum

Before I ever stepped on a stage with Anthym, I knew what I was gonna do. I'd seen them play before, along with a few other rock bands. Anthony and I had snuck into the Forum to watch the Who; the way Pete Townshend moved was so beautiful, it excited the hell out of me. He seemed out of control, like something unpredictable or dangerous could happen at any second, like he was plugged into an electrical cord, a wild current shocking through him. I knew he was from another world, and I wanted to go there. I thought, *"This music is about going crazy. If I ever did it, I would go to go-fucking-crazy-land. I would move to the music like a wild man, let it throw me wherever it wanted."* Little did I know what a vehicle of ecstasy that thought would mean for me later in my life. It was so different than the jazz and classical music I'd been exploring on the trumpet, but I had absolute faith in myself to feel it, live it, and be it. In most every other area of my life, I was full of self-doubt, but not when it came to rocking. I planned on going primal.

I took to it quickly, and three weeks from the day I first picked up an electric bass, I was on stage at Gazzarri's on the

Sunset Strip, playing a gig at a Battle of the Bands as the bassist in Anthym. (The guy in the band before us impressed me with a bass solo that included the theme from *Popeye*.)

Dude in a rock band, been doing it ever since.

When I started playing with Anthym, we would jam free all the time. Just improvising with no plan, collectively making up music as we went. That's how I learned how to play the bass. I used the few scales and little bit of music theory I knew from the trumpet and the horn experience gave me a different kind of approach. I thought of bass lines like horn parts. We went at this modal improvisation for hours on end. It was all feeling; I was just searching for rhythms, looking for those transcendent bursts that made us all fly. Our jamming was mostly self-indulgent bullshit, but in the rare moments of beauty, I discovered a new part of myself, a depth that could not be denied, a sound that could not be fucked with because it came from a sacred place within. It was unique to us because it wasn't calculated. Blisters, blood, and then with pride, calluses.

I took great comfort in that sacred place, a space of searching and satisfaction, a space that would always be home. Once I found this way to access it, I knew it would be there forever. My life had meaning.

Nothing special about me, we've all got our own sacred place, but to access it, your mission must be pure and your aim true. Just a little thought of trying to use it for a power tool, a career move, and the process becomes corrupted. You gotta go for the joy, the pain, the adventure, the search, the journey to love. I learned that from Kurt Vonnegut. You have to be willing to dedicate your life to that journey, not as a means to an end, but just as an opportunity to trip the fuck out. Ya gotta

suspend all self-judgment, and embrace all. The reward is the journey itself.

And that's how I became the bass player I'm still trying to be. Just exploring for a sense of purpose. Sometimes fun, sometimes bland or even grueling, but always pure. Sure I had some weird rock star fantasy, but I didn't even know what that meant. My reference point for a music career was being with Walter in his Volkswagen Bug, his upright bass crammed inside with the neck sticking out the window, me squished in the backseat, him going to play some cheesy gig for a few bucks while I would have a Shirley Temple then fall asleep in a red vinyl booth in the corner. I didn't consider commercial success because I didn't know what it was. The jamming was all I cared about. I just wanted to get good.

Loved getting lost in the rhythm, but did not spend time learning other people's music. This helped me define my own aesthetic, but slowed my development as a songwriter, as I didn't study the craft. I just loved feeling the metal strings under my fingers, the deep thunk as I struck them and invented my finger dances. That wood, the long piece of it, smooth and rounded on the backside so my left palm could slide up and down it like when sliding down the banister and whooping it up in an old house with a big staircase. Those left hand fingers gripping around the other hard flat side of the wood, strips of metal crisscrossing it one way and the long metal strings floating magically above it on the other. Each of my fingertips with its own little brain excitingly plotting their moves atop the strings, all of my heart and body vibrating with the *VOOM POP BOOM RAOOM BOP yeah feel that other hand the fingers running and walking up and down the four string steps right hand left hand......right brain left brain...Jackie to my*

left, Kustom tuck-and-roll amp to my right.......be the kick drum let it hum then came time for the thumb.

I was plucking with my two fingers like Hillel had taught me, then one day at school, sitting under a tree, I saw Ray rock the bass. The other popular band at Fairfax, besides Anthym, was Star. They were all black kids that were into the funk, and Ray was their bassist. I watched Ray bumping the low strings of the bass with his thumb bone, letting it bounce like a basketball BOOM the thumb came down......then his middle finger answered his thumb by digging under the high strings and pulling em up sharp POP thumb down BOOM finger up POP....BOOM POP BOOM BA BOOM POP POP. Hot damn kill it Ray FUCK WOW WOW OH I was transfixed, I had to learn to do it....................So I did. Yeah.

Anthym would get together and play a few days a week, first at Jack's house, sometimes my house, then at a rehearsal studio called Wilshire Fine Arts.

The Chordsman

Wilshire Fine Arts was an old apartment building in East Hollywood turned into a multiplex of rehearsal studios. There was a guy who played in the room next to us who we named the Chordsman. He was a straight badass scary pimp who'd arrive in a shiny Cadillac, purple three-piece suit, a bold maroon fedora, gold and silver everywhere. He'd sit in his room playing, and long as we stayed in our room we'd hear him. He would plug in and play one chord, one tempo, one strumming pattern for five hours straight. Just strum that one chord, and zone out forever, we thought he was crazy. When I look back at it, man what a Zen meditative genius. I wish I had a tape of it. He was the king of Kraut Rock. If he left, Hillel and I would go in there and pick up the roaches he left behind on the floor and smoke 'em. We practiced the days away and I started to catch up with the others in terms of technique. We jammed and jammed and jammed and played any gig that would have us.

By the way, the Circle Jerks once did an impromptu gig in there and one of their fans took a shit on the floor.

We often had to wait outside the club until we played our

show, then leave right afterward because we were too young to be allowed in a place that served alcohol. We'd drink and smoke while waiting out in the parking lot.

The band, the group, the gang, the boys. Before all this, it had just been me and Anthony. Being in a band gave me insta-family. All our ambitious dreams came together, coalescing into one throbbing thing, where we could gather momentum into a united movement. The feeling of circling the wagons, cutting everything else out. Only on the inside of the circle could these laughs and feelings exist. This was my first taste of what would become much deeper and more intense later, but it gave me a whole new sense of self and happiness, I loved it.

I was a member of a secret society that was incomprehensible to the square world. All that time in those rooms playing together, building the telepathic communication, it made everything else in the world feel paltry, shallow, and mundane. All the people who made fun of me and called me names at school, all the world where I felt so ill at ease, the cruelty of its ridiculous competition, none of it mattered anymore. I lived on a higher plane, a place where dreams, feelings, colors, and hopes were real and concrete. Like a cat, I walked light on my feet. I started going to the secondhand clothing store and buying weird old clothes to wear. I wore a burnt match in my pierced earhole. I had no sense of fashion or cool (never really did achieve that!) but I embraced my freakiness; I was alive with the love I felt in my band, it was infinite, transcendent, and where I planned on staying forever.

There were a group of girls at school who loved the band, made up ANTHYM buttons and cheered us on. They liked the Ramones mostly, and we weren't remotely that cool, but I reckon we were all they had. One of them had a big house and

when her parents were gone she threw parties. At one of 'em I had an epiphany: When I drank a lot of beer I didn't feel so shy! I'd been averse to alcohol since I vomited all over myself that night at the Rainbow with the Kiedis crew, but now I started to love it. The more I drank, the smarter and handsomer I became. At these parties I would do the crazy shit I'd always done, pull my pants down and wave my cock around, climb a tree, smush a piece of cake into my face while someone was talking to me. But in a new twist, I was now a guy in a rock band. That meant I wasn't frowned on as a weirdo, but happily accepted as a wild and interesting young man, a creative eccentric!

(Side note: My public nudity was never aggressive, but in the spirit of the streaking craze of the seventies! My sister had the bug too, after she was kicked off the Hollywood High gymnastic team for smoking pot, she popped up during the City Championship meet and did her floor routine in her birthday suit! We thought it was hilarious. Clearly, I still think it's a good look.)

The day after the first party at this girl's house, where I had pulled down my pants during an absurdly diabolical drunken dance, I received a letter from one of the party girls.

Dear Michael,

I had such a great time last night. When you pulled down your pants I couldn't help noticing that your dick resembled the beer bottle you were holding! Hope to see you soon.

Hugs and kisses,
Naomi

(P.S. My dick looks nothing like a beer bottle.)

Next thing you know I was playing around sexually with real girls who liked me, and I liked them. It was gentle and connected and made us happy.

First time I had a girl over to my house on Laurel Avenue, my parents were asleep and Julie and I were making out on my bed. Her shirt was off and I was marveling at her breasts, so close to each other we were, lost in the warmth of our oneness. In the aether. All of a sudden the lights snapped on harshly and Walter stormed in the room, fat hairy belly hanging over his tighty-whities, yelling, "Jesus fucking Christ, keep it down in here I'm trying to get some damn sleep!!" When he saw that I was with a girl his face expressed shock and he ran out of the room. Julie was mortified, I was frozen in embarrassment, and she went home.

One day we had band practice in my sister's bedroom, and a strange head popped up in the window, peeping in to watch us play. It was a kid from down the block I'd seen cruising around the neighborhood, a tough cool-looking longhair. He'd climbed over the fence into my backyard when he heard the music. He told us his name was Saul, he was a guitar player, and had a band called L.A. Rocks, or something like that. We chatted for a while, he was an intense and spirited kid, I liked him. Years later, when he was the top-hatted iconic figure of the biggest rock band on earth it always warmed my heart to see him doing his thing. His drummer Steven Adler lived up the block too, we used to hang out a lot; play football in the street and smoke weed when we were fourteen. Steven was a sweet and enthusiastic dude, a year or so younger than me. I played trumpet for his grandma once and she was nice to me.

I awoke the day of a gig lit up. The most important thing ever was *TODAY!* I thought we could change the world. My

first stage outfits — striped sleeveless shirts, tight and bright red corduroys, ballet shoes, and bad eye makeup. Striking dumb rock star poses on stage, back to back with Hillel, like literally leaning on each other's backs, faux feeling the mystical power of our riffs. Posing. I moved around a lot, but I didn't know how to let nature take over yet. As we played more shows I started dancing around more, bobbing and weaving, finding my spots. Some friends of the band complained that I was overdoing it, being a clown, making too much of myself. But I was unrepentant.

I was whooping it up at a party in someone's art studio one drunken night when the DJ started hitting the James Brown hard. "Mother Popcorn," "Papa's Got a Brand New Bag," "Say It Loud." I was dancing already, but when the J.B. got going something else switched on; something new opened up inside. I was no longer just dancing to the music, the beat was taking me over. I was lost in the ecstatic joy of movement and couldn't believe how good I felt, how great James Brown was. I already knew he was great, but I didn't REALLY know till that moment, when I learned in a way that was beyond thought. I danced unconsciously for hours.

After that, my stage movement became unforced and natural, even as I kept yearning for a rhythm that, in my band, I hadn't yet found.

Double-Edge

My desire to stir things up, be disruptive, and spark strange new fires was creatively healthy. I got off on fucking with the system. I wanted to get into that crazy zone where anything was possible; to be like Arthur Rimbaud when he shit on a table in a restaurant. But sometimes it did not serve me.

Jack Irons was my brother; a loyal friend and great drummer who was always down to jam. He had a birthday party at his house and I wanted to get him a crazy gift, one different than any he'd ever receive. So, I pooped in a ziplock plastic bag and wrapped it up beautifully with ribbons in fancy wrapping paper. The craziest gift ever! We had a lot of poop humor amongst us.

Come present unwrapping time we sat in his bedroom, his parents and sister were also there, and he opened up cool gifts. When he got to mine and unwrapped it with anticipation, he realized what it was and laughed and yelled out, "Oh god, eww!" Out to the garbage bin it went. He got the joke, that I was being as ridiculous as possible, but I saw his parents look at me with disgust, and Hillel shot me a "that is not funny" look. Later on, Hillel told me I had fucked up. For a different

friend's birthday in the recent past, a guy whom I didn't even care about like I did Jack, I'd stolen an armful of records from Music Plus on the way to the party, and given him twenty albums. I hadn't even thought about it. Hillel said, "You give that dude a bunch of great records and you give Jack your disgusting smelly SHIT???" Of course, Hillel was right. I felt like an asshole.

The weird thing was, in a way I was right too. I was foolishly excited about Jack's poop gift. I really wanted it to be something he would never forget, and in that I succeeded. It still comes up now forty years later. ("Dude, I'm so sorry about the birthday poop.") I bet he can't remember any other gift he got for that birthday. When I stole the records for the other guy, it took no thought, I just popped by the shop on the way to the party, I was a petty thief, and I bet that guy has no memory of his gift.

In my desire to transcend normalcy, I would, on occasion, be thoughtless and disrespectful for years to come. Sometimes I said and did weird shit (pardon my pun) that ripped down walls, got a new conversation going, and helped me to shine a new light, but just as often I was nothing but an obnoxious, offensive jerk.

I thought that the love and caring in my heart would always shine through, but it didn't.

I yearned to get to a place beyond thought, because I knew that's where the magic was. But I didn't know how. I had yet to learn that getting beyond thought didn't mean being thoughtless.

I've been insensitive and offensive to many human beings. For every act when I've made somebody feel bad, I've felt bad myself a hundred times over. Such is the way of the universe.

Nana and Mama. Melbourne,
Australia. 1938

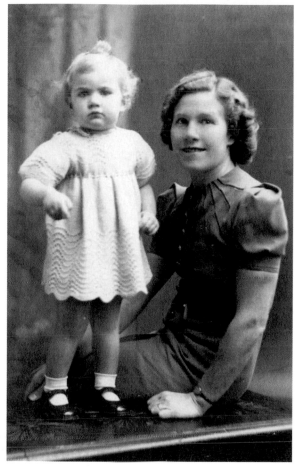

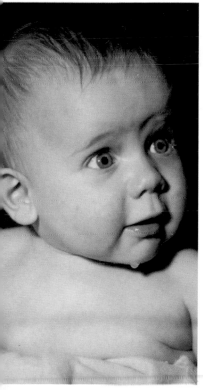

Hello world! Five months after the
belly button window view. 1963

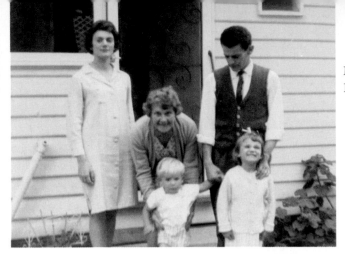

Mom, Nana, me, Dad and Karyn. Melbourne. 1965

Contemplating existential despair aboard the Oriana Express. Enroute to America. I still have the exact same body. March, 1967

The proud fisherman of Rye. 1968

I still believe in Santa Claus. Best haircut I ever had. 1969

Mom and Walter in the Larchmont house. 1971

My mom. 1972

Karyn, Walter the Cub Scout, and I. 1970

Ambling about in basement world. 1970

In drag with cousin Adam (Walter's nephew.) Larchmont. 1970

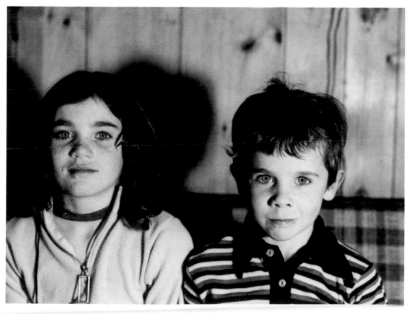

Karyn and I.
sement daze.
1970

Laying low.

At the Murumbidgee
River in Australia with
Karyn, Dad, and dogs.
Feeling the power of
nature. 1972

What's this giant rat? 1972

14 years old. With my wanna-be Norm Nixon gold chain, hairbrush in my pocket and joint in my sock. Bancroft Junior High. Los Angeles. 1976

Halloween has been a time of many challenges. Stephen Paul is at far left, his younger brother, Chris at far right. I'm the mummy man.

Rocking in the Bancroft orchestra. Always the littlest one. The other seated trumpet player is Sergio Vera. 1974

Graduating Bancroft Junior
High with my music teacher,
Mr. Charles Abe.
I wore that blue polyester
suit to my first nightclub
outing at the Rainbow.

I hated shopping and
always hid until it was
over. 1971

Yearning.

The first of the bad rockstar clothes. On Laurel Ave. 1980

Me and AK in the hot tub that Walter built on Laurel Ave. 1979

Hillel and I honoring the rock godz. 1979

A trio of hair. Anthony, Hillel, and Michael graduate from Fairfax High School. 1980

A trio of no hair. JK. Flea, and Tree. 1981

Playing in What Is This with my dear brother Hillel Slovak. 1981
Uncle Marc Wolin

Mr. and Beth *"Couples: Beth and Michael 1983" (alternate title) by Jennifer Finch*

AK, Jackie I, and yours truly at the trailhead about to delve deep into the backwoods. 1982

Playing flugelhorn in What Is This at the El Senorial club in Los Angeles. 1981

AK and I at the Wilton Hilton. 1982

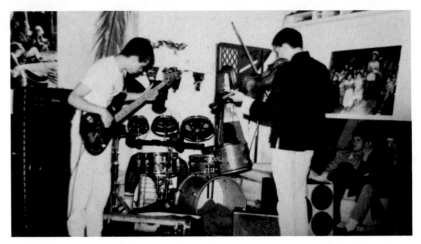

Me, Joel, and Tree jamming at the CASH club. 1982 *Janet Cunningham*

Me and Tree in the midst of a three day MDA run. At Skood's house. *Dondi Bastone*

With AK. Convex and concave. We take different roads and end up in the same place. 1983

The legendary queen, my loving nana Muriel Cheesewright, tending to me mid-show. 1993

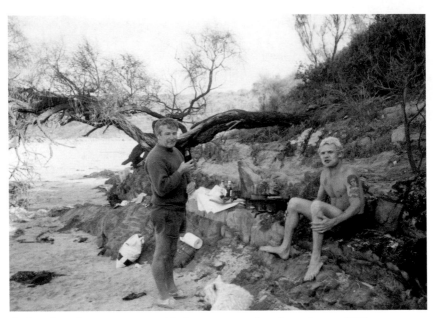

Dad and I. Many a year passed before we started to figure it out. 1993

Recording the first RHCP demo. Lost in it. 1983 *Fabulosfab*

The Oneness

I *run and I run but I can't outrun*
I come up from Pate Valley in the hot hot sun.
I saw the mocking faces in those rocks, they've laughed at a
lot of people.

*

The Anthym boys had a friend, JK. A high-strung and handsome young man, JK sang in Adrenalin. When I saw his band rock Led Zep covers at the Fairfax amphitheater at lunchtime, the girls swooned as he paraded about the stage, tossing his curly locks around in a Robert Plant–ian fashion. At one point there'd been talk of him being the singer in Anthym, but that was before my time. He did, however, end up becoming my lifelong friend.

He had backpacking experience in the High Sierras, and was spearheading a group trip to Yosemite. There were about seven of us, including all the Anthyms, and unlike my previous trip there with Anthony, when we carried our stuff in brown paper bags and had barely enough food to survive, this

time we were well equipped with proper backpacks, first aid kits, food, and poop hole shovels. We hiked hard and deep into the wilderness for eight days along the Tuolumne River, living it up; yelling, laughing, singing, seeing bears, jumping into the cold clear river and climbing mighty mountains.

In between all the yelling and farting, I was touched by beauty in a way I had never experienced. During the long all-day walks when I fell away from the group, I drifted into a meditative solitude where my dreams fermented and my thoughts coalesced. I was witnessing a nature so majestic that I felt whole. I melted away and became a part of it all. I felt insignificant, just another little component of all the nature around me. A little pea. Just love and kindness mattered. The important things became clear, my dreams of becoming a professional musician were real, I knew I could actually do it. So much beauty on the trip: the hilarious campfire night talks, the anticipation of a new Zeppelin album, my deepening friendship with Hillel. But the intangible spiritual effect the mountains had on me was transformative. All my worries were put into perspective by the enormity of the natural world.

Might As Well Jump

— Van Halen

Anthony and I made a sport of jumping off the roofs of apartment buildings. We scouted the streets daily, looking for nice two- or three-story buildings that were likely to have a swimming pool, then we'd find our way in to investigate. If the pool was in jumping distance from the roof, we stashed our clothes in a potted plant, made our way to the roof, and rocked the gonzo leap. The love of being airborne, flying through the Hollywood sky, and breaking some laws was invigorating and addictive. It was a bonus if people were sunning themselves poolside and us strange aliens came dropping out of the sky, bombing into their body of water, hooting and hollering like a couple of full-moon coyotes. It freaked them the fuck out, and it was FUN MEGA FUCKING FUN.

One day we were doing it with our friend JK. The three of us had found a good pool. It was a little sketchy because the deep end was the narrow part of its kidney-bean shape; there were just a few square feet where we could land safely. We considered ourselves experts though, and felt confident we could nail it. I jumped first, flying down fast and hit the water BAAAM, my feet banged against the bottom pretty

hard but it was okay, I came out laughing and singing "WHOOOOOOOO." As I climbed out I heard behind me a crazily loud *CRACK* like a massive tree branch snapping, and looked back to see Anthony floating on his back in the water, emitting a strange moaning sound. I thought he was joking and I made the sound back to him, while cocking my head at a strange angle and making a funny face. Then he lifted himself out of the pool and rolled over onto his back, and I saw he had turned a ghostly white color, his body was uncontrollably twitching in a bizarre way, and he was still making the animal moaning sound. I realized he had hit the side of the pool. Everything became a strange and unreal dream. Oh man, oh fuck, I freaked out. I yelled to JK, "Run to someone's apartment and call an ambulance!" I sat there with Anthony and didn't know what to do, told him he'd be okay. He was completely in a state of shock, present but not present. JK came back and told me the ambulance and Anthony's dad Blackie were on their way. Once I knew the ambulance was coming and JK would stay there with him, I thought about a warrant I had for my arrest, and all the trouble ahead. JK confirmed he'd stay there until Anthony was safely in the ambulance and with his dad, so I split. I still feel guilty about leaving him there. He could have died. Thank God they fixed his broken back in the hospital and he went right back to being the rip-roaring stud we all loved. We smoked lots of joints with him in his hospital room. Motherfucker's got nine lives.

Death Trilogy

John Lennon was murdered. How could someone do that? The closest thing we had to a saint. The sobering reality leveled me. I felt a heavy weight on my skinny teenage back, a light in my own private starry sky went out. In the weeks just before his death I'd spent many an hour lying on the floor in my room listening to his and Yoko's brand-new album *Double Fantasy*, imagining him with his relaxed thoughts in his New York apartment just watching the wheels go 'round and 'round. That seemed like a true happiness, one I could only doubly fantasize about, someone getting to a place in life where he could be so happy he just loved watching them wheels roll.

Shortly after that, I was sitting alone on my basketball in the Fairfax hoops asphalt reading a local rag, and learned of the death by drug overdose of local punk rocker Darby Crash, lead singer of the Germs. I'd heard of the Germs, but wasn't interested in punk rockers because I thought they didn't know how to play. There were Crash-penned lyrics printed in the obituary, though, and I totally identified with them; an excerpt from the song "Manimal."

I came into this world like a puzzled panther
Waiting to be caged
But something stood in the way
I was never quite tamed

I so often felt like a stray dog. A beautiful animal yes, but something ragged and wrong about me, that I'd never be fit for a more civilized society, and maybe never really know love. I knew there was something important in that punk rock, but I liked the great musicians in Weather Report, Rush, and Led Zep.

The wind was knocked out of me and I fell to my knees in tears when I found out John Bonham died. Bonzo meant more to me than anyone. He was my favorite guy in my favorite band. No more Led Zeppelin? The band was still a living thing, and full of surprises. I listened to them the most, they touched my heart and made me bang my head for the first time. I was just so fucking into Led Zep, I could not believe it was over. A momentous loss.

Star Good Nights

The Starwood, a sprawling all-ages nightclub, sat at a busy intersection, two big marquees sending glowing band names into the West Hollywood night; TEENAGE HEAD, THE PLIMSOULS, and ROID RODGERS AND THE WHIRLING BUTT CHERRIES. It went off nightly, an infinite supply of young rockers come to Hollywood from every corner of the country hoping to get a leg up the ladder of rock royalty, and every seedy, sincere, shocking, and heartbreaking companion that came along with 'em. 'Twas packed full of partiers in all their regalia getting into the metal, punk rock, and new wave freak-outs. As intense of a gathering spot as it was on the inside, it was equally packed and moving out in the parking lot (featured on the cover of the Circle Jerks *Group Sex* album), the debauchery spilling out onto Santa Monica Boulevard, the crowd always bleeding in and out.

I'd been there first when I was thirteen. Me and the Jones brothers snuck in and saw a rock band banging away. We got up to the front of the stage, where the hot female singer leaned over in front of me, smiled into my eyes, and grabbed my shoulder for a thrilling second. I tingled with pride, my friends laughing and slapping me on the back.

Come 1980 at age seventeen, we were there all the time. Me and AK walked up there and saw bands like the Suburban Lawns, Gary Myrick and the Figures, and the BPeople, or just hung out in the parking lot if we couldn't get in. Sauntering into that parking lot, acting cool as I possibly could, with hope that we'd "pick up some chicks." I never came close.

On punk rock nights when bands like Black Flag, DOA, and the Circle Jerks played, it was brutal. The Southern California punk rock scene had started out in Hollywood. As youthful, drunken, and reckless as it was, at its heart was an artistic exploration. Bands like the Weirdos and The Screamers made their own clothes, adored wild creativity, loved Captain Beefheart, and nurtured a vibrant underground community. They loved so hard. But when the South Bay/Orange County scene coalesced, crowds of frustrated jocks with standard-issue punk rock haircuts converged on the Starwood. They conformed to a dress code and a bland set of rules. They were violent, scary, and narrow in their musical taste (nothing against Black Flag, who were an incredibly adventurous art band). This new generation of hardcore fans did not express a feeling of freethinking artistic freedom. They just wanted to fight everyone who didn't fit into their close-minded world. The kids had no imagination, most of 'em in the anarchy T-shirt their mommies bought for them. At a Black Flag show one night, I was just starting to realize the magic of the band, amazed by drummer Robo and the wild synchronous yes and no movement of Ginn and Dukowski, when I saw a series of people beaten badly to bloody pulps, gangs of idiots stomping the fuck out of them for having the wrong haircut, the unconscious victims carted out to waiting ambulances. It was disgusting, and turned me off to punk rock.

The band that really touched my heart at the Starwood was X. They transcended genres. Great songs, unique grooves, and the hauntingly beautiful vocal texturing of Exene Cervenka and John Doe. Shit was poetic. They were learned in the traditions of the best rock and roll, and pushing toward the future. Exene was so beautiful, and I had a huge crush. Back before I connected with the truth-essence of punk rock, they filled me with poignant promise. I saw 'em again and again and felt the spirit every time.

We snuck into the Starwood whenever we could swing it. Same's true of the Roxy, a different club on the Sunset Strip, where we scaled the back wall and scampered into a window. Came-a-popping right into the band's dressing room. Some bands didn't dig it and kicked us out, but most appreciated our moxie, like the Ramones, who invited us in and gave us beer. Dee Dee was sweet and funny.

Take for Granted We Are
Stoned the Whole Time

(Sorry to the Minnows)

Hillel and I joined Anthony at his mom's house in Michigan for some summer vacation action. On hot and humid leisure days, the smell of moist earth in the air, we'd jump off a train track trestle bridge into the large flowing Grand River below. AK breaking his back had done nothing to diminish his appetite for flight. If anything, he took even crazier jumps, with a healthy yearning to make invisible the scars of the past. We'd drive over there in Anthony's car, a turd-colored Capri, passing around a pipe of weed, talking shit, feeling free, singing along with The Ohio Players' "Fopp." It's dangerous to jump into a body of moving water because you never know what the current is carrying underneath. It was a twenty-five-foot drop, and I always feared there might be a box spring or a telephone pole just under the surface to break my spine. But it never stopped me. Yelling out absurdities, Anthony and I jumped again and again, our bodies plummeting into the strongly flowing river, heads popping up triumphantly. Hillel would stand atop the bridge's edge, a look of fierce concentration on his face, always on the verge of launching his long thin body into the open air, sometimes

bending his knees like he was about to go, but something always stopped him from surrendering to it. He thought about it a lot. We'd sit down below on the sandy shore of the river in our underwear, laughing and yelling words of encouragement, and sometimes he'd be up there apprehensively for an hour, just on the verge, but ultimately always walked away. He finally issued the proclamation, "Jews don't jump."

In the dead of night, the three of us were out on a lake in a little rowboat. We had made a lame attempt at fishing before the sun set, but didn't know what the fuck we were doing. Night fell, and we ended up just floating around aimlessly for hours in the quietly rippling black water. We spent a while trying to build up the nerve to dive into the cold dark lake, swim underneath the boat, and come up the other side of it, without being swallowed alive into the frigid and bottomless unknown sea monster depths. We had a bucket of minnows and the idea had been floated that one of us should eat a live minnow. Then someone said we should stick minnows up our butts, then dive into mysterious scariness, an incredible rite of passage. Our laughs, chortles, and guffaws floated up into the starry night. Floating out there in the ether, being ridiculous. Yeeeeah.

I did cocaine for the first time with my two brothers up in a cabin in those Michigan woods. We sat up through the night snorting and talking. It all felt so important, meaningful and good, albeit in that weird coke way. In the years to come, during all-night coked-out blab-fests, even during our most soul-baring moments, I always kinda knew we were full of shit, our brains just looking for a vehicle to get all that chaotic coke energy out; a dog-chasing-its-tail way of emoting that never came to anything real. Drug-fueled oaths and pacts that meant nothing. But for this short time in the very beginning of it all,

the negative reference points weren't there yet, our naiveté afforded us a free pass to sincerity, and we poured our hearts out to one another till we had nothing left. Trying to go to sleep at the end, though, gripping the pillow tight, on a couch with the sunlight beginning to flood through the window…ha.

The night before we left Michigan to drive across the country back to Hollywood in the Capri, we three kings were sitting around the living room table. Either Anthony or I had said something insulting to the other one. Then we started trading insults back and forth. Hillel stayed out of it, he might have even tried to stop us, but the putdowns went on and gained momentum. It had started out lightly and humorously, but became meaner and more personal, preying on each other's insecurities, doing our best to humiliate and hurt each other. A competition. The dismal heavy vibe in the room became oppressive and difficult to breathe in. I felt sick and weighed down, and I think Anthony did too. We finally stopped and went to bed. I don't know why we wanted to hurt each other so much.

On our way driving home, he and Hillel berated me a lot, calling me "Gemellus," a strange character, a pale gay boy from the highbrow porn film *Caligula*. They would hold this fake microphone gadget and say in a radio voice, "Copilot to Gemellus," and explode in laughter. They wouldn't stop doing it. I was sitting in the rear seat holding back my tears, feeling the odd man out, the runt of the litter. I don't know what I did to warrant it. Our feeling of family meant everything to me. Nothing comes from nothing.

A Tree Grows in Hollywood

Since Bancroft I had been playing in band and orchestra with a boy named Keith Barry. At Fairfax we began to bond over jazz and weed. A one-of-a-kind intellectual at sixteen, he slept only in the hammock strung up in his bedroom, and read the encyclopedia for pleasure. His main instrument was the electric viola. He once spent three days cooking a Peking duck for an amorous dinner date in eleventh grade, and a pale spare white kid in 1978, he showed up at school with his long hair done in tight cornrows and beads like Stevie Wonder's. Lying back in his hammock he cranked the greatest tunes in his little room. Man we dug it so hard all the afternoons long — Jean Luc Ponty, Johnny Griffin, Oliver Nelson, Coltrane, Kenny Dorham, Ornette, Mahavishnu, and "Hocus Pocus" by Focus. It meant everything to be able to connect with someone in a deep way through all this interstellar music. He could cook a mean pot of beans too. He became one of our circle of friends, and we began calling him Tree.

*

Twenty years later in 2000 while touring Californication, *I went to a Knicks game at the Garden. I was chatting with the woman sitting next to me and it turned out she was the music teacher at my alma mater Fairfax High! What the?!? Hoops heroes Larry Johnson and Latrell Sprewell were disappeared by a flood of memories.........the three years I'd spent buzzing along with all the other aspiring musicians in that Fairfax music room, the sour smell of my mouthpiece, the shelves stocked full of instruments. She asked me if I would visit the music class sometime and speak to the kids about the viability of a music career.*

A few months later I found myself there in that same music room, talking to the kids and jamming out for them. The kids were beautiful, the jamming and talking was cool, but I walked away from the experience shaken. The last time I had been in that room was twenty years before, and it had been packed full of kids playing French horns, clarinets, violins, basses, trombones, flutes, tympani, and saxophones, all under the capable instruction of orchestra teacher Mr. Brodsky. It was a room alive with sound and learning! Any instrument a kid wanted to play was there to be learned and loved.

But on this day, there were no instruments, no rustling of sheet music, no trumpet spit muddying the floor, no ungodly cacophony of squeaks and wails driving Mr. Brodsky up a fucking wall. There was a volunteer teacher, a group of interested kids, and a boom box. A music appreciation class. All the arts funding had been cut the year after I left Fairfax, under the auspices of a ridiculous law called Proposition 13, a symptom of the Reaganomics trickle-down theory. I was shocked to realize that these kids didn't get an opportunity to study an instrument and blow in an orchestra.

I thought back to the dazed days when I would show up to school after one of Walter's violent episodes, and the peace I found blowing my horn in the sanctuary of that room. I thought of the dreams Tree and I shared there of being professional musicians, before going over to his house to be inspired by the great jazzers. Because I loved playing in the orchestra I'd be there instead of out doing dumb petty crimes. I constantly ditched school, but the one thing that kept me showing up was music class. FUCK REAGANOMICS. Man, kids have different types of intelligences, some arts, some athletics, some academics, but all deserve to be nurtured, all deserve a chance to shine their light. That day, I got the idea to start a nonprofit music school.

About a year after that, I was going through a sad post girlfriend breakup period and I headed down to Mexico on a solo journey to get my head right. I found a cool little village, and got down to some meditating, reading, and hiking around. I read a captivating autobiography by musician Horace Tapscott, Songs of the Unsung. *Horace wrote poignantly about the power of a music education to uplift and connect people. He'd started a music school in South L.A. in the sixties, revolving around his brilliant Pan-Afrikan Peoples Arkestra. His generosity went right to my heart, and when, with a tear-stained face I read the final page, I made a pact with myself. To go directly home to L.A. and do whatever it took to start a nonprofit music school dedicated to uplifting children with the pure beauty of playing music, and nothing to do with fame or genre.*

(Important and unavoidable side note: On that Mexico trip I also read How to Be a Chicana Role Model *by Michele Serros, which also touched me deeply. Michele and I ended up becoming great friends, for which I am eternally grate-*

ful. We all lost an incredible voice when she left us, departing this earth in 2015 at the age of forty-eight. What a sparkplug she was! RIP the eloquent, unique, and beautiful Michele Serros.)

First thing I did was call Tree. He'd been teaching music for a long time, and I asked him to be the dean. Then I asked my friend Pete Weiss to help organize it. Pete and I had both come a long way from smoking crack in my Los Feliz apartment in the eighties.

The Silverlake Conservatory of Music will soon be celebrating two decades of life. Seven days a week it's packed full of the most awesome kids learning music, and teachers handing down the sacred traditions. We have a beautiful building where we teach all the orchestral and band instruments, an orchestra, and children's and adult's choirs. Seeing the kids play is the greatest thing I could imagine. It is a place of long-lasting friendships, and a building where kids experience great triumphs. Anything is possible.

Back to '79.....

With stars in our eyes Tree and I ogled the totally rad Cherokee recording studios as we strolled by it on Willoughby. Having never been in a real studio, I could only imagine the wonders going down inside, I'd seen photos of David Bowie walking through those very doors. Up came a cool-looking dude carrying a bass case. Wow, a real studio cat! We started asking him questions: What was he gonna do in there? Could we come watch? Did he record a lot? The guy appreciated us as young musicians, saying he was there for an R & B gig. He didn't know the singer and hadn't seen the

charts yet. Shit, he was so good he didn't even need to know! He then disappeared behind the magic gates. Man, what a dream, to be an in-demand studio jammer, ready for anything, playing on record after record. Can you imagine? A better job did not exist on the earth. Tree and I talked and walked on it.

It's a Wonderful Life

The night before Christmas and all through the house
Not a creature was stirring
'Cept for a two hits of acid takin' Eric Dolphy listenin'
 motherfucker
who had joyously gotten on a wild rant and wouldn't shut
 the fuck up and let anyone sleep.

I'd dropped the mega dose of blotter acid earlier in the
evening and tripped the hardest ever in my life. The
evening started off with the dropping of the L at our friend
Skood's house, where he, Anthony, and I had sat in amaze-
ment, deeply expanding our consciousness, listening to Eric
Dolphy's solo bass clarinet version of "God Bless the Child"
over and over again for hours, its inventive and fearless power
rewiring our brains with the best possible upgrade, teaching us
things that I'd be deciphering for the rest of my life.

As Christmas Eve 1979 progressed, my acid friends and I
had gone different ways. I wound up at a house party with
the Fairfax friends of the Anthym crew. The party was on its

last legs, and kids were going to sleep, some couples paired up in sleeping bags on the floor, others crashing on couches and whatnot. Though my trip had mellowed, I was still flying on the acid and feeling talkative. There was no one to talk to, though; they were all trying to fall asleep. Despite my dozing audience I stood in the center of the room undeterred, a babbling brook blabbing stream of consciousness. I'd never had this kind of confidence before. I was inspired by the beautiful acid trip visions yes, but in this new period of my life, for the first time I felt validated and respected as a wild kid with a wild mind worth listening to.

Before this time, outside of whoever was my best friend, I'd always felt disconnected and constricted. Now, I felt safe to let it all fly, to let the accordion sound expand like a lung breathing out, let the coil unwind. The jack-in-the-box was jumping the fuck out its cage. The bowstring had been pulled back so hard for so long, now it was unconsciously letting the word arrow fly. I waxed on about jazz being the greatest gift our country had ever produced, about gun control, about the beauty of Kareem's skyhook, about there being no god, besides the gift inside us so powerful so infinite and how we had to defend it and not let our evil society crush it. I felt humorous and good as I spouted off. It didn't matter who heard what, I felt no insecurity nor jealousy that not I but Wilson Barriger was in a sleeping bag with the sexy Karen Feder. I felt a meaningful wave surging through me, I felt a loving Christmas spirit, I was unstoppable. Brenna Martin rolled over in her sleeping bag with a sleepy half smile and chuckled to her friend, "He's so fucking smart, damn." She said I was smart! No one ever said anything like that about me before! My awesome friend Brenna Martin with whom I'd spent many Fairfax

lunchtimes discussing matters of the day! I could say things that had a positive effect on people, what I had to say meant something! I surged with a new happiness and confidence.

The sun started creeping its hazy light onto the Hollywood apartment blocks and I realized it was Christmas morning and I better get home. No matter how crazy and fucked up my family was, Christmas was always a sacred time. We made a big deal out of it, and all got one another the best gifts we could come up with, everything was forgiven, love was shared, and we embraced the Santa Claus mythology with all our hearts. I crept back into the house around five a.m. and saw the glowing Christmas tree in our living room, all the presents underneath it, and I sat on the couch cozying with my dog Bertram (oh my sweet Bert the mellowest member of our household, even after I dyed his tail purple, until that fateful day he drowned in an above the ground swimming pool), waiting for my family to awaken, the acid trip tapering off into nothingness. Having been up all night, and the lysergic intensity worn off, an exhaustion and mental emptiness started to take over, I felt shattered.

Mom and Walter woke up and came blearily in the room murmuring sweet Merry Christmases to me, and Karyn came out giving everyone hugs and enthusiastically chirping "HO-HOHO Merry Christmas!" The yuletide love felt so warm, and in my post acid comedown moment it was everything I needed. It was healing. We sat by the tree and exchanged gifts.

It hit me that I'd gotten a gift for everyone except Walter. I'd rashly thought *Fuck him*, as we'd been consistently butting heads and I was completely disillusioned with him. It seemed like he was angry with me all the time and looked down on the rock music I'd found so much meaning in. For Christmas,

I wanted nothing more than a chorus pedal for my bass, so I could sound like Jaco Pastorius, but I knew it was too expensive and didn't expect it. I opened a present with a card from Walter that read "Merry Christmas, kid, I always love you no matter what." Inside was the baby blue Boss chorus pedal and my heart melted. I gave Walter a big hug, and I felt so guilty for not getting him a gift, for letting my arrogance and anger guide me into shutting him out. Completely hollow and shaken, I trembled with emotion, burst into tears, and to the alarmed looks of my family, ran from our tree gathering to my room, where I shivered in my blankets, overwhelmed by my feelings.

In powerful spiritual teaching traditions, gurus will push their acolytes to sleepless exhaustion, so all their defenses go down and egos fall by the wayside. This way the student can be open to instruction, attain self-awareness, and let go of petty distractions. How many times would my heart have to break before it would open and I could live the love I professed?

Ain't no getting high without the comedown.

=+=+=+=+=+******* — fuck!__
____ — ?>>>>>>><<<<<<<
+=+=+++=====++==+

My god, they invented the Sony fucking Walkman! Can you imagine holy fuck! Oh how we fucking marveled! After you smoke a spliff, you walk to Tree's house for a bowl of beans, put on the headphones, and trip down the street blasting Coltrane into the center of your fucking brain! We couldn't fucking believe it.

::::+++++++++:::+++++++++++++:::::###////:":":"^^^^^+=!

Escape from Witch Mountain

High school graduation, the little fledglings were pushed out of the nest; some to land softly in a cozy university full of beer kegs, sexy coeds, and more adults to do their thinking for them. Others, like me, had already been mostly flapping around out of the nest anyways, and went on to make our way in the big wide world, to navigate, associate, and inebriate with the soaring eagles and filthy pigeons.

We graduated at the Greek Theatre in Los Feliz. I wore my best rock star clothes to the ceremony, bright red corduroy pants, a fake silk kind of toreador jacket, and a guitar pick attached to a safety pin hanging foolishly from my left ear.

After Anthony and I had a victory lap graduation dinner with our families all together, my mother handed me a crisp hundred-dollar bill. I was shocked by her generosity and tucked the neatly folded greenback into my pocket, walking tall, wealthier than I'd ever been in my life. Strolling around with those two zeros in my pocket I had the power to do anything.

Later that night, driving drunk on the way home after some graduation partying with the boys, I got the bright idea of how to use that pot of gold. Get a hooker! Capital idea!

I drove along Sunset Boulevard late at night in my mother's yellow Volkswagen Rabbit. I was amazed by the hookers, their hair, makeup, short skirts, brazen sexuality, sex sex sex triple muthafuckken X. So I eased down Sunset, that C-note burning warmly in my pocket, the beer I drank safely in my system, the freedom of finishing high school propelling me forward. I stopped in front of a tall bombshell of a woman, she opened the door and stepped her long legs into the passenger seat before I could say a word. She told me, "Twenty dollars for some head," I nodded nervously and we drove off. She instructed me to make a right turn here a left turn there, and I realized I was scared to death. Once she was in the car, all the seductive mystery, all the fantasy, all the thinking about sex flew away and I was left in the close quarters of the yellow Rabbit with a hard, mean, tall, brutal, and imposing woman who knew I was a scared boy. I'd never thought it past the initial image of the erotic long legs bright orange skirt me getting my cock sucked part, and now I found myself with someone bossing me around and telling me where to drive. As we were headed farther away into the night, I was panicked, she leaned over to my side of the car, rubbing me through my pants, telling me what to do, I just wanted it to end and for her to go away, this went on and on for what seemed like hours; it was actually about ten minutes.

Finally, she told me to pull over. It was the end of night and dawn was creeping in. We were in Hancock Park, an expensive residential area, parked in front of one of its nice big houses, which sat behind a huge manicured lawn, filled with a perfect, content, healthy, sleeping family that would soon awaken for nice big happy breakfast.

She told me, "Gimme the twenty, let's do it." I was terrified,

and nervously reached into my pocket for the hundred, wondering why I hadn't thought to get change, wondering how I could get rid of her. I felt in the part of my pocket where the hundred-dollar bill was, and nothing, just empty pocket, it was gone. I realized she had taken it from my pants while we were driving, while she was rubbing my crotch. I'd been nervous and distracted as hell. I became very emotional and did my best to appeal to her heart, "You took my hundred-dollar bill! To you it is just another hundred dollars, but to me it's special, my mother gave it to me for my high school graduation, it means a lot to me, please understand, it is everything to me, you've got to give it back!" I moronically pleaded with her.

Quick as a wink, she whipped out a switchblade, the glimmering knife snapped open, and equally as quickly I flew out of the car, keys in my hand, and ran a few yards away. She cagily exited the car and faced me. Cue Ennio Morriccone. Now, she was smarter and stronger than me, but I knew I could outrun her, so I felt safe, resigned to the loss of my cash. I stood those yards away from her, us both just standing there looking at each other, and there was a moment of silence and understanding between us, the moment of actual connection. She muttered some insult at me, then turned and walked off down Beverly Boulevard, the sun rising behind her. As relieved as I was to have escaped the wicked blade of her knife, I watched her fade away and felt like I was a cog in a wheel of a dismal cycle of oppression. The whole thing was so sad.

Part Three

Crescent Moon

Beth and I often hopped the wall and strolled through the empty Hollywood Cemetery. The dark midnight cemetery full of dramatic gravestones made for a compelling walk; scary, mysterious, and cuddly. It was a great time for us to talk about our lives, real quiet and still.

But not on this night. As we walked down a secluded pathway a man slipped out from behind a gravestone. I tensed and halted, Beth gasped and grabbed my arm tightly. The man was walking away, but then he stopped and turned toward us, an elderly face peering out somberly from under a shabby gray cap. He was wearing an entirely green jumpsuit, and I assumed he was a maintenance worker, but what the fuck was he doing in the graveyard at midnight? Just a little old wrinkly dude. He smiled, saying it was nice to see a young couple on a romantic evening stroll. He told us he'd been working at the cemetery for thirty years as the night watchman, keeping an eye on everything. I asked him if it ever got spooky. He said, "Well, there is one grave where the strangest things have happened, come let me show you." We followed him on a little walk. I could tell Beth was scared, and I was doing my best af-

fectation of lightheartedness. We reached an old decrepit headstone poking up out of the earth under a tree. Extending his gnarled finger, the old greezler beckoned us closer. With his raspy lived-in voice he said, "Usually it's pretty normal and quiet around here, but sometimes at this very grave, just after midnight, if you look closely.......it's very unsettling." He was speaking very softly now, just a whisper. "Come closer, just down here, don't make a sound." He leaned over, his head right next to the stone. We leaned in with him, I could feel Beth trembling beside me, and my jaw clenched tight. He continued his gravelly whispering, slowly drawing out the words, "It's the strangest thing, but............" Then he shot his head around quickly right in our faces, and screamed "BOO!!!" We jumped back and screamed in fright, my heart pounding out of my chest. "HA HA HA HA HA!!" He laughed hysterically and slapped his thigh, his eyes lit up with merriment. "Gotcha! HA HA HA!"

The Question

At the age of seventeen Beth became my first girl-friend. She lived with her mother in an apartment in the Fairfax district. Her father had committed suicide some years earlier and Beth's mother, who worked hard to make ends meet, seemed harried and overwhelmed. The last thing she needed was her young daughter dating a weird-looking, out-of-his-mind, drug-taking, absolutely irresponsible in every way, wild-ass Michael Balzary.

Yet Beth embraced and loved me. She was the most beautiful girl I had ever seen. I admired her and was so excited to have a girlfriend. She dressed cool, she loved punk rock and arty music of all varieties, she was intelligent and curious. She had great taste and an awesome affinity for cutting-edge art and film. She turned me onto oodles of great music, like The Plugz, the Gun Club, and the Slits. She was so generous with me.

Wanting to appear worldly, I lied and told her I'd had sex with other girls. I made up a story about me and Anthony being with some girls we had met at a Blues Brothers concert. I was embarrassed of my virginity.

That all changed with Beth, I was thrilled to be having sex

all the time, it was unbelievable. Lovemaking finally revealed itself to me in all its glory. To be that close to her, to be embraced, to meet in this new dimension where love could be given and received so profoundly. Hot damn.

But the truth is, I was an asshole. Once I realized the deal was that she loved me no matter what, and would pine for me when I ran off with my friends, I was callous with her feelings. I used the relationship when it was convenient.

I had no idea what I was doing. I had never seen a healthy relationship, and it was gonna be a long time before I even began to try to understand how to build one. A pompous fool, I loved having someone who thought I was cool and propped up my ego.

We still managed to experience profound times of trust and love. We laughed a lot and comforted each other. I treasured the tenderness between us, and felt a deep gratitude for her kindness to me. She left me funny notes on her door, instructing me when I showed up at her apartment late at night after a gig. "I'm asleep, Spleep! Don't be a llama and wake my mama! Get yerself out of limbo, throw a pebble at my window!" When I got arrested for shoplifting, she ran all over town to get the bail money together to get me out, and I will never forget the depth of love-hug when she met me in the police station before we walked out holding hands under the starless and smoggy night sky.

But she trusted me with her beautiful heart and I was incapable of honoring it.

Once I got the sex, I felt like such a great macho success story that I thought I didn't need her anymore. I was the great conquistador, the heroic lover. In this great big world of beautiful and interesting women, who wouldn't want me?

Setting up a painful pattern I'd repeat again and again in my life, I went back and forth in our relationship. Arrogantly breaking up with her, then, when I was lonely and feeling like I made a big mistake, trying to win her back. How fervently I tried to regain her love! How many bad poems I wrote and arguments I made on my behalf! How insecure and jealous I was if she dated someone else, even after I'd callously trampled on her heart! How vicious the self-flagellations on the frayed netting of my nervous system......Please come back to me so I can escape this searing, sleepless, and foodless pain. So I can escape this obsessive need for your love. So I can escape myself.

Like a little orphan baby who cries out to be held, only to cry again when they are picked up, because they can't handle the closeness.

If someone truly expressed love and devotion to me, I assumed they must be defective. That's how fucked up my sense of self-worth was. A common and pathetic emotional/spiritual issue for sure, but one that has hurt me and others in my life. *I still struggle to rise above it.*

In retrospect, I would wish for Beth a kinder and more thoughtful person than I was, but she didn't choose a person like me by accident. We were both kids, searching.

I was out of my fucking mind.

Ed Yu Kay Shun

No institutions of higher learning for me. All that cutting class, along with my *Fuck it, I'm gonna be in a band anyways* attitude, lent itself to some miserable report card days, and no one was gonna be paying my way into any fancy $$$ university. *(Despite my sucky grades I did rock star my way in to the University of Southern California later, at the age of forty-six. And I loved it there.)* I tried a couple of junior colleges for a week here and there, but I knew it wasn't for me. Walking around a college campus eating their shitty food in an attempt to set up a "stable" future? I saw it as a lame security blanket, and the most cowardly, futile, boring, colossal waste of time on earth.

Don't forget, I knew it all.

Once I made the decision to rid myself of the public school system, I felt a surge of happiness. Like a snake shedding its old dead and dirty skin. The dark fear of being a loser was eclipsed by the lightness of freedom.

In my bones, I knew I was doing the right thing.

Skood

Anthony was living with a cat named Dondi from Fairfax High in a little timber house on Wilcox and Willoughby. We called him Skood. He'd played tenor sax in the orchestra with me at Bancroft. Skood was the first kid we knew with his own crib, and we all hung out there. He had great taste in music and a deep and varied record collection. Working at a record company, he got all these new releases, adding to his always evolving library. I heard many a record at his house for the first time, and learned a lot about rock music; Patti Smith, The Specials, Talking Heads, Gang of Four, Sparks, and lots of new bands that I was too geeky to know anything about. We'd get high and just listen, listen, listen. Skood also loved jazz, spurred on in part by the jazz musician friends in our circle at Fairfax High, Patrick English (he and I played a million trumpet duets together and smoked a million joints), and Tree. Patrick lived in a small one-room apartment in the backyard of Skood's, and Tree lived there at a later point. Skood's room for jazz musicians, literally one room, a toilet in the closet in the corner kind of thing. Skood dealt blow for a while, and I have a terrible memory of seeing my

distorted and tweaked-out coke face in the mirror, disgusted with myself, as I hunched over it snorting the last line, just as, on the television in front of me, Ralph Sampson hit a lucky turn-around go-ahead set shot to knock the Lakers out of the Western Conference Finals, me falling on the floor, coke straw in hand, in disbelief. "That skinny motherfucker from the University of Virginia did us in??? Goddamnit! AAAAh-hhhh! And there's no more blow??!?!?!?"

My stepdad Walter played with Patrick English's pianist dad, Jack English, on gigs sometimes. Walter and Jack must have had a tiff because I remember Walter coming home one night to Laurel Avenue in an obstinate drunken state complaining that Jack didn't know the chord changes to some tune. I was lying in bed trying to get some sleep for school the next day, and he was boorishly yelling about it for an hour, "He don't know the changes! He donno the fucking changes to nothin'!!!" (Repeat ad nauseam.)

A Neat Little Ditty

Hillel, Jack, Alan, and I sat excitedly gathered around the radio. We'd recorded a demo tape and a station called K-WEST was going to play one of our songs as part of a special Sunday night program for little local bands. We listened to song after song, our impatience mounting, until finally, the peppy DJ chirped up, "And here's a band called Anthym, with a neat little ditty called 'Clocks'!" We sat ensorcelled, hearing ourselves on the radio for the first time ever. The music existed in another form, taking a life of its own. The concept made me dizzy. It ended, and we erupted in laughter, I jumped around the room. " Hahahahah! A neat little ditty!"

I still feel like that when I hear our music on the radio. Such a trip, something so personal and close to us, gone off to live its own life, becoming different things to different people.

Working Stiff

So there I was, a young man needing to make a living in the world. I worked a full-time job during the day, and Anthym practiced most nights. To honor our increasingly arty aspirations, we changed the band name to What Is This. (While we were trying to think of new names, Hillel suggested Lorne Greene's Dog, and The Captain's Log......someone...use it...*I beg you...please.*) The boys thought I was good at speaking to music business types, so I was designated the band's manager/agent, and we had business cards made up for me. I hustled gigs. I was starting to get good at talking a line of shit to the club promoters before Jack's girlfriend Kevin took over as the band's manager.

I always had a strong work ethic. At the age of nine, I went knocking on every door in the neighborhood offering to mow the lawn for a dollar. At eleven, I stood outside the local supermarket exit and helped people to their cars with the unwieldy grocery bags to get tips. I've always been an earner, be it a substantial job or hustle. I had paper routes, worked in phone sales, been a collection agency weasel, and spent the most mundane days as a file clerk in a law office. I inherited

industriousness from my father, who showed me that no one was gonna do it for me.

My first full-time job was as a delivery boy at a liquor store, a place run by two brothers, Wilfred and Amos. Wilfred was a sweetheart of a man, and for him I would have done anything. I enjoyed whiling away the slow night hours with him chatting and listening to the radio. I told him about my dreams to touch people's hearts with music, and was uplifted by his warm encouragement. The other brother was more uptight. If there was slow time he invented work to be done. Keep sweeping. Sweep the fucking parking lot.

I was driving around delivering booze, when Led Zeppelin's "Ramble On" came on the radio. It was so beautiful I had to pull over. I wept alone on the side of the road as the music moved through me. I was so certain that my life's work existed in the form they created.

Year later, I had a similar experience with Led Zep on a plane. I was listening to Physical Graffiti *in my ear goggles when the plane lurched into the wildest turbulence and plummeted. The flight attendants hit the floor, I thought we were going down, everyone on the plane was crying and screaming. I just listened to "In My Time of Dying" in happy tears, thinking it was all a cosmic setup, that I got to hear this beauty before I died to merge with the cosmic groove...... The Mighty Led Zep.*

I delivered whiskey to a lonely old woman in a wheelchair who had me retrieve her shot glass from its hiding place in the potted plant, then hide the bottle up in the plant; expensive wine to Westside Fancypant Sophisticates who tipped nothing; and beer to stoned party dudes who tipped well.

Each night after work I took my tips directly to Aron's record store on Melrose, and thumbed through the used record bins copping everything that looked interesting. King Crimson, Alice Coltrane, Gregory Isaacs, the electric Miles Davis funk records like *Big Fun* and *On the Corner*. *Corner* blew my mind. Best weed music ever recorded. Spark up a fatty yeeeah.

I showed up to work tripping on acid one sunshiny day when the uptight brother was there. He had purchased a new car for the store and insisted on putting me through a driving test. I was trying to hide my high from him and attempted to make conversation, saying philosophical things while he instructed me about the new clutch and gearshift. He was a somewhat religious man (in a lip service kind of way), and I told him that all religions were exclusive and elitist country clubs poisoning the love in our world. Raising an eyebrow of concern, he looked at me with disgust and told me to keep my eye on the road. That was Mr. Toad's wild ride for sure, but I pulled it off. I quit or was fired after a year or so, can't remember which.

There's No Place Like Home
There's No Place Like Home
There's No Place Lik

Anthony, JK, and I rented a house together on Formosa Avenue in Hollywood. A cool little half-hearted craftsman home that had once housed a family of moderate means, but now existed in the heart of hooker and drug territory, the poor old house's feeble attempt at architectural nobility dragged slowly through a landscape of syringes, crack pipes, and used condoms, like a dinosaur into a tar pit. Half a block south on Santa Monica Boulevard, an all-day and -night parade of male prostitutes, the outlines of their cocks visible against tightly panted thighs, letched over by gay men too intimidated by society's backwards-ass prejudices to come out of the closet. Just north on Sunset Boulevard the river of female prostitutes flowed, certainly inclusive of my friend, the woman one C-note richer via me. They all walked by our house constantly. I once saw a group of women strolling by the front of our house. One of them stopped and pulled up her miniskirt, stooped over with her hands on her knees, arched her back, pressed her ass up against a telephone pole, and peed on the tarry wood.

We all worked our day jobs, and nurtured our dreams.

My first home away from my parents, I was thrilled and grateful.

Neighbors Voices

We partied our asses off many a weekend night at an underground club, the Brave Dog. A bar with a small stage in the corner, chock-full of the arty downtown denizens who made up the post-punk scene. Its festivities bled out into the parking lot and alley behind, where on those hot summer nights the unexpected always happened. The grit and grime of that industrial, desolate part of town was a canvas on which we painted like mad men. I got so excited getting dressed up in some nutty outfit at the Formosa house, all kindsa psyched up listening to X's first record, scrubbing my balls clean in hope of getting laid. Smoking brotherly joints, driving recklessly down those L.A. streets, ready for anything.

At the Brave Dog I saw a band called Neighbors Voices, and the music floored me. I was startled; it sounded like the future. Three French guys and an American singer, Gary Allen. Gary was wearing this absurdly oversized jumpsuit thing that he could squirm around in, putting his legs in the arm hole while his head came poking out of the leg. He kept morphing shape, moving around and dancing in it, singing in strange theatrical voices. All the while the band playing this wild, angular, driving,

arty, and propulsive music that just drove me fucking crazy. It had a jazzy dissonance to it. No bass player, just two guitarists and a drummer. The drummer, Joel (pronounced *Zho-elle*) Virgel-Vierset, leveled me. Originally from the island of Guadeloupe, he played African-Caribbean flavored beats that webbed into a hard-as-fuck hybrid with disco and funk.

Along with some others in our crew, I befriended them. Both Joel and Gary became close and influential people in my life. Gary was from the south. A warm and kind gay man who showed me the sweetest friendship, he was a mentor with advice and encouragement, which to be honest, felt motherly. He was like family. He made wild clothes for various artists, rock stars and whatnot, and would give me cool outfits. The three French guys in the band had been living in a parking lot in Venice. One of the two guitar players, David (pronounced *Daveed*) Mamou, told me that at one point he had gone back to Paris for three months. When he returned to L.A. he was amused to find the other two guys still living in the parking lot. He was laughing hysterically about that. Their French street hood brand of wacky and intelligent humor was different than anything I'd known. They soon got a storefront in Hollywood, where they lived and rehearsed their band. It was on Yucca Avenue right next door to the soul food restaurant, Greens and Things, a small room where a taciturn man sipping from a forty-ounce bottle of Olde English 800 would fry you up a plate of chicken that made you feel like it was good to be an earthling.

I began a musical relationship with Joel; he and I jammed frequently. We had some great rhythms happening and came close to starting a band, but just never got it together. Some transcendent long jams I'll never forget. I was finding my own rhythm as a bass player, pushed forward by Joel's unique beats.

My Three Sons

Even though we all had jobs and took care of our rent at the Formosa house, things got strange in a hurry. JK became aloof from Anthony and me due to general personality conflicts, and he was steadfastly against me and AK throwing a wild party one night (our goal was to have the craziest party ever in the history of Hollywood). His frustration was exponentially exacerbated by the fact that Anthony and I had discovered the joys of shooting up cocaine. This cocaine shooting (geezing) led to some pretty quirky behavior, and JK, who was wound tightly at the most peaceful of times, didn't dig it. He was reacting in quietly mysterious ways, cooking up plans to rid himself of us and our absurd shenanigans.

When Anthony and I had the craziest party in the history of Hollywood, I took many handfuls of brightly colored pills and capsules from the veterinary hospital I was now working at. All through the living and dining rooms of the Formosa house ran a molding about chest high, a three-inch-wide little shelf connecting all along the walls. I placed hundreds of pills along the shelf throughout all four walls of the dining room in a vibrantly color-coordinated pattern, a beautiful art installation.

The pills were for various animal maladies like diarrhea, raw spots from excessive itching, and also included antibiotics and tranquilizers. The crowd of Hollywood high- and lowlifes ate the pills and puked and pooped for days afterward.

Emerging through the craziness of the party crowd came Snickers, a dude from a local punk band called the Stains. He commandeered the stereo, took off the arty music we were playing, and put on an AC/DC record. When I tried to put on some Ornette Coleman, he jumped up in front of the record player and whipped out a bowie knife. A forty ounce of Schlitz in one hand and the knife in the other he stood guard over his AC/DC for the length of the album, stoically banging his head, greasy hair hanging down over his wildling bloodshot eyes. I wasn't gonna fuck with him. True rocker. We later became friends.

Here Come the Geezenslavs

It would be darn near impossible to justify the wisdom of injecting a solution of cocaine and water directly into your veins. I can't remember how we learned to do it properly (Anthony knew how, I guess), but we did, and in the beginning we were quite organized about the ritual.

We worked out a great hustle to get spikes, taking turns going to drugstores to work it. We posed as personal assistants for our diabetic boss, someone who needed injectable insulin. Beth's mom was a diabetic and I saw insulin and syringes in their fridge. I saw that her type of insulin was called Lente U-100.

```
        Movie of My Life,
    I'm Played by Tony Curtis

(Pharmacist is played by Walter Huston)
Scene 22B
```

INT. EARLY EVENING: SMALL BEVERLY HILLS
PHARMACY (SUMMER 1981)

WIDE ANGLE FROM BEHIND THE COUNTER POV

We see the inside of a brightly lit pharmacy
in Beverly Hills. A couple of middle-aged
women in gold jewelry and designer pantsuits
mill around, inspecting the shelved items. A
working-class, conservatively dressed young
man, Michael, enters from the street. He ap-
proaches the counter.

PHARMACIST POV CLOSE ON MICHAEL

Michael smiles humbly and offers a polite
greeting.

MICHAEL
Hey, how ya doin'?

MICHAEL'S POV CLOSE ON PHARMACIST

We see the pharmacist, an amiable gray-
haired man in his sixties sporting thick-
lensed glasses and a white lab coat.

PHARMACIST
Very well, young man! What can I do ya for?

Michael fishes into his pocket and retrieves
a piece of folded paper; he's sure to let the
pharmacist get a peek at it. On it is a long

list of "to-do" errands, almost all of them
are crossed out. At the bottom of the paper
it says "PHARMACY" with a few words written
underneath. Michael studies the list, occa-
sionally looking up in a friendly way.

MICHAEL

Let's see here, sir *takes big
breath, rolls eyes* *confid-
ingly*. geez she's had me runnin' all
day, you're my last stop. ooookey
dokey, I need, Bayer aspirin, shoe inserts
size twelve, Lavoris mouthwash, and umm hm-
mmm. what's this here? Lenty u-one
hundred ein-soo-line? Do you have that? And
a ten—pack of Cy-rings? Does that make
sense to you?

PHARMACIST

Well, we've got those first three things
in aisle two right behind you there, but
the insulin and the syringes, do you have a
prescription for those?

Michael looks confused for a second, then
a little frustrated and exasperated with
himself . . . he sighs.

MICHAEL

Gosh darn it, I knew I forgot something.
What time do you close? I guess I'll have

to drive up the hill to get it, I gotta get this stuff or she'll give me hell. I guess I can get back here in a half hour.

The pharmacist takes a pensive moment, a cloud of suspicion passes over his face, but it is quickly replaced by a relaxed benevolence.

THE PHARMACIST
Hey, no point in driving all over the place, and I'm about to get off work too. Just grab that other stuff off the shelf and I'll get your items, no worries, just remember that prescription next time, okay?

MICHAEL
(Smiling with relief)
Ah, you're a gentleman and a scholar! Thanks so much, buddy, I appreciate that.

CUT TO

EXT. EARLY EVENING BEVERLY HILLS STREET

We see Michael walking quickly down the street, he passes a trashcan and throws away everything but the fresh bag of syringes, which he eyes admiringly. He gets in a parked Dodge Dart and speeds away. He jams back to the Formosa house, fettying.

Fet-tee-ying

1. A word drug addicts use to describe the weird and excited feeling that takes hold when one has acquired his or her drugs, and is getting the logistics together to do them.

 ex. "We copped some tar from Charlie over in Venice, fuck dude, I was fettying so hard till I got in the Denny's bathroom and spiked that shit."
2. The name of a rapper, Fetty Wap.
3. When your drunk uncle tells you to clean up that fetty mess after the piñata party has ended.

If I tried this hustle when I was already high, it never worked. Sincerity and clarity were key.

Hey, whattaya know, I just found this old instruction manual I used back in the day!

OFFICIAL GEEZING INSTRUCTION MANUAL[1]

This is the 24-Step Method. For the Quick Start (when ya don't give a fuck whether you live or die anymore) Method, refer to page 33.

1. Boil a pot of water to sterilize, then let it cool to lukewarm.
2. Fill a spoon with a syringe full of warm sterile water.
3. At this point, your heart should be beating out of your

1 Sanctioned by Speed/Coke Shooting Freak-outs Committee chapter 13, according to statutes 36B and 19C of the current bylaws section 3, Terrifyinghallucinationsareus, Inc. in conjunction with Ruinedlives, a Dr. Geezenslav corporation.

chest with uncontrollable anticipation. For novice geezers, it should feel as if you are discovering a rarefied place, a lost kingdom. It helps to see yourself as Marco Polo, or Ponce de León or some shit, on a secret and unique quest. Remember! You now have the ability to launch yourself into an exotic, dangerous, wild, creative dimension where anything could happen — and that means anything.

4. Under any circumstance, DO NOT realize what an old and pathetically boring story it actually is.

5. Using a razor blade, eyeball the cocaine into neat little piles.

6. With great care, using your handy razor blade, gingerly put one of the cocaine piles into a spoon of water and let it dissolve into a potent solution. This dramatic moment should be rife with nihilistic freedom. Be secure in the knowledge that things are about to change drastically.

7. Place a raisin-size balled-up piece of cotton into the spoon of solution. The cotton will unravel and expand with the juice of insanity.

8. Poke the needle gently into the wet cotton and draw the solution up into the syringe. Careful now, as not to waste a drop.

9. At this point of the process you should be speaking only in measured, restrained, yet excited sentences. Being wide-eyed and sweating would be appropriate. The sane part inside you knows this is a huge mistake and wants to speak up, but it is suffocated by your amped-up drug delusions and causing an indecipherable internal turmoil.

10. After repeating this process of filling the appropriate amount of syringes with the explosively foggy cocaine concoction, tie off your vein by wrapping a sweaty basket-

ball tube sock tightly around the biceps of your left arm. Make a sock-knot; your young teenage veins should be bulging readily in the crook of your forearm.

11. Fastidiously clean the injection site with a cotton ball soaked in rubbing alcohol. For the rest of your life the smell of rubbing alcohol will cause your stomach to tighten and conjure a panicked sweat, a Pavlovian response triggered by the upcoming onslaught of cocaine psychosis.

12. Have Anthony prepare a syringe for you. He'll tap it with his little finger like a scientist, making the air bubbles rise to the top, then push out the excess air so you don't get a brain aneurysm, a deathly explosion in your heart, or something else real bad.

13. He'll then bring the cocked and loaded syringe to your eager vein and slide the unused and shiny point into it. The metallic cocaine passageway is now lodged inside your lifeblood passageway.

14. As he pulls back gently on the trigger, you'll see a rich red rose cloud of your blood float up and expand flotaciously in the drug juice.

15. When you see that, you feel just like you did just before you jumped off the trestle bridge in Michigan and couldn't believe the control you had over our own reality. You love changing reality.

16. He'll then methodically push the liquid into your vein and.......Holy, holy, love, god, life's essence of purpose, all the energy in the universe erupts and surges through you. You'll now be hunched over, holding the cotton to your vein and the bells will be ringing, every sound, every voice or movement passing through some divine synthesizer module creating the most glorious ringing

sound, the audio part of this godlike feeling. You are now the most centered, singularly focused, intelligent, and uplifted person on earth. This massive flood of indomitability and sheer physical and emotional pleasure fueling all your senses and every word out of your mouth. The moments that pass now become as significant or insignificant as all of time and history itself. You are an enlightened master.

17. As this feeling apexes for a minute or two, pace around the room and become more aware of the chaos. Begin to garner just a hint of desperation. Speak a lot about how incredible you feel, with serious insight into your hopes, challenges, dreams, and how great you still feel, and how great you and your geezing partners are. Keep talking to quell the approaching fear.

18. Now the richness of power will start to dissipate, the glorious sound fades and a feeling of emptiness and impending doom rears its head, just to say hello. It is still dwarfed by the power you continue to blather on about, however more feebly, furtively, and frantically.

19. Then existential despair; its voice will grow louder and clearer, your sense of strength, mega-poignant meaning, and insight disappears, and you begin to feel bereft of any sense of things being okay You'll feel like an empty shell, in horror of your very existence. You are a weak and shaky loser. Every thought of insecurity and lameness you've ever experienced is more and more magnified and taking over your being. It increases its awfully implosive intensity and you feel yourself being dragged down, pulled into a murky bottomless pond of death. (Note: If you don't feel this way, complain to your dealer.)

20. But never mind, another shot of coke will fix it! It will lift you into the exalted state once again, but this time the rush of greatness will not be as divine; it won't last quite as long and it will feel like your heart is about to explode out of your chest. Rest assured you are doing permanent damage to your physiognomy. This time around, the godlike pleasure will be briefer and less powerful, and the despair and feeling of endlessly dying will come even sooner, with more oomph.

21. Continue on, keep geezing and geezing the night away, until your arm is a bruised-up pincushion. Just keep fruitlessly chasing the feeling of that first rush.

22. Repeat until it is ABSOLUTELY IMPOSSIBLE to score any more cocaine. Any method for obtaining the money for cocaine purchase, or convincing the dealer to front you more, is acceptable.

23. You should now be a freaked-out shaking wreck, still amped and crazy, but exhausted, hollow, desperate, sad, and hopeless. You have also risked getting a deadly infection or disease.

24. Lie down and wait for sleep. Grip your pillow tight and clench your jaw intensely. Your mind should be whirring pointlessly, telling yourself it is okay in an attempt to placate the worst depression ever. Repeat until you finally wake another day, feeling like you've been hit by a truck.

Fuck, I'm so lucky I didn't die doing that stupid shit. But it hurt me bad.

For clarity's sake, I've never been a drug addict. A wildly out of control and misguided experimenter, yes. I thought there was

something to find there, but those drugs play tricks on your brain, toying with your chemicals, your serotonin, dopamine and shit, making you think something meaningful is happening. It's all bullshit. There is no romance there, there is nothing. Experiments that yielded sadness, neurosis, and physical damage. It takes from you and gives you nothing. Zero.

After one of my first geezing binges I went out partying, thinking I was so deep and intense because I had spent the night shooting up cocaine. I imagined myself as a real underground artist experimenting at the edge.

I was at the vibrant L.A. downtown underground club Al's Bar, where I saw some of the best early rock shows of my life, 45 Grave, Neighbors Voices, the Meat Puppets, and Johanna Went. *Al's was also where the Red Hots had some of our first-ever gigs.* Trying to chat up a cool girl, I attempted to impress her with my drug tales. I showed her my arm covered in fresh track marks. She stared back at me with a horrified and sympathetic look, sadly shook her head, and walked away.

Oops.

I felt like I was telling her I'd just climbed Mount Everest, or scuba dived with killer whales, and she looked like I'd just told her someone had died a gruesome death.

I thought coke-shooting meant we were living up and beyond the parameters the squares had set up for us. In that world of insane drug abuse, the most bizarre behavior seems totally natural. The way I acted when shooting cocaine, or later when I freebased or smoked crack, was frantic, desperate, deranged, and the opposite of the life that I would ever want for anyone.

I didn't really see how destructive geezing was until I witnessed someone else doing it while I was sober. I came home

with Neighbors Voices' David to find Anthony standing on the roof of the Formosa house holding a huge car tire above his head. Geezed to kingdom come and in the throes of cocaine paranoia, talking about how someone was trying to attack him. He was ready to bomb them with the car tire from above. We talked him down off the roof, then went into the house to settle him down, and help banish the imaginary demons. He kept looking for the monster hiding in the closet and under the bed. I later discovered this type of scene to be common behavior when experiencing cocaine psychosis.

My behavior was just as irrational and bizarre when I was on a coke-shooting binge, yet it seemed perfectly logical to me at the time. When I was crawling around on the floor looking for rocks of crack and accidentally smoked rat poison, that seemed like the proper thing to do. If a drug maniac screams in the forest and he doesn't hear his own insane screaming, is he still a drug maniac? When I was shooting coke I just wanted more, and in that moment was willing to humiliate myself, consciously or not, to get it. I was irrationally terrified whenever the rush wore off and that's when my own psychosis came out to play.

On that surreal day on the rooftop, Anthony eventually split, so David and I left to go eat sandwiches at the Thrifty drugstore lunch counter around the corner on La Brea and Santa Monica. David, in a thick French accent, gesticulating wildly, said, "Eet's like a cartoon, he's going to throw down the tire and it will land perfectly over the bad guy's head and trap his arms and tie him up!" We had a long laughing attack over that. It seems terrible now, to laugh over someone's misfortune, but that was us. It relieved the tension. To top it off, then David pointed farther down the lunch counter

and exclaimed in a hushed but excited voice, "Look Michael!......Popeye!" And ladies and gentlemen, I swear to you, Popeye himself, come to real life, was right there a few feet away digging into a cheeseburger. He wasn't in costume but it wouldn't have been a stretch. Buff and burly forearms, grizzled face, sailor tattoos, corncob pipe. It was un-fucking-believable. What a day.

When we were banging blow, Anthony and I used to call ourselves the Brothers Geezenslav. Thelonious and Bartholomew Geezenslav.

I didn't understand what I was bringing upon myself. I, already in such dire need of spiritual and emotional healing, bludgeoning myself further into a state of suffering.

And all that part about being so fastidious with the cotton balls and rubbing alcohol and fresh new syringes? That didn't last long. For instance, a year or so later when I was acting in the film *Suburbia*, I was at a party with a bunch of the kids from the movie and a guy named Bugboy was in possession of a fucked-up old syringe. All the numbers and lines were worn off it, it had a dull needle point, and was filled with a powerful batch of crystal meth and water. People were standing around and just stuck their arms out, about four or five of us. He stuck the needle in an arm and gave 'em some, then pulled the needle out and stuck it directly into the next hapless arm. I got in line and took my dose, Bugboy pushing the bloody syringe into my vein (more on this night later). Dear God, thank you for my survival, my benevolent guardian angel watching over me, thank you. Wow. Shit. I lived, I didn't OD or get AIDS. Could I have been stupider? More self-destructive?..........................It seemed like a good idea at the time.

*

Through all this insanity, I never stopped reading. Good literature could very well be the thing that stopped me from going over the edge, becoming a junkie, or completely frying my brain. Crucial to my sense of self was the sanity, moral guidance, and intellectual stimulation I got from books. The sanctuary that well-crafted novels provided reset me into a healthy state. I related deeply to the stories, admired the poetic prose of a great writer, and felt less alone. It expanded my world beyond my underground Hollywood cocoon. Though it is true that during this drug period I especially enjoyed the drugged and boozed-out (but no less profound) literature of William Burroughs, Charles Bukowski, and Hubert Selby Jr., I found deep peace in reading. Unless I was too wasted to do it, I read every night.

I was completely captivated by Bukowski's novels, each one better than the last. His ability to show a profound love without necessarily even achieving that love himself. But he saw it, stood in awe of it, and exposed its beauty for all of us. Sophisticated insight into humanity expressed in simple flowing language. The pages of his stories were drenched through with the grease and blood of the streets that I grew up in. I wish he were the singer in a punk band. He was also my gateway to poetry. I'd always stumbled when trying to find my rhythm in understanding poems, too impatient to feel the essence of them, thinking that I just wasn't educated enough or something. I couldn't surrender to the form. But like Basquiat did for me with paintings, so the great Buk broke it all down for me in layman's terms. They were soulful and fun to read, I fell in love with his poetry, and then Pablo Neruda, William

Blake, and Arthur Rimbaud. I met Buk once, sitting on a stool, sucking on a Budweiser, in a downtown L.A. bar. I controlled my excitement and he tolerated me. He'd written a particular poem that melted my heart, an ode to his cat, "The History of One Tough Motherfucker." That poem made me cry, I told him so, and he accepted my praise graciously. Then he said, "So you love cats, what else do you love?" I told him I also loved basketball, to which he replied sardonically, "Ahh a bunch of black guys in stinky shoes running up and down and up and down BLAAAHHH," then turned his head to speak with someone else. He came from another world.

It was rare for me to find someone to whom I could relate my love of reading. A couple of my closest friends actually put me down for it. They both said the same thing—that I was living in a fantasy world because I couldn't deal with the real one.

Angels

Beverly Hills, Century City; Everything's so nice and pretty
All the people look the same; Don't they know they're so damn
lame

— The Circle Jerks

LET'S WORK
— Prince

I got a job as a photographer's assistant. It wasn't a cool
job with fashion models lounging around in their un-
derwear listening to cool music as Helmut Newton and I
exchanged witty quips. I worked for a guy who took the pic-
tures for school yearbooks. We would drive around to the
public schools and he'd shoot all the kids one by one. My job
was to write down their name, sex, and shirt color, so they
didn't get all mixed up. Howard-Boy-Red, Agnes-Girl-
Lavender.

The photographer boss man was a classic seventies cheese-
ball. He wore polyester print shirts (buttons always unbut-

toned enough to show some hairy chest and lame gold jewelry), color-coordinated polyester bell-bottom pants below, and a blow-dried comb-over up top covering his bald spot and accompanying his unfortunate mustache. I took his reeking stench of bad cologne as a personal insult. He was always bragging about all the pussy he got, how he slept with three girls at a time, etc......He gave me the creeps. Once we went on an overnight trip to Palm Springs to shoot a high school. We had to share a motel room, and I awoke in the middle of the night to the sound of him whining like a baby while aggressively masturbating. It was the worst thing I've ever heard in my life. On the drive back to L.A., he was bragging to me about his expensive sunglasses, how amazing they were and how they bathed his eyes in the perfect light. He went on to tell me that if I stopped dressing like a loser and paid more attention to how business worked, I too could one day afford to dress like him. He then stuck his head partially out of the window to make a lane change and the sunglasses flew off his blow-dried head into oblivion. He punched the dashboard, cursing in a childish tantrum while I stifled my laughter. He abruptly fired me soon after, calling my style of dress unacceptable.

I soon found a new job as a messenger, driving around in my Toyota Corolla delivering packages. I enjoyed the freedom of being alone and listening to the radio. For the first and only time in my life I became addicted to radio jamz. I listened exclusively to a station owned by Stevie Wonder called KJLH. Kindness, Joy, Love, and Happiness! I just wanted Marvin Gaye, the Gap Band, Aretha, Lakeside, Evelyn "Champagne" King, Rick James, Prince, and Stevie himself. Prince was hitting me hard. I blew that job by not showing up one day because the beach was calling my name.

My last straight job was working for a beautiful man: Dr. Miller, at the aforementioned animal hospital on Melrose and Robertson.

It sat just where the color of Hollywood faded and devolved into the sterile banality of Beverly Hills. B.H. was the most ostentatious, boring, and off-putting part of Los Angeles, the only part of the city that I always wanted to escape as soon as I arrived. But this West Hollywood corner still held a modicum of flavor from the sheer free gayness of Boystown, that vibrant strip of Santa Monica Boulevard a few blocks above, and the Sunset Strip just beyond. The Sunset Strip was home to some of the greatest of psychedelic and classic rock in the sixties and seventies, but by the time the eighties rolled around it had been taken over by the unimaginative hair metal crowd (except for rare instances at the Whisky a Go Go). The exciting and original underground punk and art scene forged its own path on the east side of Hollywood, downtown, East L.A., and in the failed utopias of suburbia down in the South Bay.

Dr. Miller was an amazing man, a cloud of gray hair and a bulbous face of spirals. He had a giant nose you could see for miles before making out the rest of his lumbering bear body. I was a wild and out of control kid, but he was a kind, wise, and trusting man, who hired me to work as a receptionist. He knew I was a risk, but wanted the best for me. He had a remarkable gift with animals. The most violent, frothing at the mouth guard dog, the insanely psychotic, back-arching hissing cat — all beasts quickly calmed by his hairy hand gently placed on their angry heads. Amazing Dr. Dolittle type shit.

I repaid his kindness by stealing from him. I wanted geeze money for me and AK, so I figured I'd sell dog food and pocket the twenty bucks. *About fifteen years later, when I*

called him to confess that I had stolen, to apologize and pay him back, he said, "Oh Michael, I never would have expected that, you were such a nice boy, I'm so pleased that you contacted me." We went on to have a good chat reminiscing, no anger from him or display of disappointment, just forgiveness and appreciation. He was an enlightened soul.

Me, the nice boy staggering into work off an all-nighter meth run, staring into the distorted faces of impatient clients come to drop off their Fifi. Dr. Miller was no dummy, but he saw something good in me. One coworker woman was hip to my act, we'd started off as friends but it went south when she saw me high, and in front of everyone she loudly ratted me out for being on drugs. He wasn't about to fire me, but after a few months Dr. Miller decided it would be best to have me work in the back of the hospital helping with the animals, instead of greeting the humans up front. So I cleaned poopy cages and assisted in minor medical procedures. One job was jacking off a dog's cock while another guy put a cloth with a bitch's pussy scent on it in the dog's face. The dog gizzed in a tube.

I wasn't Dr. Miller's only freaky employee. In the back I worked with Kai, a hard-drinking elderly gentleman. He was gruff, hilarious as hell, and took shit from no one. He put me in line on my first day, locking me in the freezer with the dead animals, a practical joke to be sure, but letting me know who was in charge. It turned out Kai was father of the great rockabilly star Gene Vincent. Gene died in his thirties, while he was visiting Kai in California. But Gene lives forever. I love Gene Vincent! "Be-Bop-A-Lula" motherfuckers!!!

Another coworker was Tim, a free spirited young gay man who'd grown up in institutions, done lots of time in juvenile hall and prison.

Tim was my friend. We'd smoke pot, play with the little puppies and kittens, walk around the local park at lunchtime and eat burritos. Tim didn't see the sense in paying rent; he created makeshift camps in the wooded chaparral of the Hollywood Hills. He had a full-time job, and was never dirty or homeless looking, but was content to sleep out in the bushes of urban Los Angeles. He also had some sugar daddy setups where he would stay at nice houses; I once visited him at a tony mansion in Hancock Park.

I enlisted him to score a gram of blow and syringes. To my disappointment, he showed up with the yayo but no spikes. He explained that he had 'em, but threw 'em away out of concern for my well-being. He said, "Let's just mellow out and snort a few rails," before delivering an emotional plea to stop using needles. He saw a great future ahead of me as a musician, and was looking to protect my crazy ass. God bless Tim.

Idiotically, I wrote down the lyrics for "Psycho Killer" by the Talking Heads on a piece of paper and showed them to him, lying that they were mine. I wanted to impress him. Damn, I guess I was always trying to prove something.

Tim was promiscuous for sure. Our friendship preceded the AIDS crisis by just a couple of years, and I pray that he is prospering. He'd been through a lot, but was unfailingly optimistic, and always had a gentle smile for me. After that job, I never saw him again. Tim was an angel, and Dr. Miller was a saint of a man who looked out for me time after time. I treasured that job cleaning up dog shit; there was a lot of love there. Enlightenment never comes where you expect it.

What Is This

While working at Dr. Miller's I rehearsed with What Is This in the evenings. We were focused, doing all we could to make it happen, playing every club in town. I should have worked harder on music though and not partied so much. Hillel, Anthony, and I hung hard on the underground club scene.

What Is This was a one of a kind, arty, prog rock band, and occasionally damn good, but we were unable to actually break through to the other side. A band needs to be more than good at playing music. It needs to tap a source, to awaken a feeling that lies dormant in the people, a freedom and beauty that is normally eclipsed by the shadows of everyday life, a feeling we didn't even know we had. Anyone can learn to play an instrument well, but the spirits need to step in. What Is This just couldn't ever connect with people and stir their hearts, it's just what it was.

The scope of my music listening had been expanding constantly, making me gyrate in new patterns. Between Skood's massive and always-evolving record collection, Beth's underground music tastes, and spending so much time out at clubs

hearing and seeing new sounds, all different feelings flooded into the mix. Hendrix still made my hair stand on end, but a new kind of rhythmic rebellion was making me jump. Went to see Fred Frith's Massacre at the Whisky and Bill Laswell was playing the electric bass with a stick, a wild experimental thing that pushed me forward. The Gang of Four blew me away with their hard-edged beat counterpoint, and Material's *Memory Serves* had me entranced. Went to see the Lounge Lizards and got a new birth of the cool. Then the Talking Heads' *Remain in Light* came out and changed everything. Those deep grooves were unlike anything I'd ever heard. The way the rhythms moved!!! They had me dancing like an animal; intelligent and groundbreaking, the composition was stellar. David Byrne and Brian Eno then made *My Life in the Bush of Ghosts* and I only wanted to play new rhythms. I relentlessly searched for new music.

Because what I perceived as great musicianship was still crucial to me, I didn't get into punk rock yet, but there was an intangible element to some new music piercing a hole into the fabric of the future, and that's what I wanted. Some of my seventies rock heroes were feeling this same bloody heart throb of a new era, like David Bowie with his amazing *Scary Monsters* album. But many of the classic rockers had become a part of history that I visited like a great old painting.

Jazz was a never-ceasing wild weather system; Hank Mobley, Lee Morgan, Kenny Dorham, Louis Armstrong, Ornette Coleman, Charlie Haden, and Don Cherry. It had every kind of rhythm from the most distant future and always woke me right the fuck up. I was crazy about the album *Blythe Spirit* by the inimitable Arthur Blythe.

Acid for the Children

LSD was good to me. Opening me up to another dimension, it helped me see what life was for, and the purpose of my yearnings. I made many of the wisest decisions of my life while on acid or psilocybin mushrooms — I'll get to those later. It gifted me a higher vision with which I could see the vibrant movement of the invisible. In a conscious way, it stripped away my fear of being criticized and freed me from the petty judgments I often doled out. Dissolving my ego, it magnified what was truly important, and unmasked those things that sapped my vital energy and distracted me from the path of divine beauty. Though I often acted the fool and misused it, was too young, forgot my lessons quickly, and could have used some mature guidance from a wise shaman, it guided me profoundly into my highest self and helped me access the superb wealth of my subconscious.

Psychedelics; LSD and psilocybin mushrooms are a great gift to humanity. However, they are not for everybody, are not to be taken lightly, and should be researched thoroughly and soberly before experiencing.

Like the time a few years later, on Easter day in 1981 when I went to see a band I'd never heard of, Echo & the Bunnymen. I think I was with Anthony and our friend Skood when we dropped some purple microdot and headed out to the Whisky a Go Go. I was just coming on to the L, peeing in the dilapidated and graffiti'd-up backstage bathroom when I noticed next to me, under a mop of teased-up hair, a thin handsome man in the coolest suit I'd ever seen, applying lipstick and eye makeup in the mirror. The guy was fascinating.

I was fully blazing on the acid, watching from the balcony, when the Bunnymen appeared onstage in all their muted black and gray post-punk splendor. I realized the lipstick dude was the singer Ian McCulloch.

From the first note, everything and everyone in the packed club disappeared into the big nothing. Only the band existed, their vibrating bodies channeling the music and glowing with the color of the sound. They were just about to put out the record Heaven Up Here, *and were playing the stuff live for the first time. The bass and drums locked into hypnotic rhythms, building tension, then shifting grooves mid song, to drop into a new beat section in a magik way that made my heart burst open. The guitar strumming of the singer dug in hard, brittle, and terse, and the lead guitarist countered him, answering with melodic strumming patterns of his own, and then he started layering the most ethereal and haunting melodies over the churning rhythms, and I started to float. The drummer Pete de Freitas was the one I couldn't take my eyes off though. He played like an animal, but with the poetic arc of a sensitive artist. It rocked so fucking hard, but embraced me with a nurturing warmth. Man. I've shamelessly copied their concept of play (with my own sense of rhythm of course) for my whole*

career. It wasn't just the hallucinogens. The acid opened the door, but the truth of the music was there to carry me away. Throughout their gig, I was one with god.

After the show, I spoke to the kind and thoughtful drummer Pete. I asked him about his favorite drummers, telling him mine was Tony Williams. He replied, "I don't care how good a drummer is, only if he serves the music in his band." That got me thinking.

People often ask me about my electric bass influences, ready to hear about the great players like Jaco, James Jamerson, Stanley Clarke, Willie Weeks, Bootsy, and Larry Graham. Of course all those guys have impacted me deeply, but I've stolen shamelessly from Les Pattinson of the Bunnymen, and Jah Wobble again and again. I also wore my belt like Ian McCulloch for years, the end of it sticking out too far through the buckle from under my shirt.

Rest in peace, broken through to the other side, Pete de Freitas.

Many years passed before I learned of other ways to access the healthy and limitless part of my mind that psychedelic drugs had opened in my youth. In 2001, deep into a Vipassana course, a few days into silence and ten hours a day of meditation, I found myself in a psychedelic state. My body had become nothing but light, I was one with the universe and anything I could imagine was possible. I was a rock in an Alaskan stream purified by the freezing water rushing over me as a massive beautiful brown bear lumbered by. I looked up to see an intricate geometric pattern of shapes in motion in the air above; changing and unfolding, the most beautiful vivid and sharp color combinations to make Josef Albers cry with joy.

I realized a profound simplicity of purpose, my focus crystal clear, I saw the beauty in all, and was overwhelmed with love and gratitude for all the joy and pain in my life.

In that moment, I learned that no drug was ever necessary for a mind-opening experience.

Unlearned

We pay fuck all.......
Do a runner!
 — The Slits

In the corner of our kitchen stood a tall ramshackle monument of supermarket carry baskets. Anthony and I had perfected a two-man method of shoplifting. One of us would walk through the market and fill up a carry basket with expensive food, then walk purposefully through the store with it. When approaching the cash registers and the entrance turnstile, the second guy would walk equally as purposefully in the opposite direction toward the exit, but on the other side of the turnstile. Then a swift and flawless handoff of the basket of goods over the turnstile, the second guy exiting the store with the gourmet grub. With smooth efficiency, we perfected our timing like an Olympic event.

Let's Have a Pah-Tay

It had become too chaotic at Wilshire Fine Arts, so Jack found us a new jam space on Venice and Hauser. Run by a dude named Beaumont, it was a dilapidated little stucco duplex, a small studio on one side, and Beaumont's home on the other. The studio walls, ceilings, and floors all covered in brown shag carpet, it was like walking into the belly of the Snuffleupagus, a dark, soft, and furry cave, the air rife with the smell of spilled food mashed into the rug, cigarette smoke, and moldy rotting wood. It was so dark inside, when we opened the door for a break we'd be blinded by the afternoon light, and do a squinty-eyed stroll down the street for a burger at Hank and O's.

No one else ever attended our jam sessions. No friends, no hangers-on, never a music business person, not that any had ever heard of us. Just us four finding our sounds. We never recorded a note, the countless hours of improvised jamming were untethered to anything but hope.

Beaumont had written a song, "Let's Have a Party." He was convinced it was his ticket to fame and fortune, and was always working on new versions of it with many different mu-

sicians and singers. It had a distinctive riff and lyric, and as a long-running joke we often broke into wacky renditions of it. He once enlisted us to record a version in exchange for a couple of weeks of rehearsal time. "Tonight's the night to party hard / Let your body move / It don't matter who you are as long as you can feel the groove / Let's have a pah-tay!".... etc. I wish I could hear that song right now, it would make me so fucking happy. I wish Michael Jackson would've sung it on *Thriller*. I wish Beaumont made a zillion dollars and drove a Rolls-Royce.

Joel Virgel and I once showed up there late night after a gig to drop off an amplifier. Beaumont was hanging with friends, listening to the new Cameo, the subdued group sitting ominously in the dark shadows of the shaggy walls. Minimal pleasantries were exchanged, the vibe weird and the deathly smell of angel dust hung heavy and inescapable. In the awkwardness of the moment, Joel fidgeted with a little wooden box that'd been left on the mixing desk. A menacing voice shot out, "Don't touch that shit, nxxxx!" and a microphone flew across the room, cracking Joel in the cheekbone. Wide-eyed, he jerked back, blood trickling down his face. The room was dead silent for a long moment. Joel and I scurried the fuck out of there.

Wayne

On another night at the Brave Dog, I met Wayne. A gay dude, he wore sharp suits and sunglasses, his hair bleached white and braided, a one-of-a-kind look in 1981. He was in the music business, and we hit it off. What Is This got together with him and discussed the possibility of his managing us. The meeting went well, and we decided to meet again after an upcoming backpacking trip. I don't remember what the other guys thought, but I was totally down. I spoke to him on the phone often, about music, books, things I loved. He was supportive, kind, and funny, and I was happy to have made a new friend. He lived in an apartment right down the street from Paramount Studios, whose ornate and intimidating wrought-iron gates could be seen from his front yard. Wayne told me how one day he'd be such a powerful creative whirlwind that those gates would open when he approached, just by the force of his presence. We sat on his porch dreaming of the future. After I had known him just the few weeks, me and my buddies left on our (absolutely fucking awesome again) backpacking trip. When we returned, I called him, full of nature's enthusiasm, to get to work. No answer. The next day I

saw in the newspaper that he had hanged himself in his living room. Man.

I was in and out of emotional pain, depending on my relationship with Beth or my friends. I lived with a sense of unease, a thing that has plagued me all my life. I can't outrun it.

A dingy East Hollywood storefront on Melrose near Edgemont, young people dressed in dirty leather jackets and dyed hair, drinking beer out in the street, a packed party inside. Vibrating with the energy of it all, I got myself inside to see the Circle Jerks crammed onto a small riser in the corner of the room. I thought *Well, punk rockers, let's see whatcha got.* I stood alone drinking a dollar beer when I was startled by a sudden loud *CRACK!!!* A bolt of fear shot through me and I spun around to see the sound coming from bassist Earl Liberty, he slammed his fist down violently onto his instrument again making the harsh banging. He paced in a circle with an animal urgency, a ferocious look on his face like he was about to explode if he didn't get to rocking soon. I was thrilled that a musical instrument could scare me, it was beyond notes. The band blasted into "Wasted," the room erupting into a wild throbbing throng. Pure primal joy, all for one. The physicality and speed of the music, the sheer free abandon of the crowd and the band joined together pulsing as one. Something awakened in me. I realized music could jar people out of their comfort zone, challenge them as to the very meaning of their existence. All the times in my life I'd wanted to disrupt things, to shake things up, and I now saw it being done in the healthiest way. Real alchemy. I fell in love with punk rock.

I played music and dreamed of the romance of being in a band that had mystical powers to move people.

One indelible image fed that dream: Anthony and I in San Francisco seeing the Dead Kennedys play the On Broadway club. As we were coming up to the venue, trying to figure out how to scam our way in, I saw the DKs guitarist East Bay Ray entering the backstage door. Carrying his guitar, he was modestly dressed in thrift-store attire. I thought it was the most beautiful thing, that image stuck in my head forever. They were such a wild band, their shows an extremely over-the-top, theatrical, violently visceral punk rock experience. Seeing them helped me understand, and fall in love with punk rock. And there he was, cool and meek, quietly going to do his gig. He seemed like a magical being. Just him in the dark with his guitar case. That was everything I wanted. To arrive out of the shadows and slip quietly into something so heavy and important. To belong.

That trip to San Francisco deserves some more attention:

Dawn/Don

or,

Buried Under Beets

Anthony had a crush on a girl up there in San Francisco, and we were always up for a Wildling's adventure. Before leaving L.A., we went over to some girl's apartment who gave us mohawks while we listened to the Smiths. Freshly mohawked (believe it or not, it was completely unacceptable to have a mohawk; jocks hadn't coopted it yet, and people wouldn't even talk to you), we headed downtown to the L.A. train station. Our scheme was to board the train to San Francisco, and when the conductor came by to punch our tickets, hide in the bathroom till he passed, then return to our seats and *chugga chugga* on up the coast.

Things began to go askew with the choo choo when we got in the bathroom. The two of us crammed into the tiny little john, we decided to shoot up coke. We fixed up, getting all surgical with the needles, spoons, and whatnot, and within a very short while we were gazibbaleeacked out our ever-loving minds. Now, our most earnest intention had been to just do a little coke and save the rest of it for San Francisco, but once we got started, we reappraised the situation and decided to do it all.

Right at the manic peak, our eyes bugging out of our heads

like we were in a Big Daddy Roth comic strip and the square wave sound whaling through our brains like the entire Mormon Tabernacle Choir was singing falsetto in the toilet, there came an insistent banging on the bathroom door accompanied by a militant yelling. "This is Amtrak security! Open the door this instant!" We stalled them while putting the paraphernalia in our underwear, socks, and various hidey-holes, just in time to be sitting there like two clean-cut college boys playing a harmless prank when security forced open the door.

The Amtrak people were all business, handcuffing us and escorting us off at the nearest stop. Into an office we went. An Amtrak official interviewed us; he said that the local police would arrive soon to deal with us punk rock freaks. So here we are, flying on this coke like a couple of demonic psychos, with needles in our socks, and Anthony starts telling the authorities that they are making a big mistake, his father is one of the top men in charge of Amtrak, and they're all gonna be in big trouble if they don't release us immediately.

Ha! A teenage Anthony could talk his way out of anything. I swear to you, if he went to hell he could convince Beelzebub to let him out, and if he went through heaven's gates he might convince the little baby Jesus to let him go enjoy a quick little afternoon in hell to get his ya-yas out, as long as he promised to be back by dinnertime.

After a little while of the third degree with the authorities, and AK threatening that his father would have them all fired, they let us go. We were somewhere in central California with minimal money, having geezed all our drugs; tumbling and crashing hard down a steep cliff into a post-coke shooting malaise.

"Posting" was our terminology for coming down from

shooting cocaine. The trip down is an instant abject sadness. As if your heart was broken to smithereens, all your hopes, vital energy, and worldly belongings gone, and your dearest loved ones dead. We paid money and risked our health for that feeling. Go figure.

Sticking to our plan, we walked onto the highway in the dead of night and stuck out our thumbs. We regained our equilibrium after a few hours and were picked up by a woman who introduced herself as Dawn. At about two or three in the morning on a lonely stretch of highway it was pretty bold of her to pick up a couple of freaky-looking mohawk boys, especially with that shaky coke vibe we had going. But, sheeeeeeeeyit, we downright appreciated it.

Charlie Chaplin, ever the Freudian, said, "The first thing any man does, consciously or not, when meeting any woman, is size up the possibilities of having sex." Of course, after the sizing, the answer is often no possibility at all. She was super dolled up; artfully applied makeup, a sexy dress, and smelling feminine, telling us she'd been out dancing and having a great time.

The three of us drove along for a few miles making small talk, when Dawn says she has to pull over for a second. She stops the car by the side of the highway, gets out, and disappears behind some bushes. A few minutes go by and Anthony and I are exchanging puzzled looks. Next thing ya know, a dude pops out from behind the bushes in lumberjack shirt and Levi's and says in a manly voice, "Hi, I'm Don!" Hahahaha, the guy changed out of his woman's look to go back home to his wife! What a genius. He drove us a ways more down the road before bidding us farewell. Kindness comes in all shapes.

Still a hundred and fifty miles or so from San Francisco, we

found a roadside motel where we curled up under a stairwell in its back parking lot. Not the coziest sleep I ever had but not the worst either *(that would probably be the one in the center divide of a road in Paris one night…yikes! Cold!)*. We woke from our concrete bed in the early a.m. and sauntered out to the highway, stuck out our punk rock thumbs, and, lo and behold, Don picked us up again and drove for a few miles. Then we got picked up by a classic hippie dude in a VW van with blacklight posters plastered about its interior. "Hey man, you guys want some trail mix?" He was totally cool, and drove us about fifty miles out. One more ride from a tweaky yuppie kid took us all the way into the city. San Francisco!

Right off, we went to visit the man Will Shatter (RIP), soulful bass player in Flipper (five-legged spider music, best known for the song "Sex Bomb"). What a great band! *(Rick Rubin had a band in college that totally copied Flipper.)* We were interested in purchasing crystal meth from Will and he obliged us, telling us to be careful if we shot it up because it "had a real kick." Dope in pocket, we headed down into a BART bathroom to shoot up that speed and get the party rolling. Whoop whoop! There we were in that dingy, stinky public bathroom stall, filling our syringes with meth solution. I spiked up a big load of it, and BAAAAM!!! Fuck me, it nearly blew my head off, I thought I was gonna die. It was so intense, my heart pounding, the world shaking, and Anthony just as blasted. After a moment, I gathered my senses and realized I was still breathing. Anthony came back into focus, and we commented on the extremity of our situation, then headed out into the San Francisco night.

We cavorted with some punk rock scallywags, friends of Anthony's who had a skate/street/punk gang called the Jax.

I wasn't much of a good communicator at the best of times, and now I was so high and nothing but a pulsating blatherer. As the night wore on we went to see Flipper and the Dead Kennedys, and man, the DKs were so exciting. Jello Biafra was an amazing intellectual animal of a front man, and the band was just vicious, people risking life and limb to dive backward off balconies into the crowd below, slamming into each other, feeling the spirit like elderly women speaking in tongues at a Baptist church meeting. D. H. Peligro was on drums and he shredded so hard, I was enthralled. Amped up like a couple of overcharged crackling telephone pole wires, we then headed down the street to see Snakefinger, a brilliant guitar player with a fiercely adventurous band, including the awesome bass player Sara Lee (who I loved in Robert Fripp's the *League of Gentlemen*). It was uplifting and inspiring. *Snakefinger previously had a band called Chilli Willi and the Red Hot Peppers but I swear to you from my heart, we did NOT know that when we came up with our RHCP name later.* It was a phenomenal triple-header of entertainment, meth or no meth.

We ended up the night with nowhere to go, walking the streets aimlessly with a guy we'd just met. We ambled along talking, unwinding, and coming down from the meth, until we ended up in the upscale neighborhood of Nob Hill.

As we hiked the streets, it dawned on me that our new companion was homeless. Anthony and I had nowhere to sleep that night, but it was like that for this intelligent dude every night. I'd experienced a similar feeling when I did heroin with real junkies; that I was just visiting, but they lived there. This guy assumed that we were homeless too, and we were in it together. I was straddling the fence, and it was a heavy feeling. Looking at two separate worlds of opportunity living right

next to each other, yet far apart. The Tenderloin ain't far from Nob Hill.

We needed to sleep. My mother had once told me that if I was ever caught out in the cold, newspaper made great insulation, so we went onto somebody's porch, took their *San Francisco Chronicle*, made newspaper blankets, and crashed out hard. Hadn't slept more than a couple of hours in two days and I passed out like a dead man. Next thing I knew, the sun had risen and I was being rudely awakened by a cop poking me in the ribs with a nightstick, causing me no small degree of discomfort. He was saying, "Get the hell out of here! Who do you think you are on someone's property??" AK and I got up, muttered apologies to the cop, and headed out into the day, no money, no food, and no way to get home.

We started hitchhiking, got a short ride or two, and then tried the train tracks again. This time we hopped into a freight train full of beets and hid ourselves under a mountain of the red vegetables for fear of being discovered and beaten by the much-storied cruel railroad bulls. The train began rumbling down the tracks, and buried under beets we were laughing and congratulating each other on how we were gonna have a nice beet nap all the way into L.A. Unfortunately, the beetmobile took us way in the wrong direction to a food processing plant in Salinas. As the darkness arrived, we got out and wandered around the railroad till we found an old rusty toolshed, where we bedded down for the evening, depleted and shivering on the corrugated metal floor, having not eaten since breakfast the previous day.

The next morning we got a ride from a man to whom I send love and thanks. He picked our tore-back, tattered, dirty mohawked asses up, rode us for fifty miles or so, dropped us at

a fast-food place and gave us money to get some lunch. I'm a health food nut, an environmentalist, and against shitty fast food poisoning us for their petty profit margin, but that could have been the most satisfying meal I ever had in my life.

(*As I type this I am sitting in a suite in a five-star hotel in Madrid with a belly full of sushi, and it doesn't come close to the deep satisfaction I got from that burger, fries, and chemical sugar dessert.*)

Night fell. Satiated, we got back on the highway, our thumbs extended. We got a ride pretty quickly from a friendly Chicano gentleman. First thing we noticed was a screwdriver jammed into the ignition and a driver on edge. He sported a large neck tattoo representing his gang affiliation. Hunched over the steering wheel, he expounded in a yearning vato voice, "I can't wait to get home and get that needle in my arrrm!" He explained how he'd stolen the car to visit his girlfriend in prison up in Chino, and how she'd been busted a week before by some bounty hunters, while the two lovers were in the middle of fixing. The hunters hadn't even let her finish getting high. They had neither morals nor compassion. I liked the guy, he kindly drove us all the way down to L.A., even picking up another hitchhiker along the way. He wasn't about to leave a fellow human stranded out on a cold stretch of road. Helped people out and minded his own business; what William Burroughs would call "a Johnson." He had been talking about a big chunk of black tar heroin he had at his apartment, and when we arrived there, he invited us up to have a taste. I had to talk Anthony out of it, and we said our goodbyes. He gave us the car and we drove it for a short while, before the fear of being busted made us dump it on a side street.

We finally got home and I got dropped off at my girlfriend

Beth's house. I was shattered and dying for an affectionate embrace. I ran up the stairs, knocked on the door, and when she let me in, I was disconcerted to find Hillel there. They were all mussed up, like they had gotten themselves together quickly. I expressed a jealous concern, but they assured me they were just hanging out, that I was frazzled from my journey and the drugs, and shouldn't be paranoid or irrationally envious. They were two people I cared about a lot, so in my vulnerable state I trusted them.

After Hillel died, Beth told me she had come on to him. She did it purposely to revenge me for my own infidelities. That hurt. I guess I had it coming.

Fuck. Fuck.

June 27, 1988, was a nice hot summer day in Hollywood. We'd been home from a grueling European tour for a week or so. I was relaxed, unwound, and hanging with my awesomely pregnant wife Loesha. I felt whole. Those were beautiful days when I slept nine hours a night, and in the lazy mornings she giggled while I sang rhythms to her swollen tummy, my face pressed against the limitless potential inside. I only wanted to work for my family. I felt happy and healthy, full of love, strong as an artist, riding a river of creativity, sharing my days with good friends, and was basking in the glory of a Lakers repeat championship. All was navigable and felt simple, deep, and open.

The recently completed tour had begun with Hillel in a state of weakness. He was pale, depleted, and ghostly; his spirit diminished. During the first show, he left the stage after one song, unable to keep it together because of dope sickness. He

gathered his strength as the tour progressed though, and as he kicked the habit, his soul, humor, and flowing funk grew back into its naturally evolved state. It had become clearer than ever that this drug thing was no game. I saw it rob Hillel of his natural truth for a time. This was no experimental romance of youth anymore. It was fucking terrible.

Loesha and I woke in our sunlit apartment, banging the new Public Enemy and dancing around the room. I worked for a little while putting the baby's crib together, then we went out to meet friends for a breakfast on Fountain.

In the afternoon we picked up Perry Farrell and Casey Niccoli to go watch the Tyson fight at the house of our friend Rick Van Santen (the visionary who invented the Coachella festival). Perry had just finished making the Nothing's Shocking *album and we rocked out to it in the car. When the lushness of "Summertime Rolls" washed over me for the first time, I was blown away, realizing the expansive and powerful vision of Jane's Addiction. Shit was heavy.*

It was an awesome fun day at Rick's with lots of great friends. Eating ribs, smoking weed (None of that for preggers Loesha though! My god she was funny, smart, and insanely gorgeous, I was so lucky) and laughing at the jokes of Dirty Walt Dog King of the Freaks.

I loved Mike Tyson so much; he embodied our time. Ali will always be the greatest, he floated like a butterfly and stung like a bee, but Tyson was OUR champ. Cosmic zeitgeist. Overflowing with the pathos of the USA in 1988, and hammering all the punkrockhiphop feelings we shared into his opponents' skulls. The edgy vibrating feeling I got when he marched into the ring to Ice Cube's "The Nigga You Love to Hate" — wow. Full of love for him, yet quaking with terror at the violence he would

unleash. My mom was a huge Tyson fan and always said she wanted to give him chamomile tea with honey in it, put him to bed on time, and keep him away from all the evil sharks surrounding him. He demolished Spinks in a few seconds, and our awed silence erupted into a cacophony of jokes and speculation; we partied the day away. We drove home, satisfied and happy.

As we walked in our apartment I noticed a huge quantity of messages on the answering machine. The first one was from RHCP manager Lindy, who said tersely, "Call me as soon as you get this," and hung up. The phone was ringing off the hook, Loesha answered, didn't say anything, just looked confused, and passed me the phone.

The sky fell in.

Hillel was dead.

I crumpled to the floor.

No more nothing. No more dancing. No more arguments or petty bullshit. No more supportive discussions. No more yearning. No more discovering ourselves together in the funky grooves. No more of the easy laughter at the unsaid jokes. No more chance to fix it. No more righting the ships in our fleet gone astray out to sea. No more outdoing each other with the absurd. No more of his soulful guidance that had helped me profoundly time and time again. No more nothing.

His inspiration lives in me.

I would never be the Flea y'all know without him.

Left with love and admiration for him.

Left with the confusing pain of all that was unresolved.

And the absolute knowledge that love is the only thing that counts in the end.

It was devastatingly final. I lay with my bride Loesha, my unborn Clara, and we all wept.

Hillel, I love you. In my dreams, I love you. In my soberest assessment, I love you. In my thoughtless silence, the sun rises and sets for you.

For a while I was obsessed with questions. I wondered what it was like for Hillel on that hot smoggy day, in the apartment he was so happy about, where he partied, made love, danced to Prince, and created his funky Strat rhythms. Did he feel death coming when he shot that last dose of smack? An enveloping darkness? Did he drift away painlessly into a pleasant ether? Did he panic as life drained away, or was it just a numb cessation of the conscious mortal world? Did he feel his body and soul separate? And if so, did they rip apart wildly or part in a dignified and orderly manner? I imagined that the profundity of death would rise above the pettiness of drugs, and allow for a conscious departure.

I know nothing.

My gorgeous, sweet, brilliant, funny friend.

The layers of grief.

The shock. The numbing heaviness. The regret. The gratitude. Eventually, the clarity.

Love. Love above the disappointment, judgment, fear, and hurt. Love to clear the fog that blinds us, and unlock the shackles that bind us. Life is naught but a journey to achieve love.

Beyond thought, where greatness resides. Anything is possible there.

Play to Pay

I lived in a cocoon of my own making. I didn't read the newspaper, watch television (not even basketball during this period from 1980 to 1983), or pay any attention to popular culture. Sometimes though, it couldn't help but leak in.

What Is This was practicing at a defunct pool hall called the Crooked Cue on Heliotrope Avenue in East Hollywood. 'Twas a dilapidated couple of big rooms where we could play loudly at any time, day or night. The joint was owned and run by a mysteriously beautiful young woman named Addie Brik. She became a great addition to our crew, and then she and Hillel fell in love. The Crooked Cue became his home for a time. After he left there, Perry Farrell and Casey Niccoli moved in; they had a rooster running around inside, and I remember seeing the sculpture from the *Nothing's Shocking* album cover up against the wall, its plaster crumbling onto the floor.

One hot and dirty afternoon I was pulling up to the Crooked Cue in my '61 Dodge Dart with leopard-print interior, listening to the radio. Michael Jackson was playing through the shitty speakers. The song ended, and the radio announcer started gushing about how many zillions of records M.J. had sold, so excited about the massive triumph. Ignoring the artistic great-

ness of M.J., I thought, *I don't give even the tiniest little speck of shit*. I'd never cared about mainstream success, and if anything, it repelled me. If something was popular, it meant it was boring, and I didn't want to hear it.

This started when I was a little boy in New York and first got excited about music. Not a thought-out response, just my childhood gut. When I became enthralled with jazz through Walter and his friends, I was uplifted. Then, out in the world, I heard pop music on the radio, "My name is Michael I got a nickel," and "I got a brand-new pair of roller skates you've got a brand-new key." The pop music had no effect on me, it just floated by like a TV commercial for salad dressing. (Who made the salad? Seven Seas!)

I'd tingled all over and rolled on the floor in a hysteric trance when I heard the visceral power of live jazz. This other stuff had zero power. I wasn't aware of the music business yet, the selling of music, but I knew what it was like to be physically transformed by the spirit of music.

As I became conscious of music sales and commercial success in the early eighties, I was arrogant. Though there was popular music of the time that I loved, like Grover Washington Jr. with Bill Withers doing "Just the Two of Us," for the most part I categorically rejected, ignored, and/or insulted any mainstream music. I heard it as a product created for thoughtless people that didn't really love music. They just did what they were told and embraced the pabulum forced down their throats so they could get laid. Squares and lames. If everyone liked it, it couldn't be good. Gimme the underground stuff, the weird stuff, the stuff for people who really care.

My greatest ambition was to be able to pay rent and eat by playing music that sounded like nothing else.

Cash Rules Everything Around Me

— Wu-Tang Clan

Joel, the drummer of Neighbors Voices, had begun living at a place called the Contemporary Artists Space of Hollywood, more commonly known as CASH. A communal space dedicated to supporting the underground art and music scene, it existed in a double large storefront up on Cahuenga near the 101 freeway on-ramp. CASH was conceived, run, and owned by a matronly, full-breasted, platinum-blond no-nonsense woman from New Orleans, Janet Cunningham. Freaks from the Hollywood underground hung out there until the wee hours of the morning, playing music, making art, and getting high. There was a never-ending ever-changing river of great artists going in and out of that place, as well as crazy junkie ne'er-do-wells, rough street types, punk rockers who ran the gamut from innovative to seriously damaged, and fringe weirdo intellectuals, all mixed up and fermenting into a wild brew. Throw a bunch of drugs and sex into the mix and all kind of hijinks ensued.

Despite its anarchistic rhythm there was an unspoken ethos at CASH. Forward-thinking artists were respected. Posturing and posing yuppies were found out quickly and laughed out

the door, and there was a prejudice against the hair metal types. A revolving flow of interesting art on the walls and strange music being performed/played nightly was a matter of course. Just a big empty room with a bunch of couches, and a few curtained-off areas that, with Janet's consent, young people had claimed as their bedrooms.

Things had become uncomfortable with JK at the Formosa house, so Anthony and I decided to fuck it off and move out. We let JK have the joint. I don't recall where Anthony went, but I decided to join Joel at CASH. My French friends spoke well of me, so after sitting me down for a talk and peering into my soul, Janet, benevolent matriarch that she was, let me move in. I found a couch, sat my bag of clothes next to it, and called it my home.

This was the most wild and free time I'd known. I felt like I belonged, a part of a movement much less insular than what my life had been. For the first time, I was out in the world, away from my parents, and not living with any friends from school or the band. Out of my comfort zone and in a new world, I began understanding how and where I fit. I was mostly a quiet and shy boy, but in that crazy place, no one ever judged, took advantage of, or was mean-spirited to me. Even the pretty punk rock girls (and there is nothing prettier than a pretty punk rock girl, well err umm.... except for maybe a super hot chola, or maybe Cecelia Williams from Fairfax High, or well maybe this one girl I saw dancing in a 2 Live Crew video, or any pretty, tough, self-possessed kind of girl, well let's just say nothing was as hot to me as a punk girl at THAT time) yes, those beautiful punk rock girls made me feel comfortable, despite my insecurities. CASH was a sanctuary. I don't know about being in a church, temple, or mosque,

but maybe that's how it feels for religious people when in a house of worship. The toughest and gnarliest dudes were respectful and thoughtful with me, even if they were on an intense meth run. There were moments when the CASH freaks could wave a flag together, and few are the times when I've ever felt like that. I was just a nervous, shy kid who longed to be a relevant musician. I learned a lot about people, hanging with these young rascals from all over the country who had cut their ties to any idea of socially accepted normalcy, and who'd let go of the desire to garner respect in a conventional, competitive society. There were many great musicians around, creative people connecting from all kinds of eccentric viewpoints. There was no faking it or being cute with the music, shit was real. In that place, when I really dug deep into my bass, I felt seen.

I started dressing weirder and weirder. I got off on people thinking I was crazy, squares giving me judgmental or concerned looks when I walked into the grocery store. Like, *Yeah I'm an outsider, I DON'T BELONG TO YOUR WORLD, MOTHERFUCKER.* I loved the feeling of being on the edge, that a strange or unexpected creative act might unfold at any second, and I was open to it being life-changingly beautiful. I felt lucky to be at CASH, it was exactly where I was supposed to be. It was the center of the universe.

I was still heading out to the animal hospital in the mornings, god bless Dr. Miller for putting up with my stumbling into work after an all-nighter, either barely conscious, or in a way too elevated state of consciousness for the earthly matters of veterinary work.

I was jamming with Joel frequently, but we were just too damn crazy, high, and unorganized to get it together. Besides

his profound influence on my musical growth, the only thing that remains from our twosome is a recording, one obscure burst of rhythm we composed, "You Always Sing the Same," which Joel sang in French. *Anthony sings it in English on the first RHCP album.*

One morning I awoke on my couch in a bleary hungover state. Head sideways on my pillow, I saw a smartly dressed young man sitting and reading on a neighboring couch. He had a cool vibe about him and we started chatting. I liked him right away. He was smart and well read, we spoke about books and writers. His name was Larry, he told me he had recently acted in a film for Francis Ford Coppola called *Apocalypse Now*. I didn't know what a Coppola was, but it sounded important. Laurence Fishburne has since gone on to have a deep and prolific career, and whenever I run into him or see him in a film, it makes me happy.

So many of the people who hung out on the scene at that time, ones I knew and respected, ended up strung out, in jail, given up on their dreams and barely surviving, or dead. I always get a profound pleasure whenever I run into anybody from my past who is doing well and whose spirit is aglow.

With melancholy nostalgia I remember those days, a golden hour of my life............ will never happen again. I was liberated when I walked down the street, I was one up on the squares. It was beautiful and I was ready to shine my light.

An after-hours club/art gallery opened up next door to CASH, called the Zero-Zero. It was a labyrinth of rooms in a storefront that supplied cheap beer and shadowy corners, a boisterous place that partied hard till the break of dawn, full

of the aforementioned denizens and those wild-eyed searchers who appeared in the dead of night with their party shoes on to fraternize their way to nirvana.

There was a sense of family in the wee hour debauchery at the Zero. All those underground bands: X, the Weirdos, 45 Grave, Top Jimmy and the Rhythm Pigs, Tex and the Horseheads, Wall of Voodoo to name a few, and all the people I'll never forget who found a sense of community in our secret place: Top Jimmy himself, a whiskey-soaked jumpin' blues singer who could stir a crowd into a maelstrom of pure fun, the loveable Donnie Popejoy, who was there every night absolutely wasted off his ass. Yet if you went to eat at the fancy restaurant Chianti with your corporate money lawyer and his silicone wife, there was Donnie, bright-eyed and spry in a three-piece suit with his hair slicked back suavely serving you spaghetti. I once saw him on a boiling hot summer day, walking down Yucca, pale white skin in Bible black suit, clutching a bag of raw eggs, cracking them open and slurping them right down his throat fresh out of the shell as he strolled along the burning asphalt, his key to work preparedness. Animal, a meth'd-up punk rocker with a peculiar brand of intelligence and a sweet vulnerable side, would carve "FEAR" into his forehead with a razor blade in two-inch-high letters in tribute to said hardcore band, but it would be all backward 'cause he did it in the mirror; Tequila Mockingbird, an irrepressible art piece of a woman! David Lee Roth, a rock star, but he loved to hang with the underground trippers where no one gave a shit, Carlos Guitarlos, a tough and volatile man whose guitar sang sweet R & B ballads and hard-swinging blues with a virtuoso touch, and he could pen a classic tune too; the girls from the Go-Go's, a local punk band that had broken through into pop

stardom; Keith Morris, the exploding in all directions spinning planet of a singer of Black Flag and the Circle Jerks; Pleasant Gehman, a connected and free-flowing enthusiast of the L.A. punk scene; El Duce, the star of the Mentors, he was a royal king of the most offensive humor and out-of-control behavior.........the list goes on and on, all of them seared happily into my memory till the day I drop dead.

The Wilton Hilton

After about six months of living in the CASH club, Joel found us an apartment on Wilton and Franklin. A four-story red brick building on the southwest corner, it was managed by our seventy-year-old landlady, a woman with a crazily colorful vibe. She radiated a long faded Hollywood glamour, the muted remains of which were found in her sparkly old-timey dresses and wildly colorful makeup fitting for a character from Pink Floyd's *The Wall* or a Ralph Steadman drawing. From under a platinum-blond wig her whiskey-soaked rasp croaked spiritedly at me and Joel, affectionately scolding us for one thing or another. She had us in hysterics, and we soon dubbed our new home the Wilton Hilton.

Inside were darkened hallways, moldy carpets, and a creaky dilapidated old elevator, yet our apartment was nice and spacious. I loved it. I'd float down the hallways late at night in all kinds of drugged-out states. There was one man who took it upon himself to patrol these dank and shadowy unlit passageways at night. Johnny was an elderly dude who dressed tight, sharp, and mean. He'd appear out of the shadows, the hard-angled silhouette of his porkpie hat straight out of the

best film noir, and whenever our paths crossed, a blade would slide down the sleeve of his black leather jacket into his palm, the metal glimmering in the dark, competing with the piercing glint of his yellowed eyes. I unsuccessfully attempted to converse with him once or twice but he remained stone-faced. He never uttered a word or greeting, the *Playboy* bunny tattoo on his wrist did all the talking. I humbly walked by, deferring politely like a dog way down in the hierarchy of the pack. That dude was hard.

I spent the most peaceful and light hours practicing trumpet on the roof. Our sweet landlady was a tripper who'd come up there to sit and listen to me play; she told me it was beautiful, and I once saw a soft tear roll down her painted face when she said it. I had two different friends later on, Maggie Ehrig and Ione Skye, both who told me they would hear the trumpet sounds flying through the neighborhood, not knowing their origin, and it bought them joy.

Joel and I lived there happily; I worked each day at the animal hospital, and came home to our awesome abode: "Honey I'm home!" We were soon joined by other roommates; Anthony crashed there a lot, and Hillel put in a lot of time too. Another friend of the Neighbors Voices, the Frenchman Fabrice Drouet, also moved in. Fab was a junkie. A gentle, intelligent, and artistic young man, but nevertheless a junkie. Like an emaciated Alain Delon, he was a slight and bespectacled dude, in gold-framed New Wave Godard glasses and sharp thrift-store suits. He was our age, though he seemed to live on a different parallel from years of age, he could have been a child or an old man. He was the first junkie friend I ever had, and his heroin addiction both entranced and repelled me.

A few years after we left the Wilton Hilton our landlady jumped from its roof, to her crushed and misshapen demise on Franklin Avenue, her sweet and faded Hollywood limelight extinguished forever.

Gary Allen explained that he knew a chemist in Germany with access to a new drug, MDMA. He said it was the happiest drug ever made and we had to try it. A couple of nights later we did, sitting out on a cliff in the Pacific Palisades feeling the loving euphoria and talking the night away. Next morning I woke at the friend's house where we'd crashed, called in sick to the animal hospital, and we had a mellow morning tripping around, getting breakfast. I was so happy to be skipping work and meandering about in my post-druggie state. I looked at Gary in his wild white flowing outfit, laughing in the street, pondering whether to go write lyrics, make clothes with a trippy new fabric he'd come across, or just smoke a joint and go to the movies. I coveted the freedom he was enjoying; that was the artist's life I wanted. I was grateful to have a job, and knew I'd always be a hard worker no matter what, but oh how I longed to live my days at my own rhythm. I felt more of an urge than ever to push myself as a musician and create that life for myself.

Loves Keystone Cops

Anthony and I went for ribs at Love's Wood Pit Barbecue on Hollywood Boulevard. After stuffing our faces with the poor butchered hogs, and not a penny between us, we rose quickly and quietly to make it for the rear exit, from where we planned on making a run for it. Unfortunately, when we got to the door it was padlocked shut with a big metal chain. Oh fuck! We tried to force it open, shaking it, giving it big kicks, and making a loud racket. The restaurant workers were on us in a flash. Trying to remain cool for the other customers, they calmly jogged over to apprehend us, so we ran wildly through the restaurant, in between tables and chairs, doing our best to outmaneuver the pursuing busboys. We somehow made it to the front door, and in full sprint, jetted out to the Hollywood Walk-of-Fame sidewalk. Unbeknownst to us, while we were in there grubbing up the ribs like porky pigs, it had begun to rain. The star-laden sidewalk of fame is smooth, and the rain had made it slick and slippery. When we hit the sidewalk at full gallop, we slid out, got airborne, and fell flat on our backs, sliding wildly into each other, and into some trashcans, which in turn fell on us and emptied out. Scrambling

frantically in a wet pile of trash we managed to pop upright and run like hell down the boulevard. As we ran I looked back to see the busboys and restaurant manager come flying out and onto their own asses, into the trash pile, in another display of slapstick buffoonery. We ran cackling into the afternoon.

Hair on at the Mayfair,

or

Three Fools

I had still never tried heroin. I know this sounds crazy
considering I'd been shooting up cocaine and meth like
a fucking lunatic, but heroin scared me. Smack acolytes had
been effectively vilified in my psyche by movies and books. I
had some ridiculous theory that cocaine left your system
quickly and wasn't so bad for you. I could spike up coke all
night long until my arm was a bruised and swollen mess and
I'd become a shivering psycho, but the idea of doing one shot
of heroin and mellowing out terrified me. I thought I'd end up
like Frank Sinatra in *The Man with the Golden Arm*, or wind
up dead in a bathtub like a sixties rock star. They never
showed geezing in the movies.

I first saw a heroin-happening back at our old house on
Formosa when I was eighteen. An older dude in his mid-
twenties had come over. Ray Nobody was the drummer in a
group of some local fame. He spoke in a cool and spare ca-
dence about the dope, issuing a disclaimer about how he didn't
wanna be responsible for us becoming junkies or losers or
anything, then asked us if we wanted to give it a whirl. I was
hesitant, but Anthony accepted the invitation. I watched their

silhouettes from the kitchen as they fixed in the living room, obscured by the shadows. Mr. Nobody was a perfect-looking rock band dude, standing under a jet-black pompadour, his junkie soul housed inside translucent pale porcelain skin, eyes hidden by some sweet seventy-five-dollar black Ray-Bans, vintage black leather jacket, and all black rock-and-roll clothes. I looked on with trepidation from the other room as they engaged in what seemed to be an ancient and sacred rite of sorcery. A heavy vibe. They finished and came into the kitchen. I sensed a little uncertainty and guilt from the junkie in black. Like a little kid, I eagerly asked Anthony, "How is it? What's it like??" He shot me a knowing look of satisfaction.

The first time I tried heroin, I snorted a line of china white at the Wilton Hilton. After a few minutes, it gathered momentum and a warmth began to rise through my system, this purring pleasure, this lightness of being, and I drifted back onto a cloud of goodness. Along with this easy sense of well-being, I was capable of thinking of only the things I chose, the happy thoughts, X-ing out the unpleasant life worries, the ever-lurking nagging ones that always subtly popped up to cause anxiety. All those insecurities about being too little, too skinny, scared of girls, they all dissolved away in the nurturing bath of euphoria. I walked down the street, the usual weight of the hot, thick, and gray Hollywood sky lightened and lifted itself open so I could fly more easily, and I ambled into a boulevard Thai restaurant. I slid into a cushy booth and sat there at the table staring into the fish tank, completely content, those multicolored fish just floating in psychedelic space. Man, I felt good, I was the coolest. As if the gates had opened and I was initiated into a world where everything was beautiful, life was easy, and the squares were not allowed to tread. I

thought I was so hip, such a real artist. Such a fool was I. It's a fool who is seduced by that which feels good, nothing but a simple fool.

Fabrice was dealing heroin that arrived from Paris to the Wilton Hilton, secreted away in cartons of Gitane cigarettes. One of the packs, when opened, appeared to be a regular pack of smokes, the cigarettes all properly lined up like little French soldiers, but underneath the tops, the rest of the cigarettes had been cut off and the bottom half of the pack was filled with the valuable white powder. It was high-grade shit too. Yeah, it was a happy day when those beautiful and exotic cigarette cartons arrived. Fab would get us all high as kites. Now, I'm not recommending a soul-sucking path to being a complete loser junkie pathetic fuckup; it will without doubt ruin your life and hurt all those around you. But let me call a spade a spade, for a short while there, I dug it. Being high on heroin is a selfish, myopic, shutdown type of pleasure, but nonetheless, a pleasure. Like a seductive angel of death.

I knew where Fab hid his heroin in the closet, and I once snuck in there when he was out, and stole a little. I was so ashamed for years. Despite his heroin addiction, Fabrice was always straight with me. He was my dear friend, we shared many a fine conversation together, he had my back. He was always encouraging me to dig deep into the music. Years later I confessed to him, and apologized. A spiritual man, by then he had been sober for many years, and graciously accepted my humble mea culpa.

He also helped us make the first ever RHCP demo, coming up with some clean $$$ to help us get in the studio.

I was too ambitious and excited by the things I loved to ever become a junkie. And goddamnit, a heroin hangover is the fucking worst. It took quite a while to figure out that the hangover was worse than the high was good, that it was a losing bargain, and stop. Yet, back in my time of using I never did it two days in a row, out of fear of being hooked. I never got strung out. I loved playing basketball, reading books, and rocking out way too much to surrender to a junkie life. Whatever the gene that makes someone keep doing drugs when they consciously understand that it's destroying their life, I don't have it, even though both the father figures in my life are/were drug addicts/alcoholics. As it was, me being a weekend warrior, it still became a bane to my existence. A bottomless pit of sadness awaited.

Part Four

I got my foot on the accelerator, drivin'.
I got no time to think of how you feel, drivin'.
— Pearl Harbor and the Explosions

I'll prove it to you,
No, I'm not just a fool.
— Arthur Russell

Born in 1962, ya always got something to do. The world is spinning like a top, don't stop moving or you might fall off.
— Flea

Winter 2016. Morning.

*R**aw and uncertain.*
I wonder.......is this angst the engine of my life?

Is this the reason why I've been able to touch people when I play music, when I speak from my heart, why I always go as hard and deep as I can? Is it why when people who care about me tell me to take it a little easier, I say, "No fucking way, it's all or nothing." If I was more happy and stable would I be a boring musician? Before I learned about spiritual practice, discipline, thoughtfulness, self-love, and restraint, I stumbled and bumbled along through life, pushed this way and that by pleasure and pain. I'm still evolving. Gig tonight in Interlaken, Switzerland.

Astral Road Fork
Phantasmagoria

February 1983

I often wondered, even in my dreams, if I should give up rock music and focus all my energy on being a jazz trumpet player, that it might be a higher calling. I fantasized myself blowing the cutting edge of revolutionary jazz, having a honey sandalwood girlfriend who wore classy dresses and listened to Lester Young with me, like really listened, without talking in the middle of a beautiful solo......

Living in New York City in ancient underground catacombs, playing a Calicchio horn all the days long, flying over these bop changes, and I got that new beat that no one else knows about pulsing through my bloodstream, I hear it so clear a jagged edge funky boom bap beat that morphs and evolves constantly, its accents always falling differently with no bar lines to tie 'em down. Tonight I'm going to sit in at the Star Café. I pour my heart into this horn, guts and blood my beautiful insides fly-

ing out of the silver bell a sea of color like the northern fucking lights spreading out over the sky.

Some of that ginger onion lo mein from Sun Sai Gai over on Canal and Baxter would do me right. Leaning forward, horn in hand, I float into a relaxed horizontal position about ten feet above the ground, creating an energy out of my body that keeps me afloat, gently cruising above the sidewalk. Can anyone see that I am actually flying? Why don't they look up? More of a float than a flight but I'm riding the invisible waves of energy yeah man somebody's gotta bear fucking witness to this. Oh shit who's that coming out of that brownstone there?

Is it?

Holy fuck, it's Art Blakey! Buhaina. Whoa. He's walking in to get that Chinese grub ahead of me.

We're talking like we'd been friends forever, must be in past lives we were brothers or something. He's like my dad right now. Looking at Art across the table watching him fuck up a plate of egg foo young. We are up and beyond......words, laughter, and comfort.

> **Me:** *Art, you know I'm about to be a Jazz Messenger man, I've got all the fire, the sweet unique fire in this horn, dude.*
> **Art:** *Don't call me dude.*
> **Me:** *But for real Art, bring me in, I'm ready to blow.*
> **Art:** *Mike, you know we don't let any little white motherfuckers in the Messengers, this is black music. White people are always stealing everything.*
> **Me:** *What about Chick Corea?*
> **Art:** *Ahh shit you got me there. Wait isn't he like eyetalian or Spanish or something? Hahaha.....Let's cop.*

Against an endless gray background, I see Gumby and Pokey walking into a ten-foot-tall purple book. Gumby's face is Art's and Pokey's is my stepdad Walter's.

We walk into the Star Café, which is not really a café, just a funky little bar, a hush falls over the crowd. It's Art Blakey. Even the gangster smack dealer lurking in the hallway by the toilet becomes reverential, and the college jazz students are frozen in awe. Art steps up on the little bandstand riser, motions for me to join him. We're playing "Bemsha Swing," it's all different though, Art is playing some hard-ass funky voodoo beat. It's my turn to solo, I know these other musicians up here are far ahead of me. I see multicolored halos glowing all around their heads as they play. One minute they are little babies in suits and ties, then I blink and they are old wise men in robes with King Tut beards.

I feel the magnetic pulling of a sewer hole on the stage next to me, it's full of whirlpooling water that wants to suck me down, down, down, into the bottomless soulless void of failure.

But I'm me, and I've got my own story to tell. I'm digging deeper than I ever thought possible, it's coming out warm, clear, and mean, jumping in and around Art's beat like a funky clavinet, I'm dancing.....gone in the rhythm like in a ricocheting pinball, feeling the arc rise and resolve. I finish and the 'bone player steps up, I look back at Art, he's looking right back at me with a big toothy smile, the light beaming out of our eyes meets mid air crashing. The low ceiling becomes a psychedelic sky, fireworks rising, hovering and mixing with the cigarette smoke, we're all flying in the pinkpurpleredgray softness. Off the bandstand, he gives me a huge loving sweaty bear family hug. I feel Dizzy Gillespie's hand patting my head, and smell his fine fabric cologne armpit.

Me and Art sitting in a pyramid smoking a joint, him holding up a picture of Lee Morgan, pointing at it, talking to me like a professor.

Him wearing a giant star and crescent moon wizard hat, sitting at the piano plunking at the keys, looking up and explaining.

Us in a rehearsal room, I'm standing with Wayne Shorter, Bobby Timmons, and Kareem Abdul-Jabbar, who is hovering three inches off the ground and brandishing a bleating baby lamb above his head. We're blowing in deep unison, hard funky bop, throbbing together as one in an explosive rhythm.

Up on stage in a packed and adoring club, I'm standing at the back in my sharp suit, covered in sweat at the end of a show, enjoying a Gauloise. Art is up front giving the enrapt audience a talk. "Support live music!"

On the side of the stage while we play is an official-looking podium. My trumpet teacher Jane Sager is standing at it dressed in a shimmering gold jumpsuit looking at me from behind outlandishly giant eyeglasses. I'm now a seven-year-old but still in my suit smoking the Gauloise. Jane and I are sitting in a little room. She tells me, "You don't ever have to prove anything to anyone." My heart starts to palpitate. My family dog Bertram walks in the room up on his hind legs. He's holding a gold medal inscribed with French writing and says something profoundly serious to me in French. I solemnly bow my head and he places it around my neck.

Art with big angel wings, confidently flying over the Manhattan skyline, holding me under one of his wings. I excitedly look at the unfolding new world below me.

All of us in the studio tracking, I'm blowing my highest self. Looking through the control room glass I see my honey girl,

eyes alive, a book about my childhood friend Stephen Paul in her lap, she looks at me with the infinite romantic depth, the hint of a smile on her lips. Stephen's picture on the book's cover makes the same sweet and melancholy smile.

I put the horn to my lips again, feeling the metal mouthpiece warm and good, but it starts to taste bitter and acrid, it tastes like shit, I pull the horn from my chops and look back at honey who is up and walking out, dissolving into nothing.......my mood curdles, a creeping moldy miasma permeates the air like a cloud of death and Art looks at me with suspicion. The music starts to warp and fall apart, What? I hear a thick French voice coming from the dark reaches of the universe into the increasingly dissonant and dismembered recording room, Michael Michael *Michael* Mykuul *MYKUUL MYKU-UUUUUUL...*

I open my eyes to see Fabrice in his underwear leaning around my doorway. "My-kuul, don't you have to go act in ze movie today? Wake up, My-kuul!" I'm covered in sweat and stare at him blankly until things start to come into focus. "Fab, I had the wildest weirdest fucking dream, man, I was a Jazz Messenger. Man, Me and Art...dude...." "Oh! Fuck! I do haffta work on *Suburbia* today." Fab asks, "Deed you take ze MDMA last night too?" I jump out of bed.

Severed String Striking Siblings

or

Sauntered Jauntily

Joel, with the sides of his head shaved at a rakish angle, wild mismatched dreads shooting out aggressively, boldly predated the haircuts of the hip young black men of 2018 by thirty-seven years. We were always wearing the most strange and beautiful thrift-store attire; I had taken a fondness to brightly colored old ladies' pantsuits. We'd dosed acid an hour earlier and were strutting proudly down Sunset Boulevard to the Club Lingerie to see the West Van Nuys Gay Man's String Quartet. This was a nom de plume for the band FEAR, an L.A.-based punk band whose name was carved into the forehead of my CASH cohort Animal. I didn't really know what to expect, but had been told they had an original sound. As we slithered into the club, the acid was kicking in and the room was a living pulsating thing, all the colors extra deep and moving. We sauntered around jauntily, crazy-eyed and grinning, greeting acquaintances. Then FEAR took the stage.

Hoe — Lee — FUCK! It was rhythmically ferocious, and focused, unlike anything I'd ever heard, it destroyed everything. Within these short, sometimes simple (even remedial), and

other times rhythmically and harmonically complex songs, was so much power and deep groove sophistication I couldn't fucking believe it. The razor-cutting musicianship throbbed violently. I looked at Joel, we were both tripping hard on the LSD, and with a wildly happy expression on his mug, he excitedly said in his thick French accent, "My-kul! Ze way hees fingers dance on ze streengs!" while doing a funny pantomime. The way they danced indeed. Guitarist Philo Cramer was wickedly adventurous, using whole tone scales and rocking out without any of the boring rock clichés. Drummer Spit Stix had a boldly unique style, all within the context of these high speed punk rock explorations, playing sixteenth notes with his right hand on the high hat with the most remarkable precision, leaving his left hand to set up interesting syncopated grooves, as well as the most badass of all oom pah oom pah beats. On one song, "We Destroy the Family," he beat on a collection of old steel oil barrels with metal sticks. The five-four beat had a brashly hypnotic African flavor and the demonic riff made my spine do the jerk spasmodically. With ace deadpan humor, bassist Derf Scratch was perfect. They all played downstroke sixteenth notes at high speeds, like a jackhammer doing the Watusi through weird chord movement, grounded by a street simplicity straight outta the gutbucket. Singer Lee Ving was just a superstar. He commanded the center of the stage, a sparkly eyed, buff, kinda scary looking biker type, but handsome, humorous, and disarming. He sang in intense percussive phrases, straight owning it.

The songs were funny, severing the veins of hypocrisy at the quick, both offending and entertaining, a complete bacchanal. Their jokes were often weirdly homophobic, which I chalked up to adolescent beer-drinking satire. I assumed they

were too smart and artistically together to be that stupid. I know, I know, I was on acid, but I walked out of the club thinking I'd seen the perfect band. I felt like the blackboard of my mind had been erased. They managed to have both the most ferocious elements of punk rock, and the musical sophistication I found so important. I was ready to get together with Animal for a dual forehead carving session. The next day I got the FEAR album *The Record* and listened to it repeatedly.

It occurs to me that for these hugely influential shows like this FEAR one, and the Echo & the Bunnymen one, I was on LSD. I had mystical experiences, the evaporation of self, and pure childlike wonder at the essence of a loving creation. Maybe I could just go see any lame pop act while tripping and I would gain an awesomely life-changing insight. All music has magic in it ya know, even shitty pop music. Thelonious Monk was once asked about what kind of music he liked to listen to, and he replied, "I love all music." The journalist persisted, asking, "Even country music?" Monk said, "What part of what I just said do you not understand?"

In a strangely fortuitous twist of events, the following week while I was still buzzing about the show, raving to all my friends, I saw an article that FEAR had parted ways with Derf Scratch and were auditioning bass players. I made a beeline to the phone, called the given number, and was told to go to Damax, a storage facility deep in the valley, in the hot and barren industrial landscape of Reseda.

The realness of FEAR's existence had me in its grips. People were gonna freak out and make crazy unpredictable shit happen at the gigs. I welcomed the violence and chaos. It con-

nected on many levels. There could be no qualifying debate, it just was.

What Is This got some deep grooves going and were clever and interesting, but we weren't robbing people's hearts and making their bodies move. No one in the audience did anything physical at a What Is This show. They just nicely appreciated the art. As cartoonish as FEAR could be, they moved people. I was tired of being clever, I wanted to fuck the music, fuck with people's heads, and go crazy.

In my mind, it was a foregone conclusion that they'd want me. I knew in my blood that not another person on the planet could or would go as hard as me. I showed up that day, a young arty bass player, into long, modal, groove-based improvisations, the Talking Heads, Hendrix, Zeppelin, Bootsy, T-Connection, Parliament Funkadelic, and Robert Fripp's the League of Gentlemen. But when I walked into that crazy-looking dingy storage shed, I was ready to let go of everything I knew. The feeling of that day is etched in my nervous system forever. I was so hyped up, feeling like I had entered a portal through some underground secret passageway, into a center of magic, a secret chamber of music making. I'd studied the music inside out for a week, and the coiled steel spring that tightly wound itself in my heart was ready to explode.

Just amps and drums around, a couch, a few chairs, and funny graffiti on the walls that said "JAZZERCISE!" and other obscure musings. The miasma of cigarettes and beer. Only Philo the guitarist was there when I arrived, acting casual and aloof, setting up his amp. He didn't introduce himself or ask my name. He glanced over, "You got a rig?" was all he said. I thought he was asking if I had a syringe for dope, that's what we called it amongst us drug-shooting freak-outs, and I

replied, "No." He shot me a disappointed look, pointing to an old Ampeg amp in the corner. I belatedly realized what he was talking about and said, "Oh, an amp! Yeah I got one in the car!" Man, were my reference points in life askew or what.

I was the first bass player of many they were auditioning that day.

Then Lee and Spit showed up. Spit, a small and quirky man with a quick smile, popped up and gave me a polite greeting. A muscle-bound tough guy in tight Levi's, sleeveless Levi's jacket, spiky black hair, and a tattoo of a big skull with a dagger going through it on his shoulder (tattoos were still the badge of an outsider back then), Lee tossed a six-pack of Budweiser on a chair, grabbed one, cracked it open, took a swig, then saun-tered over and gave me a big hearty charismatic handshake, introducing himself. I'd been called Flea here and there before, amongst other nicknames, but without thinking, and wanting to appear like a punk rocker, I blurted out, "I'm Flea."

Lee strapped on his Les Paul. Springing a strange odd tempo song on me he said, "Well Flea, do you know 'Camarillo'?" Looking him dead in the eye, I said, "I know 'em all." Lee stepped up to the mic and shouted with the rapid fire, "1-2-3-4-1-2-3-4!" I banged hard and deep into the rhythm, one with Spit's kick drum, the beat surging up through my feet, balls, and heart, from the center of the earth. The song ended and I was uncontrollably screaming out whoops and animal sounds. I jumped up into the ceiling and accidentally knocked some shit over. "What's next?" I en-thused. I saw another prospective bass player standing in the doorway waiting his turn. I sneered at him.

That night Lee called me and gave me the gig.

I never had a straight job again.

I'm Flea

Shortly after my audition, Beth and I were out with a couple of friends, driving around in an old Studebaker trying to find a house party in the Hollywood Hills, when one of them said, "I heard FEAR got a new bass player. Some unknown kid called Flea. Can you believe it? Imagine stepping into that band. That kid better be serious if he's gonna keep up with those guys. That band is fucking hard. I still can't believe they fired Derf." I sat in the backseat feeling a surge of pride and happiness, and Beth gifted me a knowing smile. I quietly thought, *People who don't know me talk about me in cars. I'm not just regular old Michael anymore, I'm fucking notorious. I'm Flea.*

While buoyed by an exhilarating rush about entering FEAR's world, it dawned upon me that I had to quit What Is This. The burden weighed heavily. I would lose friends, and something would be ripped painfully from me, especially in the case of Hillel. He who had asked me to begin playing the bass and was my soul brother, who counted on me to be there, his man, his string-striking sibling.

I was saddened but I knew switching was the right thing to do. A few days later I got together with the boys to tell them.

As soon as the words left my lips, Hillel turned ashen, stared at me for a painfully long moment with a disgusted, angry, and disappointed look, shook his head mournfully, and wordlessly left the room. I didn't see him again for a month, and then only accidentally, over at Tree's house. He failed to acknowledge me and left as soon I walked in the room.

On the other hand, Anthony was enthusiastically supportive, excited for the changes in my life. He wanted me to experience that feeling of growth.

Hillel saw it as careerist, selfish, disloyal bullshit.

A few months later I ran into Cooper, a musician on the scene (who Beth had left me for), who told me, "Yeah, I understand FEAR is exciting and popular and all, but What Is This seemed like something for the future, like ya know, an evolving musical entity." I knew that both Hillel and Cooper had their valid points. I valued the sacred connection of my friendship with Hillel, and had faith in the artistic vision we shared, but What Is This wasn't an adequate vehicle for that vision. My gut told me I was doing the right thing. I needed to feel what wild dangerous rocking was like, and though I didn't understand it clearly, I knew there was a larger arc, a bigger picture being served.

Lee Ving took a liking to me and was like a big brother/father figure. It was 1982, I was eighteen and the rest of FEAR all in their early thirties. I looked up to Lee, trusted him, and felt safe around him. His wife Barbara was matronly and kind without any of the usual patronizing bullshit. They often invited me over to their house for dinner, welcoming me into their family, which included their spirited young son Deacon. It was a great vibe, they'd make big Italian feasts, we would drink beer, smoke weed, and eat hearty; the house full of warmth.

The FEAR gigs were wild, fun, and drunken. I lived to lock into the groove with Spit, and it meant everything to be there for them, a solid rockin' rhythm of power. I learned about being an entertainer. I learned how to talk confidently into the microphone, that I could say anything, anything at all that would stir the pot, add some excitement to the occasion, just to get weird and let the craziness ensue. I learned to use all the sound and fury at my command, that all the energy I had, whether positive or not, could create an event. Whatever passed through my cranium was as good as the next thing. "I had cereal today. There are a family of ants in my ear that tell me what to do so fuck off!" Just embrace it. I learned to rock the people, to connect with them. I also figured out that the audience yearned to let go and be in touch with their primal selves. They wanted to freak out and be free. It was our duty to provide a place for that. I learned to just get down to it, no pussyfooting around, no posing, get deep and lose your fucking mind. The immediacy of the music, tasting the moment, physical risk and danger; art and action coming together. The shows were wild anarchistic slam pits, violent and unpredictable. I learned to attack the audience, to channel all my rage into the music, the music like multiple stab wounds into the chests of the audience. Make their hearts bleed.

My rage contained all the differences and disconnection from people I'd felt all my life. This rage became my power because it was real; it was my life, my pain, and I had found the fuse to detonate its fiery soul. I didn't care about being cool on stage, I just wanted to let my fucking spirit go wild any way I could. I knew I had a one of a kind way of being in the world, and that FEAR was only the beginning.

*

Despite the crucial lessons imparted to me, I always felt like the new guy in FEAR, the one who didn't really belong. There were foundational things about them I didn't understand, and there was a part of myself that I had no room to express. There was music I loved that Lee referred to as "fag-noise." Lee occasionally scolded me for straying from the FEAR ethos, not doing things exactly how he wanted them. There was no room for exploration.

I looked longingly at my frozen friendship with Hillel, hoping it would thaw with the warmth of time. As much as I had utter confidence in my creative vision, as the months passed by it became progressively clearer that the only people whose vision harmonized with mine completely and organically, and to whom I was able to relate to with all openness, were Anthony and Hillel.

On a synchronous side note, bluenote, truenote, let me mention that Lee Ving was once the bartender at Slugs' jazz club in New York. He started working there just days after Lee Morgan, a hero of mine, one of the greatest jazz trumpet players that ever lived and a protégé of Dizzy Gillespie and Art Blakey, was shot to death on the Slugs' bandstand. He was murdered by his common-law wife Helen Morgan. Lee's death was a jazz tragedy of mythological proportions. Lee Ving told me "Working at Slugs' was like working in a morgue," because the aftermath of Morgan's death was so heavy. The Lee Ving–Lee Morgan connection. Leelee a dulu a bop bam boo. Do that dance human beings, do that dance......

Lee helped launch me into the world like Art Blakey launched his many protégés.

She Picked Me

My strange acting career would never have begun were it not for Lee. One night at his house for dinner I met Penelope Spheeris, director of the defining documentary of the L.A. punk scene, *The Decline of Western Civilization*. Somehow, in my stoned and satiated state, my spirit had popped through enough for Penelope to take a shining to it. The following day I received a phone call from Lee (ahh, the great days before texts, when each phone call was a human surprise! I'm sure the pre-phone era had it even better with mysterious door knocks, and faraway shouts), him crooning to me a joyous tune, "Flea's gonna be in the movies, da da da ba bwah!" Penelope wanted me in her new film, *Suburbia*. Later on, she told me she thought I was a kid from down the street. She was shocked to find out I was the new bass player in FEAR, because I was so much younger than them, and appeared to be cut from a completely different cloth.

I went down to a building in Hollywood to rehearse with the other actors; all punk rock kids without a lick of acting experience between 'em. Though I was the bass player in FEAR,

I was into fringe art music, jazz, prog rock, Hendrix, and funk, I still didn't really know shit about punk rock. I found myself thrown into a maelstrom of punk rockers, kids who really believed in it, body and soul.

Though most of them didn't see far beyond the punk culture they embraced, they wholeheartedly believed it to be their savior, and outside of the occasional run-of-the-mill poseur, were pure in their love for it and it touched me. Just punk rock kids, mostly from the outlying beach communities of L.A. They were meant to be tan, surfing, Californian-orange-eating, stand-up citizens, but instead they were all pale, dressed in black with weird dyed hair, skulking around in the shadows, smoking and alienated.

They were mostly uneducated, growing up in cultural vacuums of blandness where ain't nuthin' happenin'. Punk rock got them spat upon, ridiculed, and disowned. But it gave them something real, a genuine sense of community. It was vital, the gigs were on fire, each one an adventure, and they were so happy for it. The *Suburbia* experience was a massive validation for them.

I learned a lot from them, saw so many bands, I felt part of something, and a speedy chaotic rhythm coursed through me. There was a lot of silliness and phony bullshit too, but only because the true center of it was so viscerally magic. It was bound to have lightweight riffraff floating around its periphery, trying to get near something real.

I'd seen a band called Twisted Roots some months before at the Whisky, and I loved them. I was especially taken with the singer, a snarling, laughing at the world, out-of-tune, wild-ass Pippi Longstocking on acid. Her hard-ass attitude undoubtedly protecting a beautiful vulnerable heart. Maggie

Ehrig. I had such a crush on her, never had I seen a girl like that before, so willing to spit in the face of everything. Man, what a funny kind of intelligence she possessed. The way her striped skirt fell on her torn stockings, the funny and mean way she belittled everything with a sarcastic laugh. All to protect whatever deep wound she was scared to show. Man, I was infatuated. When I showed up at *Suburbia* rehearsals she was there, and when I realized I'd be spending every day around her, my heart fluttered like a butterfly adrift the Santa Ana winds.

As rehearsals went on and I got comfortable, I started acting out, cutting up, getting boisterous, and making friends. Penelope kept making my part bigger, giving me more and more things to do and say.

And so started my obscure sideline of film acting.

The feeling on the set was the best I've ever experienced; totally communal. No stars, no egos, no careerism, no hierarchy beyond the negligible rankings of punk rock street cred. Years later, when I did *My Own Private Idaho* with River Phoenix and Gus Van Sant it was pretty great that way too.

Penelope had laid out a rule that if anyone were caught doing drugs they'd be instantly kicked off the production and sent home. One day of filming, tall, pale, green-haired, cadaverous Arthur Kane of the New York Dolls showed up in my trailer and proceeded to light up a joint, which I didn't partake in, as I was just about to shoot a scene. Nonetheless, my trailer was filled up with the pungent aroma, and I was called to task by Penelope. It took some negotiating to save my spot.

Another instance on the *Suburbia* set: One of the actors was shooting up coke in the trailer — and I've already told you how insane that makes you. He had to go shoot a scene in the

middle of his run, and it took him hours to accomplish the simplest task, to walk through a room and say one line.

Despite these drug stories, filming *Suburbia* was a great experience. I had no worries about the result. I just dug the process of making a movie. I deepened my crush on Maggie, realized that I loved acting in films (though it was rarely ever that fun again), and kept stashing away the hundred dollars cash a day they paid me under my mattress at the Wilton Hilton.

Campo's Famous
Avocado Burrito

During filming, I got to chatting with the boom man, Pete Weiss. A smart dude with the sense to be both amazed and bored by the world, he and I hit it off and became lifelong friends.

Pete exposed me to the world of the art film, taking me to see Luis Buñuel's *Viridiana* and Godard's *Band of Outsiders,* opening my mind to a rich and infinite universe of underground movies. This was a gift of happiness, a sanctuary that has added to my life immeasurably. It helped me to access a new part of myself. I've spent gazillions of meditative hours exploring the worlds of great directors who make art outside of the mainstream bullshit. They lift and center me.

Pete and I would drive out to the beach every day in his Plymouth Valiant (named Sergio Valiente), listening to college radio, which led to my discovery of a massive fountain spring of underground music. Never will forget the first time I heard the Weirdos doing "A Life of Crime," it made me jump around in Sergio's front seat like a caged monkey on meth. Pete filled me in on lots of music I didn't yet understand, turning me on to great shit like the Velvet Underground, Jonathan

Richman and the Modern Lovers, the Buzzcocks, and Percy Sledge. Yeah.

One sunny afternoon Pete enthused, "Every day I pick you up. We drive out to the beach, we smoke a rockin' joint, the sun is shining, we jump in the ocean and party in the waves, then we go get an avocado burrito, then we smoke the roach." I said, "Yeah man we're livin' the dream!" He continued as he lit up a cigarette, "But dude, you're missing out on the best part. After the delicious burrito and the spliff, when you're all fresh from the mighty Pacific, comes the incredible Marlboro to wrap it up all perfectly!" I was like, "Really? They're that good? Gimme one of them fuckin things." I started smoking that day, kept it up for fifteen years or so. Damnit, I wish they were good for ya 'cause I loved 'em. Unfortunately they make you sick and die.

Hollywood Swinging

One afternoon I walked over from the Wilton Hilton to the Mayfair supermarket on Franklin and Bronson to get some cat food. Strolling into the store with my FEAR jacket on, sporting a purple mohawk, I noticed a couple of redneck cowboy types and a countrified woman standing in the produce section under the fluorescent lights. They looked at me then snickered and sneered arrogantly. I responded by staring at 'em hard with my best psychotic look, grabbing my crotch with my left hand, and throwing up a fuck-you middle finger with my right. Thinking, *I showed them!* I about-faced and continued my way to the cat food aisle. As I reached up to the cat food to grab a couple of cans, I heard an incongruous sound behind me. Before I could turn around to see what it was, SLAM!! a blow to my head, boom, another to the stomach, I hit the ground and...pow a kick to the ribs, zo o o o m a foot coming to — wards my f a a a c e everything went slow motion and I went into dream land...
............I awakened to another couple of painful kicks in the spine then I heard, "He's had enough, the fucking faggot." I lay there half conscious for a minute, realizing what

had happened, then got to my feet and wobbled around until I got my bearings.

Bruised and banged up, dazed and in pain, but with no major injuries, I left the cat food and deliriously made it the few blocks home. I walked in to find a shirtless Hillel at the stove cooking a pot of lentils. He was looking pale and skinny, and when he saw my swollen, cut face and asked what happened, I told him some rednecks had beat my ass at the Mayfair. Brandishing the lentil spoon in a righteous anger he proclaimed, "Let's go get 'em, let's fuck 'em up!" I appreciated the gesture, though it was pretty comical. Hillel was even less of a fighter than me. I resigned myself to the fact that those rednecks were long gone, and most likely would have beat the hell out of little-ass me and Hillel anyways.

That Mayfair is the same supermarket Bob Forrest sang about in the Thelonious Monster song:

"Yes, Yes, No" —

"*I went shopping to get some aspirin....my head was hurting from a combination heroin and gin*

"*Saw a man in the parking lot......he was doing some peculiar fishing*"

Poor little Bobby had gone to the Mayfair market at the break of dawn one morning to get some aspirin after pulling an all-nighter drug binge; he was hurting bad. He saw a guy there in the parking lot practicing his fly-fishing, enjoying the break of day. It sent his mind spiraling.

Moonlit Meadows

At the end of the filming of *Suburbia*, we were all out partying at an apartment in Hollywood. By now there was great family feeling amongst the cast members, and to top it off, Maggie was paying attention to me, and I sensed that she might even possibly, maybe, by some incredible stroke of fortune, embrace me romantically. My heart skipped a beat whenever she spoke to me.

The aforementioned Bugboy was packing a bag of meth and a syringe. I was hesitant to take my shot of speed, not out of concern for my well-being, but worried that Maggie would see me all gacked out of my mind and think I was weird. I must have mentioned it, and it got to Maggie, who approached me and said, "Flea, dude, it's cool, do your drugs if you want, we all get freaky sometimes." So against all common sense I asked Dr. Bugboy to stick that needle in my arm and I blasted off into being THAT way. I rocketed into a bizarre state where things became very clear and important, accompanied by a burst of the most optimistic confidence, and a parallel overwhelming awareness of my most confounding fears and insecurities.

The insanity of having just been intravenously adminis-
tered crystal meth by a guy who had moments before stuck
the same unwashed needle into a bunch of other dirty arms
at the party, not to mention that he had probably been us-
ing that syringe for a month, is terrifying to consider. The
fact that I escaped my drug-using days without catching HIV
is one of the most fortunate developments of my life. My
lord, the anxiety and fearful projections I experienced years
in the future when waiting out the week for the results of
my HIV test. This was back when HIV was a death sen-
tence. Phew. Yikes and phew, I am lucky to have gotten out
of that absurd crapshoot alive. Guardian angels, my sweet
angels, thank you.

Getting geeked up on the speed that night proved to be too
overwhelming after all. I knew I was bug-eyed and crazy as a
loon, and wouldn't feel comfortable around Maggie no mat-
ter how nice she was being to me. I took off with Peg Leg,
Will Wonderboy, and a few others to go spend the night at Peg
Leg's house in Alhambra. We knew we were gonna be up all
night, and he said his house was a great place for us to freak
out unmolested. And that we did.

André Peg Leg Boutilier was one of the cast members of
Suburbia, and we had become buddies. He was an interesting
young man, of high intelligence, and an aggressively forward-
looking attitude. An avowed punk rocker he went wild in the
slam pit at gigs. One of his legs was amputated just below
the knee, and he wore a prosthesis. He'd occasionally take it
off and throw it at someone if provoked. He was an inspira-
tion to me, the way he dove into things with such a joyful
optimism and reckless abandon, regardless of his supposed

"handicapped" status. I never saw him restricted by his absence of leg in any aspect of life.

We arrived at his place, a converted garage behind his parents' home. His father was a preacher or some sort of professional stalwart of Christianity. Now, Peg Leg was a wild man, and definitely not living within the confines of religious constraints. He cuddled up to punk rock hotties on the scene, tried all drugs, his curiosity went well beyond what was sanctified by the church.

After we'd hung out for a while in his den, we decided to shoot up acid. I'd never heard of injecting LSD till this moment, and I was intrigued. We put blotter acid in a spoon of water and let it soak for a while. I then took a nice shot of it and man.........whoa.......I felt myself surging off into the ether, flashing colors and lights and all. The trip was influenced by the meth psychosis too, and the colors and lights weren't all friendly, taking on the shape of animals, mammals, and raging weather systems. A pioneering adventure. I was communicating with the three-headed elephants and two-foot-tall tigers, negotiating with them to let me pass through the gates of life, their beating hearts of love protected by bared fangs and growls. At the ends of darkened paths through thick foliage were openings to moonlit meadows caressed by gentle breezes where deathly huge serpents lurked in the tall and swaying grasses. I was taken over by an earnest desire to rise above all the constantly shifting creatures around me, convinced that the only way to live through this was to laugh in their faces. Only unrelenting laughter could save me. If I could see them as hilarious comedians, we would all be saved, swept away by a beautiful wave of levity. I had to rely on my innermost core of strength and focus to come out of this psy-

chedelic jungle unscathed. This was serious business. I stayed focused on the light within me. In the process, I experienced a sad realization that the meth had dimmed my magic light. But I kept faith that my little glow would pull me through, and as always, it did.

After what seemed like an epic forever, I opened my eyes, becoming present in Peg Leg's room again. Seeing my friends smiling and laughing, I was grateful to be back in the mortal world. There were multiple candles nailed upside down to the ceiling, and my comrades were standing on chairs, lighting them. Then all the lights in the room were turned off, and we lay back as the candlewax began to drip from the ceiling, the ever-flowing waterfalls of little balls of fire lighting up an infinite blackness.

We watched the fire fall from the great beyond, comforted by the fiery comet trails, talking until daylight.

> When the stars threw down their spears
> And watered heaven with their tears
>
> — *William Blake*

Come sunrise, reality called, and I had to go to the bathroom. Peg Leg reluctantly agreed to escort me to the john in the main house. He was on edge and admonished me to remain quiet, mind my own business, and avoid his parents. As he led me outside, the bright light of the outdoors shocked my system. I did not feel fit for the world outside, so harsh and cruel. I longed for the lysergic sanctuary the garage had provided me through the night, and I nervously braced myself. If I could only make it to the toilet unnoticed, and scamper back to the safety zone. As we tiptoed across the well-appointed

dining room, adorned with a large crucifix and images of reli-
gious icons, a large and ominous shape appeared from behind
a doorway. Peg Leg's father. I halted, frozen in place by the
mighty Christian authority facing me. I was ready to be smote
down right then, I knew I was a goner, there was no point in
continuing, I could feel the long tentacles of Satan wrapping
themselves around my ankles to drag me down into the burn-
ing furnaces of hell. In all his power the reverend looked me
dead in the eye and uttered the most brutal statement, "Good
morning." Gathering courage from the confident look thrown
my way by Peg Leg, I stammered out a reply and quickly
made my way across the final five feet to the bathroom. I ran
in and locked the door, hyperventilating, aghast at my pale and
skeletal face in the mirror. As I left, the coast was clear and I
made an outright run through the house to the garage.

We got in my '66 Dodge Dart and drove back to Hol-
lywood, the Sex Pistols blasting me halfway back to sanity.
Toward the end of the drive the subject of the film *Freaks* came
up and I made an attempt at a joke involving one of the char-
acters who's limbless and rolls a cigarette. The joke offended
Peg Leg and he let me know it. I felt so sad about that, an in-
sensitive fool, I was crashing hard and the bottom fell out. Oh,
the comedown....one always has to pay the piper one way or
another to get back in to the real world. I made it home safe.

I'm Sorry

After the filming was finished, there was a cast and crew screening. Not the proper premiere, more like a party for the people who worked on the film, a chance to watch it all together. Penelope had told me jokingly, "It'll be fun, it's our time to drink, yell, and throw shit at the screen, get loose." I took her too literally and before the screening, was hanging out with Chuck Biscuits, the Keith Moon of punk rock drummers (D.O.A., Black Flag, Circle Jerks, and Danzig). We got shitfaced beer drunk, then showed up at the screening in a wildly arrogant and irresponsible state, looking to stir shit up.

Bill Coyne, another actor in the film, was friendly and cool. He had a prominent part and was focused on doing a good job, it meant a lot to him. He and I and a few cast members bonded one night when we ended up crashing out in a hotel room and sleeplessly laughing our heads off the entire time. I felt satiated with a beautiful camaraderie that evening. Us against the world.

At the screening, Bill showed up with his mom and siblings

all dressed nicely and proud of their Bill. I was totally wasted, and as the film began, I started yelling out weird stuff, thinking I was a real comedian, being a general nuisance.

All the kids in the film are runaways who live in an abandoned house in a failed part of suburban L.A. During a pivotal scene, Bill is comforting his younger brother. A pensive, quiet, vulnerable moment. The theater was silent and everyone was totally into it when I screamed out "GIVE HIM A FUCKING OSCAR!!!! HA HA HA HA!!!!!!!!!" Even in my distorted inebriated state, I realized it was a hurtful shitty thing to do. The producer tiptoed over and told me to shut up. I realized I had embarrassed myself, and much worse, embarrassed Bill, who was there, after all, with his mom. Now, I have done and said a lot of insensitive, thoughtless, shitty things in my life, probably much worse than that, especially when I used to drink. I wanted to prove how wild I was (needing to prove something, my Achilles' heel), but that display at the screening has pained me all my life. For years, I've carried the shame of that moment. It was a great night for Bill and I shit on it. Mr. Wild Punk Rocker, Flea the Great Bass Player, the mean-spirited, selfish, drunken, arrogant asshole.

A few years ago, I tried to look Bill up, to apologize and make amends. I found him on the internet, only to make the numbing discovery that he was dead by suicide. Bless his soul. I never got the chance to apologize. So, I take the opportunity now.

Dear Bill,

Dude, you were a kind, fun, humble, and thoughtful man. You made me feel comfortable and accepted when I was scared, insecure, and didn't know anybody. I'm so fucking sorry and

I apologize to you and your family, for my thoughtless blundering. I hope you didn't let my idiotic display bother you. I'm honored to have known you, and you fucking killed it in Suburbia. *I trust you exist on the highest plane now.*

Love,
Flea

Back to the Base

I always had a crush on Penelope. Something about her being a productive artist, making movies, getting work done, and realizing her vision, was just so damn attractive. Whenever I saw her at shows or wherever, I walked around holding her hand. It wasn't romantic or sexual, it just made me feel connected to something real. She was kind to me and treated me as an equal. It felt nurturing, in a matronly way maybe, I don't know, I was just happy she was there. I'm proud to be her friend.

But my crush on Maggie was electrically charged. She was the wild one I wanted. Hard, cold, sarcastic, and mean on the outside, but I knew if she would just let me past those violent gates, the most tender and vulnerable love lived within.

FEAR was still my career focus. We rehearsed most nights at the Damax storage shed. My big physical challenge was learning to play with a pick and doing fast sixteenth notes, all downstrokes. To be honest, I never got that great at it.

Spit taught me how to warm up before a show. Exercises to heat up the muscles in the arms and fingers, to build them up slowly to a strong and fluid space, and keep them that way

until hitting the stage. This lesson impacted my stage perfor-
mance profoundly, and is the reason I can dance around the
stage like an unfettered animal, never having to worry about
what my fingers are doing.

Things began to get weird. When I got a tattoo of Jimi
Hendrix on my shoulder, Philo made a racially insensitive
comment about it. I knew it was his humor. I didn't think he
was a racist, but it felt ugly and wrong, and it wounded me. I
told myself it wasn't that bad. They were good guys enjoying
a freak-out-the-squares kind of humor. I was all for freaking
out the squares.

But if punk rock means never having to say you're sorry, in
the long run that makes me no punk rocker.

Swallow Me Up

There was one heavy instance when Lee Ving met my stepdad Walter. For a pittance, Lee was selling me his old car that didn't run, and Walter came over to Lee's to get it going. After introductions, Walter was lying on his back in the street underneath the car, getting his grease monkey on. Lee and I were standing there on the hot summer suburban Reseda day, the three of us chatting, and the conversation turned to music. Now, as I have expressed, Walter was a jazz guy, pure and true. He was what one could call a jazz elitist, looking down at simpler forms of youth culture music. I know this elitism is an unhealthy attitude, but I also understood that Walter and his jazz cronies, who had dedicated their lives to this beautiful art form to no acclaim outside of their small circle of appreciation, felt ostracized and disrespected. I didn't agree with their snobbish attitude about rock music, I think it hurt them. But I understood their frustrations.

I'd previously told Lee that Walter looked down on punk rock. Being the proud punker that he was, and standing up for me, Lee said, "No one wants to hear jazz anymore, it's over, it's dead. The kids wanna bang their heads and go wild. Jazz

is old and boring." Walter poked his sweaty head out from under the car with a seriously concerned look on his face, oil-stained hands tightly gripping a wrench. I saw in his countenance that simmering rage he had before he got violent. He opened his mouth for a second, but nothing came out. He exhaled and silently disappeared back under the car.

It wasn't just the tension between them that made me feel terrible. The slightest hint of unease between people I care about has always caused me extreme discomfort, but in this case, because of Walter, it was particularly painful. Despite all the trauma and fear he'd brought to my life, I loved him deeply. The musical gifts he showed me changed my trajectory in the most meaningful way, setting me on my greatest course. This man who'd always been so big and scary to me, and such a ferocious freight train of a musician, seemed so demeaned, small, and defeated at that moment, putting up with this shit so he could get his kid's car going. Walter loved me. Funnily enough, I know that Lee had a true appreciation for great jazz. But he just had to get his licks in. Lee was like a big brother to me, and Walter my most prominent father figure. They were two parts of me, and they were at war. Oh, war. Oh, Weltschmerz. I wanted the earth to swallow me up into nothingness.

The beautiful music that Walter had shared with me made all his violent dysfunction worth it, the jazz, the jazzman, the music. It is the most venerable art form that North American culture had ever produced. For me, it is the high-water mark of art and the human spirit. Damnit, he'd been hearing this shit about jazz all his life, and all his life he had persevered because of his faith in the music. I think of all the great jazz musicians that came in and out of our house, Freddie Redd, Omar

Hakim, Philly Joe Jones, and the many others, how they'd dedicated their lives to this deep and complex thing, to be rewarded with only the music itself. They saw all the pop and rock music around them, so often insubstantial, its progenitors making millions, while they worked menial jobs to make ends meet. The plight of the jazz musician in Los Angeles in the seventies. They grew up idolizing the bebop greats Bird, Mingus, Monk, Brownie, and Fats Navarro to name a few, learning this immaculate art form, a lifetime of unrelenting dedication. Its gifts holding the solution to so many mysteries for the willing listener, yet jazz was disregarded as culturally irrelevant by an increasingly tabloid- and haircut-based culture. Walter didn't need to hear that shit.

Pretentia What?

— Twisted Roots

Punk rock opened the door to a new way of thinking that applied to every facet of my life. One night I was with the FEAR men at a house party. I was drunk and rambling around through the rooms, seeing what I could get into. I went in one of the bedrooms of this large old craftsman house and heard music I'd never heard before. It stopped me in my tracks. Spit was standing near me and I asked him, "What is that music?" He said dismissively, "Oh it's the Germs, they couldn't play for shit and the singer was a creep." I'd heard of the Germs before, trying and failing to get in to see them at their last ever show at the Starwood, and I'd felt emotional when I read of the singer's death, even though I knew nothing about him. But I wanted to be in tune with the FEAR consciousness, so I left it at that and went on to join the party in my pursuit of the perfect punk rock girl.

Next day, I went directly to the record store and purchased the Germs album *(GI)*. It was a serene evening at the Wilton Hilton, no one was around. Perhaps Fabrice was quietly painting in the corner. I put on my headphones, spun the Germs album, and lay down on the dirty carpeted floor. As

the first piercing feedback sound of "What We Do Is Secret" flew into my earhole, everything else completely disappeared, casting a magic spell, the music having its way, reverberating through all my dimensions. Over the course of the next thirty-eight minutes and fourteen seconds, the way I heard music changed forever. It was more than the sum of its parts. The lyrics poetic, insightful, and visionary, the music wrapping itself around my heart like ancient vines around a mighty oak tree, and coursing all over like a raging river embracing a huge boulder in its center. In all its distorted violence, it made me feel warm and not alone. They were just rocking out, but a force beyond their control surged through all the music, like maybe they couldn't see it themselves, they had unwittingly opened a magic box of spiritual power and let this thing out. I was completely satisfied. It split me wide open. I gazed at the pictures of Darby, Pat, Lorna, and Don on the back cover and fell in love. "He could set your mind ablaze / With sparkling eyes and visionary gaze." He took on all my heroes, and thrashed around them at the peak of my mystical mountain of music. They stood with Coltrane, the Beatles, Billie Holiday, Jimi Hendrix, Clifford Brown on the Mount Rushmore of my heart. Nothing but punk rock. A few chords per song, a simple or nonexistent melody. Not clever or arty, it was just raw and reckless, and produced perfectly by Joan Jett.

It became clear that virtuosity and musical sophistication were no longer essential to me and could even be an impediment to the power of expression! This realization did not diminish my love for the most complex music, but made my world a less limited place, blowing to smithereens the walls of judgment that obscured my view of art. I was a freed man. All that mattered was the integrity of motivation, the ability

to express your own world, your own emotion, with whatever vehicle was available to you.

I listened to that Germs record over and over, it had everything; femininity, animal lust, soaring power, sexuality, asexuality, intellect, poetry, one-of-a-kind groove, classic riffs, unforgettable songs, it was perfect. I air drummed to Don Bolles for the rest of my life, even after he had a fling with my girlfriend. Without a whiff of pretentia, it was the highest art, like any of the transcendent music that had ever touched my heart, but it wasn't high, it was low and dirty like a brutal crack whore muttering deliriously after she/he sucked somebody's cock behind a dumpster, then pulled out a switchblade and took his punk-ass wallet. Bob Marley said that it didn't matter what kind of music one played, or even the quality of it. All that mattered was complete commitment in the creative process of channeling it.

I began to emotionally move away from FEAR. I had some explosive shows with them, experienced utter hilarity, and learned how to make a rock band work. That first FEAR record is a fucking classic and it was blast to rock it with them. But ultimately, I was always an outsider. I was just a lot younger, and had a completely different set of reference points. I loved music they didn't dig, and vice versa. Their racial and homophobic jokes made me feel sad and disconnected. I got it, like Don Rickles, but I began to wonder if it was a joke or not. Don't get me wrong, I'm open to offensive humor. Nothing is off the table, death, love, hatred, all the things that we hold sacred, all are ripe for a laugh. But their vibe was growing stale, and I started seeing them in a different light.

I was reading the great book *Soul on Ice* by Eldridge Cleaver, who, discussing racism, wrote, "You either have to be

part of the solution, or you're going to be part of the prob-lem." That hit me hard, the concept of no gray area. I wanted to be part of the solution, and the moment I read that, I de-cided to quit FEAR, come what may. Then, right at that same moment the craziest thing happened.......There I was sitting by the phone, having just read the Eldridge Cleaver thing, and I was building up the nerve to call Lee and quit. I sat there pensively in my sister's small apartment where I was temporarily living. I loved her cozy wooden one-room place overflowing with the copious book and record collection con-taining Joni Mitchell records and the Anaïs Nin texts, which stimulated my erotic imagination so vibrantly, and the phone rang. It was Lee.

__Lee:__ Hey Flea, how ya doin' man?
__Me:__ Cool man, everything is cool.
__Lee:__ Look Flea, it's hard for me to say this but um....we
 feel like this isn't working out....uh......we need to
 move on and get a different bass player.
__Me:__ That's cool, I wasn't into the heavy metal anyways.
 (FEAR had started to move into a more metal direction
 which was opposite of my arty tendencies of the time)
__Lee:__ (slightly perturbed) What?
__Me:__ Nothing, never mind, I understand.
__Lee:__ Okay Flea, take care man, you're a good kid.
__Me:__ Thanks, Lee, you too.

Click.
Done.
Chili Pepper time.

The Sea of Lost Causes

Was up at the Hallucinagenius's house in Topanga Canyon. His roommate dealt coke, and me and AK were on a gnarly geezing run. Toward the end of our binge, after harassing the poor dealer dude out of his sleep all night to keep fronting us half grams, we decided to shoot a big double dose each, a big bang finale, a deep kick that would finally catch the first one we'd been chasing for eight hours. I took the big shot, my eyes widened, the ringing bells became deliriously distorted, and then everything went black.

I awoke on the floor with a bump on my head and a sizable purple hematoma in the crook of my arm. The hematoma was there because I had missed the vein and my arm swelled up, but the shot was so strong it still knocked me right the fuck out. If I would have scored a direct vein-to-heart-to-brain hit per usual, there is a very good chance I would've died.

I've been saved again and again by angels all around me. Not just from the insane stupidity of banging blow, but from becoming an aimless flounderer. A person who maybe talked a good line about doing shit but never ever put in the work to see things through. I could've easily dug myself into a hole,

become someone who never got a clear picture of cause and effect, holistic health, or emotional well-being. I bow before the guardian angels that always showed me a light and a way up. My sanctuaries of friendship, books, basketball, music, and nature kept me sane.

Even though I didn't have a clue of how to stop running myself ragged, to be still and know myself, or treat my body itself as one of those sanctuaries, I had my sacred spots. And in them, despite my utter ignorance of how to self-love, I knew that love existed. That knowledge was the life raft that saved me from floating away into the Sea of Lost Causes.

Pavlov's Narcoleptic Flea

I went through a few years where it was an absolute physiological impossibility for me to stay awake in a movie theater. No matter the intrigue unfolding on the screen, I fell asleep. I entered the theater vigilant: *I WILL STAY AWAKE THIS TIME.* (Much like my pre-bed thoughts as a ten-year-old: *I will not pee the bed I will not pee the bed I will not pee the bed tonight.*) But like my urine flow, the over-whelming heaviness of my eyelids won out every time. From someplace deep inside my mind, a Pavlovian response was triggered by the shifting light of the big screen, s a f e t o s l e e p l e t g o, and I immediately went comatose. Always awak-ened by a tapping on the shoulder, to see the end credits, uneaten popcorn on my lap. Every fuckin' time.

My life was constant stimulus. I'd never learned what it was to have quiet time, or to nurture myself. I ran at full speed day in, day out. My body decided for me, go to sleep.

Be Like Water

All my life, during times of change I take solace in water. Scared, heartbroken, confused, hurt, and angry, I plunge my body into oceans, lakes, pools, and bathtubs to find peace and faith. Fortifying me, wiping the slate clean, this baptismal act guides me again and again, helping me to tap an infinite strength.

Anthony's always shared this affinity with me and late nights, after the clubs closed, inebriated and hopped up on life, we'd go swimming. An apartment building on Fountain and Fairfax had a huge, lit-up swimming pool, the only thing separating it from us, an intimidating ten-foot-tall ivy-covered fence stretching down the street. We'd show up with a couple of carloads of people and all us boys and girls would stealthily climb the fence, silent but for the whispers and muted giggles, strip down and dive in. The apartment building sat at one end of the pool, a beautiful old construction from the twenties, filled with its peacefully ignorant sleeping tenants, while we frolicked away the wee hours in the glowing baby blue rectangle of welcoming water. At every opportunity I've swum in so many amazing oceans, rivers, lakes, some of the finest swim-

ming holes in the world. If there's water around, I'm getting in it. But back then, before any of us could afford to live in a place with something exotic as a pool, *let alone the macking houses on the beach we enjoy today,* sneaking into that pool in the dead of night, silently diving into the deep end, feeling everything relax, seeing the other bodies underwater joyful and dolphinlike, heads emerging from the water with peaceful, happy grins.........I reckon those were the greatest swims I have ever had, and that's a hard competition versus Hawaiian cliff jumps and remote Australian crystal blues. The perfect nightcap, the ultimate in luxury. We never got caught, we never got kicked out, we never did anything weird. We just appeared and disappeared from those dark smoggy nights and enjoyed the weightless beauty. Lifted up by those swims, having rocked a wild-ass punk rock show hours before, partying till they kicked us out of the club, then turning into Aquaman, all of us together on the sly, floating and quietly howling at the moon.

That kind of togetherness we had then, our friends, that sense of exploration and the wonder of all the life that lay ahead of us, it was so beautiful. I love growing up, I am turning fifty-seven in a couple of weeks, an old-ass man, and I still frolic and play as ever, diving off cliffs, running through mountain trails, so many things I love to do. But that free for all, all for one togetherness of yesteryear? I miss that. Ah, melancholy nostalgia! We get older, work hard to make money, families happen, and like the protagonist in Shel Silverstein's *The Giving Tree* (which I can never read to a child without feeling the moistness of a teardrop), we separate. Sure, we all get together from time to time to yuk it up at dinner parties and fancy Hollywood shit, but that three a.m. stealth swim in someone else's pool? A romantic memory.

In a Circle

Nothing to be gained here.
— Jean-Michel Basquiat

The energy at the Wilton Hilton, though drug-addled and unhealthy, was beautiful. All flavors of people flowed through, all ethnicities, gay, straight, sane, insane, sexy, ugly, beautiful, all of 'em. Art pervaded everything. This period was alive, occasionally peaceful, and perfectly imperfect. Wabi-sabi, motherfuckers! I'd had a great gig in FEAR, having quit the animal hospital and sweet Dr. Miller. I fulfilled my dream of becoming a professional musician. But the drug scene was heavy, heroin was always lurking and if I was ever gonna take the turn into being a hopeless drug case, this is when I woulda done it.

One crazy drug made a showing on the scene called MDA; it was a bizarre toxic blend of a stimulant and some other weird shit that produced a primal kind of euphoria. I went on some crazily long three-day MDA runs. It had people fucking like rabbits all over the place; elevators, stairwells, on the kitchen floor while I was making my cereal.

For a short time, the entrepreneur in me came out, and I started a burgeoning small business. I acquired a garbage bag full of syringes (dog syringes from Dr. Miller's), about fifty doses of MDA, and was bundling and selling them for a good price. After selling a dose or two and nearly starting a powerful and far-reaching Hollywood drug cartel, I ended up just giving it all away.

Jean-Michel Basquiat would come by to cop dope off Fabrice. He was friendly, taking time to chat, and listen to Bird. My heart opened when I discovered his art. His were the first paintings I truly related to organically. To discuss them, I didn't need to adopt a pretense of intelligence. They inspired me, and I wanted to make music that sounded like his paintings. I had no idea he'd become an international superstar.

What Is This had found a bass player to replace me, and with time, Hillel softened his resentment, letting forgiveness in. He started coming around and being my brother again. For my birthday gift, he drew a beautiful clown. I took it into my room and sat on my bed clutching it happily, tearfully overcome with emotion.

The right group of people at the right time, sitting around listening to records at the Wilton Hilton, and I felt part of a circle, with my people, hearts as one. A love amongst a weird cast of outsiders who had nothing to gain from each other.

But heroin made that circle hard to maintain. When copping is a foremost concern, the smackolytes are either too distracted by the hustle and the jones, or they are high and barely present. There's also the never-ending soap opera of jealousy and judgment over who has it and who doesn't. The smack syndrome's gray cloud of confusion sucks out the love.

It's Crowning! Push! Push!

Life is but a dream; It's what you make it
Always try to give; Don't ever take it
— The Harptones

The unplanned, unexpected, and organic series of events that led to the birth of Tony Flow and the Miraculously Majestic Masters of Mayhem was a confluence of things that could only have been the work of angels. There was no forethought on our behalf. We had nothing to do with it. Without the divine powers that set up the whole thing the band would never have lasted this now nearly four decades. The essence of what it is — the longevity of its ability to relate to people, is all directly connected to the way it began.

We were removed from the competitive financial nature of the world, and had surrendered completely to living the lives of artists. There was no "backup plan."

The greatest writer in history — Mikhail Bulgakov is my personal favorite! — could not have dreamed up a more fertile setting for the birth of a rock band.

— The way Jack and Hillel had started playing on the same day back at Bancroft, embracing KISS and the rock star mythology.

— My, Hillel, and Anthony's broken families, rife with dysfunction, fueling our yearnings for togetherness. I looked to create my own family with my street running friends.

— Young Hillel's desire to shepherd his family.

— Jack with his solid family unit, where he was safe enough to nurture and release his nutty obsessions, like covering his car entirely with glued-on Anthym flyers and playing drums relentlessly. Not out of control like me, he steadfastly forged the integrity of his love and respect for humans.

— Me and Anthony's deep friendship, fired in the hustling streets of Hollywood, both of us unwatched enough that we could run wild in them, burning and searching, fighting and dreaming, to make our mark in the world. My musical aspirations, his thespian ones. Both of us privy to our fathers' attempts to make a living in Hollywood show business from unorthodox angles.

— Anthony's coming from a non-musician, non-musical-study life had everything to do with his approach to music, the naiveté of it being the only truly perfect vessel that could have put the rest of us in the right context. The genius of his worldview as part of our collective effort was unrestrained by any musical rules. Anthony didn't even consider himself a musician; he was free of the whole thing.

— My jazz upbringing. Until I met Hillel I had zero interest in rock music and actually had disdain for it. Thus by the time it became a part of my life, I came at it in from my own weird angle and developed a rhythm all my own.

— That in FEAR I had learned what it was to apply my

street life to music and go hard. It was also critical that I'd quit What Is This, hurting my friends, so that we could then experience the gratitude and joy of reunification.

And a zillion more things, all of it just simmering and building, out of our realm of knowledge and beyond our control. We were high and innocent enough to get out of the way and let the universe work. All the elements expertly mixed by a team of divine scientists and ready to go off. None of the music we had worked on seriously in the past could hold a candle to the process of ceding control to the godzzz and letting our humanity breathe honestly through the sounds. Joy and pathos in full bloom. We were finally ready.

From the depths of brotherhood in my life came Anthony Kiedis, the missing link that I had never considered. My closest friend on the planet, right in front of my face the whole time, he was the magic key to the cosmic kingdom. I never thought to look to him for music, he who had traversed the wily trails of my teenage years. We found so much, failed and succeeded so wildly during our stealthy and bumbling search for connection along the streets of Hollywood. He was the spark to light the fire, and it was all there ready to ignite......

Whether we knew it or not, back then in the Wilton Hilton, the spirits worked, giving us the opportunity to spread those wings and fly. We had worked our chops for years, all we had to do was jump off the cliff.

Anthony came into the kitchen at the Wilton Hilton bursting with excitement about a group he had seen perform the previous evening: Grandmaster Flash and the Furious Five. Blown away, he related deeply to the way the MCs did their thing. He

wanted to do it too, the hip-hop concept had him enthralled, and he saw a place for himself in a band.

He had never outwardly expressed his desire to be a singer before. I do recall him speaking to me once when we were fifteen about an English teacher he had in middle school, who had commented on the pleasant and resonant timbre of his voice, that he could be a singer. But I had never noticed musical aspiration, he'd never mentioned a desire to focus on music (outside of our one rehearsal of "Spigot Blister and the Chest Pimps" where we got fucked up and made noise for a couple of hours with Skood and Patrick English, and then Skood went and crashed his car into a stop sign), but after seeing Flash he sat right the fuck down in the kitchen and started writing lyrics to what became "Out in L.A."

I lived and loved to funk. It's my most natural rhythm, and I came up with a bass line for his poem, inspired by the jagged edges of Basquiat, and the song "Defunkt" by the band Defunkt, an awesome avant-funk band from NYC led by Joe Bowie, brother of Lester Bowie, he of the Art Ensemble of Chicago. We used to rock out so hard to "Defunkt" at Skood's, go into a dancing frenzy when it played, whirling and dervishing our way into the land of the free. Defunkt was ingrained in our psyches.

Our friend Gary Allen was playing a gig at the Grandia Room, and asked if we would get something together and open the show for him. Anthony had come up with the overly alliterative moniker Tony Flow and the Majestic Masters of Mayhem, and we agreed to do it. The Grandia was a cool little bar spot, one night a week it was called the Rhythm Lounge and run by another Neighbors Voices associate, a

slinky French cat named Soloman. It was the first club in Hollywood to play all the hip-hop coming from New York. Afrika Bambaataa and Fab Five Freddy hung out there. Man, it was another era, no internet or cable television (well, maybe there was some cable but not for us lower end of the economic scale folks), and I was getting rocked by this amazing shit for the first time. I'd soon start hearing and going to see local L.A. rappers like Ice-T and the Egyptian Lover, but not yet. Music took longer to ferment then. A group of people would discover a sound that would stew in a slow burn, taking in the character of the neighborhood they lived in. The unearthing of new music was a deeply social, communal experience.

I had the guitar and drum parts for "Out in L.A." in my head. We never rehearsed, but we got together in the living room at the Wilton Hilton, and I scatted, sang, and grunted through those rhythms to Jack and Hillel, who immediately understood. Anthony was raring to go with his "Out in L.A." poem, and a few hours later we headed over to the Grandia Room for our first show.

Love Is the Only
Serious Work

The source was being tapped, and there was no stopping the flow, the worms were squirming around out of the can, the cat ate the bag, the levee broke.

We showed up at the Grandia that night in February 1983, loose and ready to roll. We only had one song, which was about two and a half minutes long, but we'd also worked out a dance routine to the song "Pack Jam" by the Jonzun Crew, a futuristic electro funk freak-out we loved.

One of us was holding up a boom box blasting "Pack Jam," and we danced our way from the sidewalk outside, through the club, onto the small stage, wearing our funky thrift-store clothes, tension mounting, and our friends hooting and hollering. We busted into our choreographed dance. It was funny and fun. Then we grabbed our instruments. Anthony hunkered down on the mic for the first time in his life, and 1 2 3 4 we started to play. BAM A LAM A MUTHA FUKKA!!!

From the first notes, we were swept away and all twenty-seven people in the audience swept away with us, a raging unstoppable current of the mightiest river unleashed, all of us GONE. I was FLOATING. We were unknowingly tapping a

new vein of electric rock music, without thought, just partying our asses off, lost in it. No rehearsals, no planning, no conceptual discussions. All that self-destruction, all that hopeful love whirling in and around us, something had to give. Death or Life. We could have imploded, but to live, all that intensity needed to find a place to process itself in a healthy way, and finally, organically, orgasmically, it did.

It was out of our reach, out of any construct. I felt my body being hurled around by the rhythm, we were puppets for the godzzz. This was the first time I knew what it was like to touch hearts with music for real. I was a conduit, and did not exist as a means to an end. My lord. I was in love. I was my truest self for the first time. Riding a wild stallion. We were a young Mike Tyson entering the ring, that monk in the photograph setting himself on fire, an unseen whale breaching by a massive glacier in remote Alaska.

Not until this moment did I realize I'd never felt a heart-opening magic like this while playing before, nothing else had come close.

Like when I first heard Walter and his buddies hard-bopping in the New York living room all those years before. That same pure feeling as a little kid rolling around on the floor in ecstasy, just colors and shapes, perfection, a world beyond rational analysis and human logic.

It'd be a long time before I'd grow up and even start to work through my shit, but that night at the Grandia Room, four became one.

From the first note, our band was already a massive success, as big as it would ever be. I knew it was all there. I could see its path stretched out before me, but like Dorothy and Toto, I had no idea what walking it could mean. Not a clue of the

depth of joy running through its fertile stretches, nor how strenuous and lonely it could be. What was it like to get lost in its thick forests and, bereft of all vital energy, despair in its infinitely barren deserts? I had not an inkling of the dedication and sacrifices it would take to stay on it. But, no question it was all there I saw it crystal clear.

*

I go through periods when I awake each night with a start, jerked from my slumber by a panicked dream. The empty and endless void of pain I stare into engulfs me with the terror. I tell myself it's gonna be okay, but I'm standing precariously at the edge of a bottomless pit, into which I might fall and disappear forever. I feel cold hands reaching up from there, squeezing my cranium. My stomach tightens, and the sweat starts to pour. In times of weakness, I've been blinded by the intensity of the fear, and deaf to the chorus of loving kindness. I've acted like a fool and hurt myself.

Only faith can save me. In my injured and depleted state, I walk back into the light, willing to face the cruel stare of the world and risk love.

When I tap the ever-giving joy I'm the happiest man on this beautiful earth. In those fulfilling times, I pray that I may share it with all that I am able. I know the profound happiness of being an uplifting presence. I love you all so much and I will never stop trying.

Compared to many, my childhood was a cakewalk.

Because your childhood beat you around and left you in pain doesn't mean that you'll continue the cycle. Let your hurt be the source of the greatest compassion, the deepest love and

understanding. You can do anything. Walk through it, don't numb or hide. It's been twenty-eight years since I stopped drugs and dedicated myself to a spiritual path, but those hard drugs I did, the heroin, cocaine, and meth, they hurt me bad, it took a long time to really recover from 'em. I hope for you that you don't waste your energy there. Even the weed. Man, I was way too damn young for that shit, it made growing up a more difficult challenge than it needed to be. For years and years, I made the mistake of trying to run away, before I learned to surrender, accept my pain as a blessing, trust in the love, and let it change me.

You will come out the other side stronger and kinder than ever.

The First Twenty
(A Slight Return)

Like an old dirty piece of rock pressured for millennia by the molten magma in the mantle meeting the earth's crust, the wild tumult turning it into a beautiful gem or crystal, so did the painfully unpredictable chaos of my life shape and pressure me into who I am today. Despite constant failure due to my own shortsightedness, selfishness, and pain, I crawl back along the thorny branch to the tree of love, bloodied and beaten, but back to the source, where I serve.

From when I was a tiny little tot I have felt alone. Sometimes I'm cool with it and sometimes, um, not so much. I emerge from my solitary place and try to contribute something beautiful to a world that seems hypocritical and cruel. It's hard for me to relax and trust. But when I meet another heart and we are both being charged from the same source, we see each other and together we know it's a sad and beautiful world. We are in awe and I overflow with feeling.

All my life I have wrestled with the shadow part of myself, and then miraculously been rescued. I keep jumping into a pile of shit, and my patient guardian angel keeps picking me up, cleaning me off, and putting me in a place where I can let an

infinite love rhythm blast through me. Each time, I get a little bit better; less shit, more light.

I don't know if I will ever trust enough to live permanently in a state of grace. But in my trying, I've been living fully, engaged in the struggle, and I'm me.

Thanks for reading my childhood.

DON'T MISS
FLEA VOLUME TWO!

WILL FLEA LEARN HOW TO TRUST LOVE?

WILL TONY FLOW AND THE MIRACULOUSLY MAJESTIC
MASTERS OF MAYHEM BE TRUE TO THE SPIRITS WHO
GIFTED THEM THIS OTHER WORLDLY OPPORTUNITY,
ON STAGE AND IN STUDIO??

WHAT COULD ROCK STARDOM ACTUALLY DO TO A
VULNERABLE HUMAN BEING/GUINEA PIG???

WOULD THE WILD STALLION GET SPOOKED?

IS THIS WORLD TOO PAINFUL FOR FLEA TO BEAR???
CAN HE HANDLE IT WITHOUT MAKING A
COMPLETE ASS OF HIMSELF??????

IS THERE A PRICE TO PAY FOR INGESTING TOXIC DRUGS
FOR YEARS ON END?

DOES GOD EXIST?

IS IT POSSIBLE TO EVER GROW UP WHEN YOU START
SMOKING POT AT AGE ELEVEN???

Lists

CONCERTS THAT CHANGED MY LIFE

Dizzy Gillespie — Royce Hall — Los Angeles, 1974

X — The Starwood — Hollywood, 1980

45 Grave — Al's Bar — 1980

Art Blakey and the Jazz Messengers — The Maiden
Voyage — Los Angeles, 1980

Echo & the Bunnymen — Whisky a Go Go —
Hollywood, 1981

The Meat Puppets — Al's Bar — 1981

Twisted Roots — Whisky a Go Go — Los Angeles, 1981

The Gun Club — Whisky a Go Go — Los Angeles, 1981

The Circle Jerks — a storefront on Melrose —
Los Angeles, 1982

FEAR — Club Lingerie — Hollywood, 1982

The Dirty Dozen Brass Band — The Glass House —
New Orleans, 1984

Fela Kuti — Olympic Auditorium — Los Angeles, 1986

The Butthole Surfers — Olympic Auditorium —
Los Angeles, 1987

Nick Cave and the Bad Seeds — Pinkpop Festival — Holland, 1988

Ahmad Jamal — Catalina's Bar and Grill — Hollywood, 1991

Fugazi — Hollywood Palladium — uh…duh…,1993

Nusrat Fateh Ali Khan — Universal Amphitheatre —
Los Angeles, around 1996

Patti Smith — Some Theater — London, 2005

Sam Rivers — The Jazz Bakery — Los Angeles, 2008

The Wayne Shorter Quartet — Royce Hall —
Los Angeles, 2009 or so

Radiohead — Outside Lands Festival — San Francisco, 2016

David Byrne — Shrine Auditorium — Los Angeles, 2018

ALBUMS I LISTEN TO AGAIN AND AGAIN AND AGAIN —
MY COMFORT RECORDS

Kind of Blue — Miles Davis

Hardcore Jollies — Funkadelic

Clifford Brown & Max Roach — The Clifford Brown and
Max Roach Quintet

The Procrastinator — Lee Morgan

(GI) — The Germs

Hotter Than July — Stevie Wonder

Sandinista — The Clash

The Boatman's Call — Nick Cave

*The Complete Hot Five & Hot Seven
Recordings* — Louis Armstrong

Hunky Dory — David Bowie

Channel Orange — Frank Ocean

Axis: Bold as Love — Jimi Hendrix

The Argument — Fugazi

Ruff Draft — J Dilla

Unknown Pleasures — Joy Division

Wild Gift — X

Una Mas — Kenny Dorham

Glenn Gould — Bach: The Art of the Fugue

It Takes a Nation of Millions to Hold Us Back — Public
Enemy

Metal Box — Public Image

MOVIES THAT GREW ME

Spirit of the Beehive — Victor Erice

Walkabout — Nicolas Roeg

Orfeu Negro (Black Orpheus) — Marcel Camus

Willy Wonka & the Chocolate Factory — Mel Stuart

Ratcatcher — Lynne Ramsay

Throne of Blood — Akira Kurosawa

It's a Wonderful Life — Frank Capra

Drugstore Cowboy — Gus Van Sant

The Deer Hunter — Michael Cimino

The Wizard of Oz — Victor Fleming

To Live — Zhang Yimou

Persepolis — Marjane Satrapi

BOOKS THAT BLEW MY MIND LIKE WHEN YOU MAKE TWO HOLES IN EITHER END OF AN EGG TO BLOW ALL THE INSIDES OUT OF IT

The Master and Margarita — Mikhail Bulgakov

Of Human Bondage — W. Somerset Maugham

Jane Eyre — Charlotte Brontë

The God of Small Things — Arundhati Roy

Slaughterhouse-Five — Kurt Vonnegut Jr.

The Slave — Isaac Bashevis Singer

Against Our Will: Men, Women, and Rape —
Susan Brownmiller

Jazz — Toni Morrison

Coming Through Slaughter — Michael Ondaatje

True History of the Kelly Gang — Peter Carey

*There's just too many damn books so I gotta stop but those
ones really had an impact.*

Acknowledgments

Humble thanks to those who gave me heart.

My wildly cool editor David Ritz, who patiently put up with my immature shit, wisely told me how to write a book, and was there for me in every way.

David Vigliano, who asked me to write a book with no conditions and supported me every step of the way. Nuff said.

Suzanne O'Neill from Grand Central, who kindly heard me out, gave me great advice, and let me do my thing. I thought she'd bug out when I turned in a not-rock-star-book, but she believed I could write a piece of literature without it.

Eric Greenspan, always selflessly in my corner.

And most of all, my beloved and trusted friends who advised me. I am so damn grateful.

Ian Mackaye

Thoranna Sigurdardottir

Debra McDermott

Amy Albany

Karyn Balzary

Julia Edwards

Muna El Fituri

Claudia Pena

Patti Smith.

And my Melody, the other half of my heartbeat.

About the Author

Flea is an Australian-born American musician and occasional actor. He is best known as the bassist and co-founding member of the Red Hot Chili Peppers, and co-founder of The Silverlake Conservatory of Music.

This book's title comes from the whimsical mind of Tony Rugolo, and the song "Acid For the Children" by the seminal band The Too Free Stooges!